THE WATERCOLORIST'S
GUIDE TO PAINTING

WATER

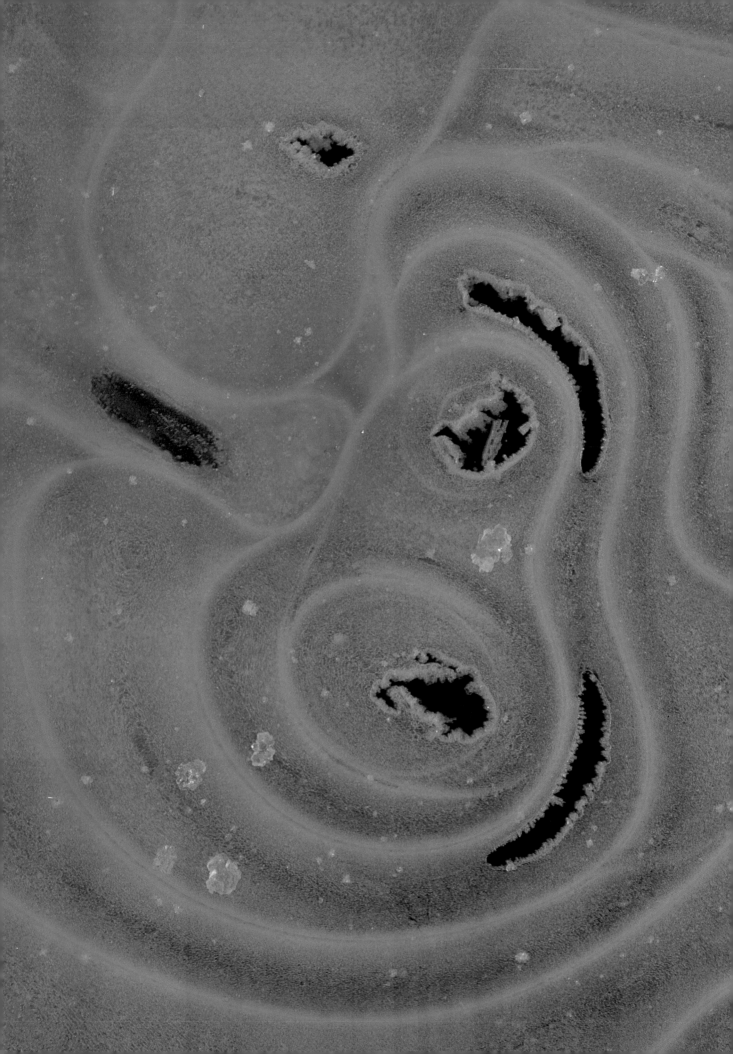

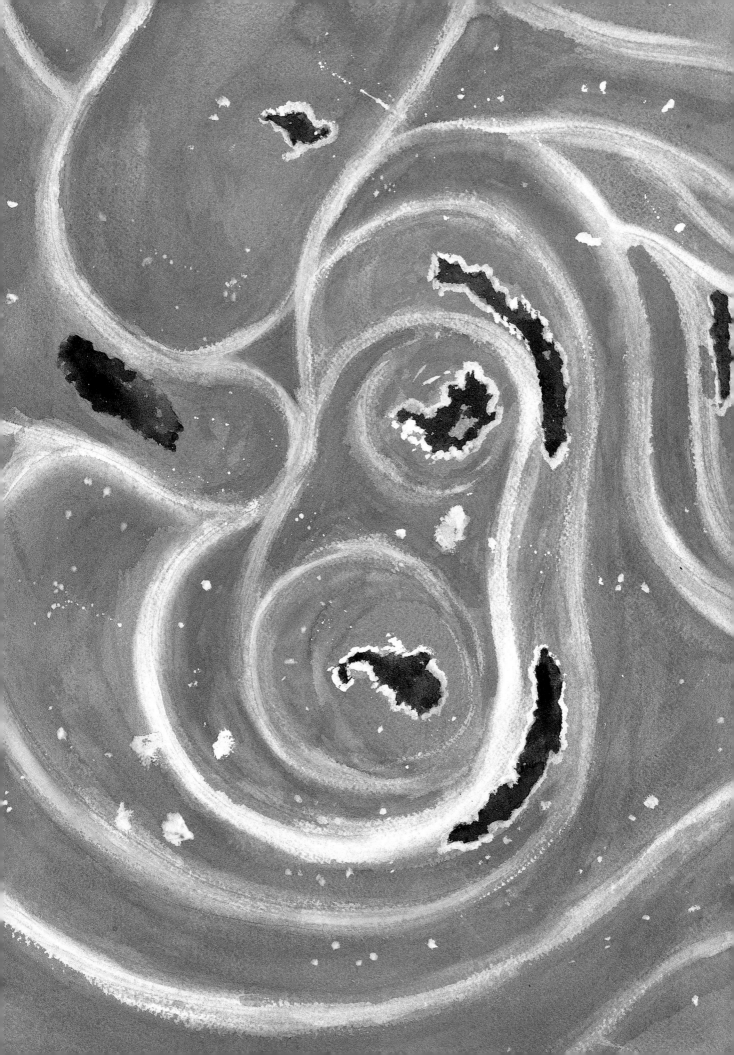

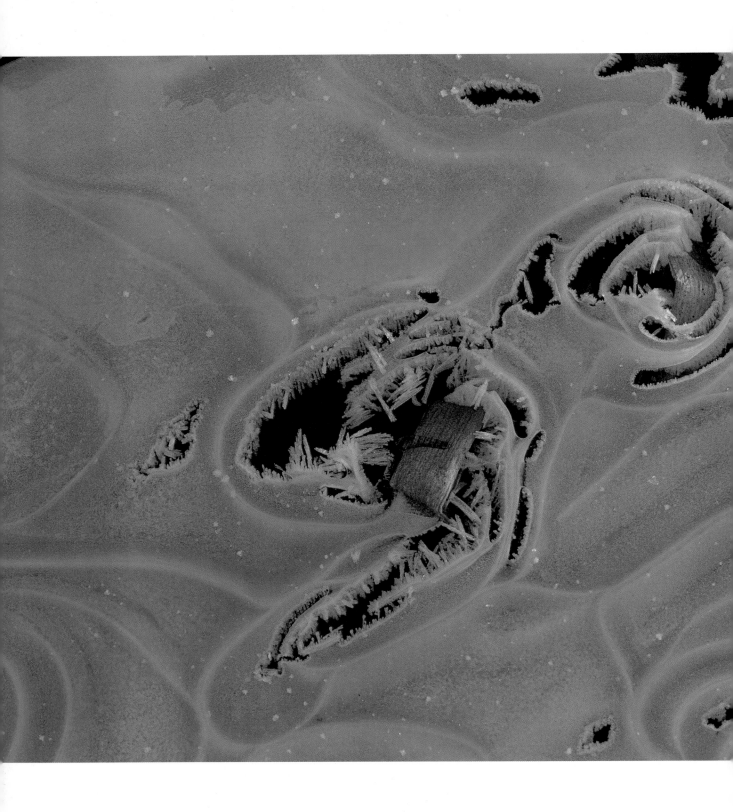

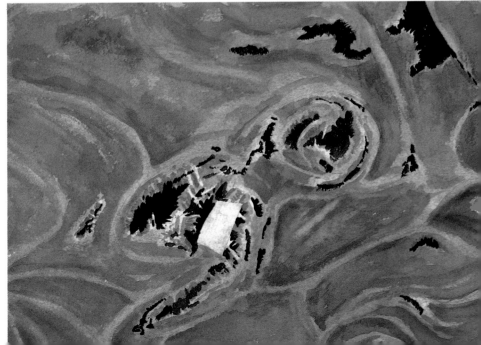

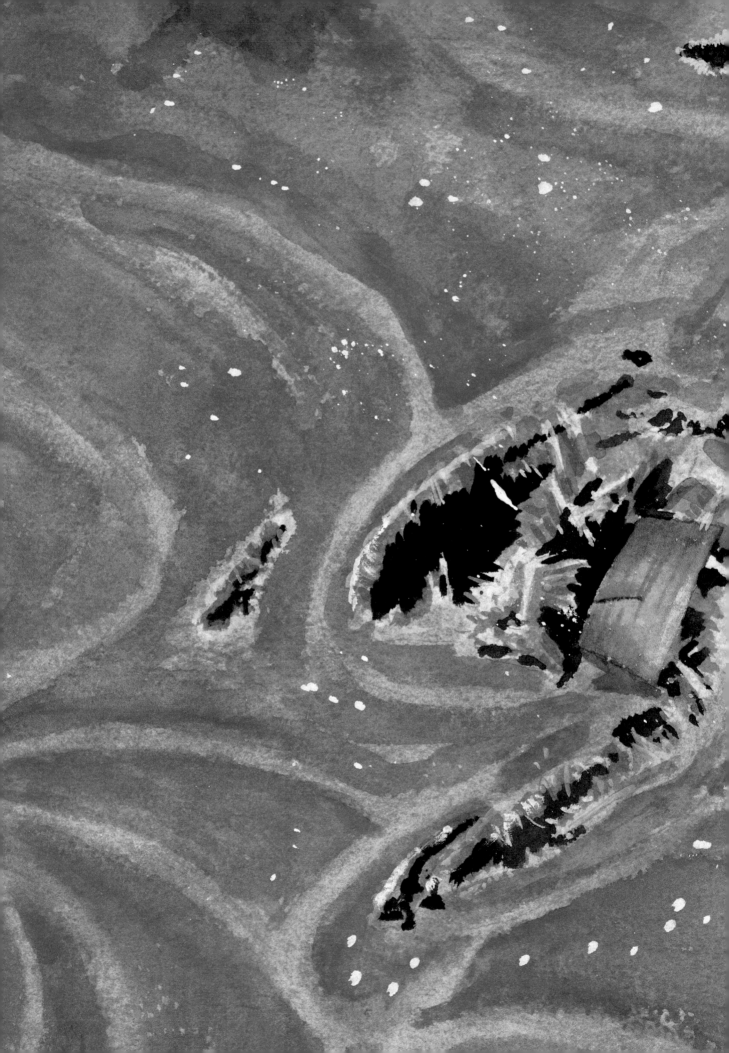

THE WATERCOLORIST'S GUIDE TO PAINTING
WATER

WATSON-GUPTILL PUBLICATIONS/NEW YORK

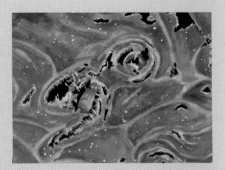

PAGES 2–3

The quiet, swirling patterns of the gently moving water are frozen in place by the rapidly forming ice.

Here the challenge lies in depicting a maze of light lines against an overall middle-tone blue.

Sketch the scene; then cover the paper with a deep wash of cerulean blue. Now take a rag and wipe out the light lines.

As the paint dries, harsh edges may appear. If they do, soften them immediately with a brush that has been dipped into clean water; then go over these areas once more with the rag.

As soon as the surface is dry, establish the darks with cerulean blue, ultramarine, burnt sienna, and Payne's gray. At the very end, add the whites with opaque gouache. First add the white swirls and define the crisp, white edges that surround the darkest passages; then spatter bits of white over the entire surface.

PAGES 4–7

Bits of wood break through a thin layer of ice that coats a slowly moving stream.

Instead of picking out the light lines with a rag, try a traditional watercolor approach: Work from light to dark.

First sketch the scene; then cover the paper with light tones of cerulean blue and ultramarine. While the surface is still wet, blot up touches of the paint with paper toweling.

As soon as the surface is dry, begin introducing darker tones; in addition to your two basic blues, add a touch of Payne's gray. Try using a drybrush approach in some places; in others, soften edges with clear water and add texture by blotting up the paint with paper towels.

Next, lay in the darkest areas. Here they are rendered with a mixture of ultramarine, Payne's gray, and alizarin crimson. Finally, paint the wood with cadmium orange, yellow ocher, and burnt sienna. Then, to enliven and enrich the surface, add white, jagged edges to the dark areas, and spatter droplets of opaque white paint over the paper.

First published 1985 in New York by Watson-Guptill Publications, a division of Billboard Publications, Inc., 1515 Broadway, New York, N.Y. 10036

Library of Congress Cataloging in Publication Data

Main entry under title:
The watercolorist's guide to painting water.

Includes index.
1. Watercolor painting—Technique. 2. Water in art. I. Petrie, Ferdinand, 1925—
II. Shaw, John, 1944—
ND2365.W37 1985 751.42'2436 85-9561
ISBN 0-8230-5693-7

Distributed in the United Kingdom by Phaidon Press Ltd., Littlegate House, St. Ebbe's St., Oxford

Manufactured in Japan

First Printing, 1985
1 2 3 4 5 6 7 8 9 10/90 89 88 87 86 85

Contents

Introduction

Water is the richest and most varied of landscape elements. Imagine a rushing stream set against a curtain of greenery; then imagine a still, quiet tide pool surrounded by pebbles and sand. Next conjure up the sight of waves crashing against rocks or of tide gently lapping over a sandy shore. Now picture thick, wet fog pressing down toward the earth, or cold, brittle ice forming on a slowly moving river. In each scene, it's the water that establishes the mood.

Water is constantly changing. Its color shifts as the sun moves through the sky. On a clear day, it catches the flashes of light cast by the sun; on an overcast day, it mirrors the cool gray found overhead. It changes, too, as it washes over submerged vegetation and rocks or when wind ripples over its surface. Capturing these many elusive moods is one of the most challenging aspects of landscape painting.

WHO THIS BOOK IS FOR

This book is designed for the intermediate watercolorist, someone who is familiar with the basics of the craft. If you are just starting, though, there's plenty here for you, too.

The clear problem-and-solution format of this book can make learning to paint with watercolor easier and much more fun. Spend a little time becoming familiar with the fundamental principles of watercolor. Learn the basic vocabulary and get used to handling a brush and paints; then work your way through a few of the simpler lessons. Soon you will be ready to move on to more complex subjects.

Whether you are an intermediate painter or a beginner—or

even an advanced artist—this book will do much more than simply teach you "how to" paint water. As you explore the lessons, you'll discover how to analyze the problems you encounter when you paint water, and you'll learn how to solve them. Through these lessons, you'll see how easy it is to solve a problem once you have isolated it and developed a logical approach.

HOW THIS BOOK IS ORGANIZED

This book contains fifty lessons, each highlighting a concrete problem that you are likely to encounter when you paint water. First, the problem is presented; then a practical solution is outlined. In many cases, there are several possible solutions; so whenever possible, we discuss alternate plans of attack.

Each lesson offers step-by-step painting instructions; in addition, many lessons provide step-by-step illustrations that reveal how the artist actually developed the composition.

As you read the lessons and work through them, you'll come to understand the variety of considerations that come into play when you paint water. Moreover, special assignments that accompany many of the lessons will help you apply what you've learned to new painting situations.

THE PHOTOGRAPHS

Every lesson begins with the actual photograph that the artist worked from as he painted. Taken by a world-acclaimed nature photographer, these shots can teach you how to compose what you see. More important, they give you an advantage that few books provide: They reveal to you how the artist interpreted his subject.

To learn more about composition, spend a few minutes studying the photograph every time you turn to a new lesson. Try to figure out how the photographer set up the scene and what makes it interesting or unusual. How did he frame the composition? How did he use light to enhance his subject? Does the angle make the composition more lively? When you begin to choose your own subjects, put what you've learned into practice.

THE IMPORTANCE OF DRAWING

A good, clear preliminary drawing can save many a painting. It provides a framework and helps you to organize your thoughts before you begin to paint. What's more, in your sketch you can work out any compositional problems that might get in your way once the painting is underway.

You don't have to be an accomplished draftsman to execute a strong initial drawing. Just concentrate on the major elements in the composition and how they relate to the whole picture. If you are uncomfortable sketching, try spending an hour or so every day working with pencil and paper. You'll soon feel at home with a sketch pad and you'll see the difference in your watercolors.

TRANSPARENT AND OPAQUE WATERCOLOR

When most people think of watercolor they conjure up images of clear, transparent washes of color floating over crisp white paper. Often that is the effect you are after. But watercolor isn't always transparent; gouache, an opaque medium, is watercolor, too.

Gouache is invaluable when you want to paint light passages over a dark ground. It is helpful, too, in strengthening the profile and

power of crashing white waves or ocean spray, and it can be used to pick out highlights flickering over a lake, stream, or ocean.

If you are unfamiliar with gouache, experiment with it as you work through the lessons in this book. You'll soon discover that it handles much like transparent watercolor, and you'll see the exciting dimension it can add to your paintings.

SELECTING YOUR PALETTE

You don't need an elaborate palette to make paintings that work. In this book, just twenty hues come into play. In most cases, the paintings are built up of five or six colors. The following colors provide a basic palette:

Alizarin crimson
Burnt sienna
Burnt umber
Cadmium orange
Cadmium red
Cadmium yellow
Cerulean blue
Chrome yellow
Davy's gray
Hooker's green light
Hooker's green dark
Lemon yellow
Mauve
New gamboge
Olive green
Payne's gray
Prussian blue
Sepia
Ultramarine blue
Yellow ocher

If you have been painting for several years, you probably have established a basic palette of ten to twenty colors. If the colors listed here aren't among them, you may want to give them a try. Experimenting with new colors is one of the easiest ways to inject your paintings with life and to find new solutions to old problems.

CHOOSING THE RIGHT BRUSHES

Synthetic brushes are much more popular today than their expensive sable cousins. Well-made synthetics handle almost as well and cost much less.

You'll need brushes in a variety of shapes and sizes. In the initial stages of a painting, when you are wetting down the paper with clear water, work with a large, flat brush—one an inch or more wide. Its broad surface is ideal for carrying water over the surface.

Round brushes are a good choice for laying in pigment. Use the broad side to lay in bold areas of color; rely on the tip when it comes time to focus in on details.

MISCELLANEOUS MATERIALS

Sponges are ideal for moistening a broad expanse of paper. Natural sponges are preferable to synthetic ones; they are less abrasive and less likely to damage the paper. Sponges also come in handy if your painting gets out of control in its initial stages. Working quickly, you can often run a sponge over the paper and remove the paint; then you can begin again.

Paper towels or rags are also useful for blotting up color. Try them if your paper becomes too wet and begins to buckle or if you have laid too much pigment down initially. Masking solution, or liquid frisket, is an important tool. Use it to cover or "reserve" light, bright areas as you develop the rest of your painting. When you are ready to turn to the masked areas, just peel off the frisket.

Razor blades are great for scratching out bits of pigment—an effective method of depicting highlights on water. Finally, a toothbrush is ideal for spattering color onto your painting.

SELECTING THE RIGHT PAPER

All of the paintings featured in this book were executed on 140- to 300-pound paper. In most situations, the lighter 140-pound stock works well, but when you begin working with several applications of water, the heavier paper is probably your best bet. It won't buckle when you repeatedly saturate it with water, and it will

stand up if you want to pull out highlights with a razor.

Choosing a reasonably sized support matters, too. Tiny pieces of paper can make your work fussy and labored; expansive pieces of paper may make you overly ambitious. Choose an intermediate size. The paintings in this book were mostly executed on paper 12 inches by 16 inches.

TECHNIQUES

The paintings were executed using standard watercolor techniques—techniques such as laying in washes, working wet-in-wet, working with a dry brush, spattering, and scumbling. Don't be put off if these techniques seem foreign to you. In almost every case, they are fully explained in the lessons. If you are truly just beginning to paint, get your hands on a basic watercolor book and spend a week or so becoming acquainted with the basics.

SELECTING YOUR SUBJECT

Complicated scenes and subjects filled with complex detail can be the downfall of even the most experienced artist. They are difficult to paint and can be terribly discouraging. Start with simple, focused subjects—a calm lake shore, a simple waterfall, or a still tide pool. As you become more experienced working with water, gradually increase the difficulty.

DEVELOPING YOUR OWN STYLE

The lessons in this book needn't be followed slavishly. Each time you turn to a new lesson, spend a few minutes studying the photograph and analyzing how you would approach the scene if you encountered it out of doors. Then read the plan of attack that we suggest. Don't feel obliged to follow the solution we offer. If you think your own method is more effective, give it a try.

Painting water is infinitely challenging. It presents an artist with a lifetime's worth of diverse and interesting subject matter.

THE WATERCOLORIST'S
GUIDE TO PAINTING
WATER

Capturing the Power of a Waterfall

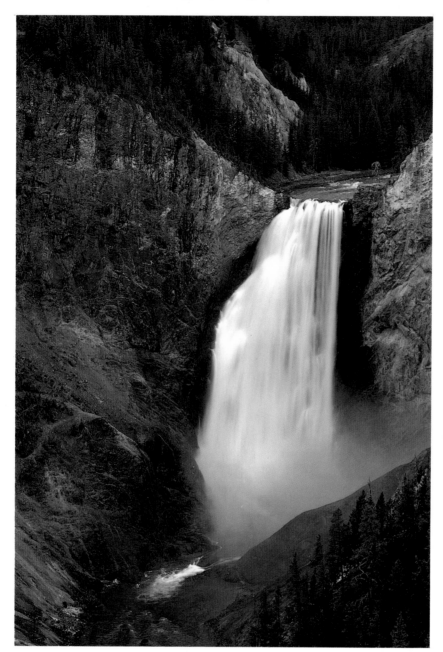

PROBLEM

The surging power of the waterfall will be difficult to capture. What makes this scene even more challenging is the hard, rough rock formations that lie behind the falls.

SOLUTION

Working from light to dark is the standard method of working in watercolor, but scenes like this one call for a different approach. Since the rough rocks are packed with textural detail, develop them first. When you've completed them, turn to the light, cascading water.

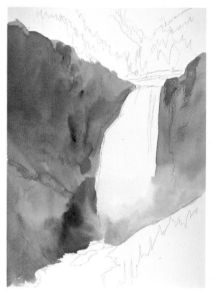

STEP ONE

Sketch the major lines of the composition—the waterfall, the rocks, and even the trees; then begin to lay in color. Start with middle-tone washes. Here both warm and cool colors come into play: yellow ocher, burnt sienna, mauve, cerulean blue, and sepia.

On the Yellowstone River, a waterfall pulses over dark sheets of jagged rock.

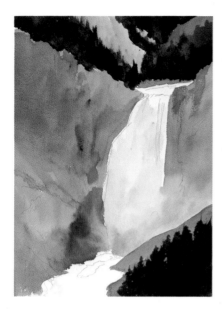

STEP TWO
Continue developing the middle tones; then begin to work on the darkest values, moving from the top of the paper down. First, paint the distant rock formations with washes of burnt sienna, yellow ocher, and mauve. Now strike in the dark greens with Hooker's green light, burnt sienna, mauve, and Payne's gray.

Turn from the trees to the waterfall. Moisten the area of the fall with clear water; then drop in very light touches of new gamboge, cadmium red, and cerulean blue.

Develop the foreground rocks and trees with the same techniques that were used for the distant formations.

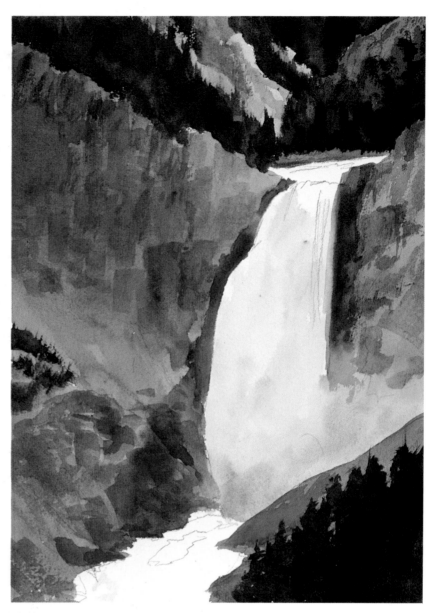

STEP THREE
Gradually add texture to the rocks. In this step, your palette will consist mostly of mauve, burnt sienna, and ultramarine blue. Dilute each color to a medium tone; then scumble the color onto the paper. To do this moisten your brush with diluted colors, shake out most of the moisture, and then pull the brush over the surface. As you work, keep your eye on the dark, shadowy portions of the rocks. They are what you are out to capture.

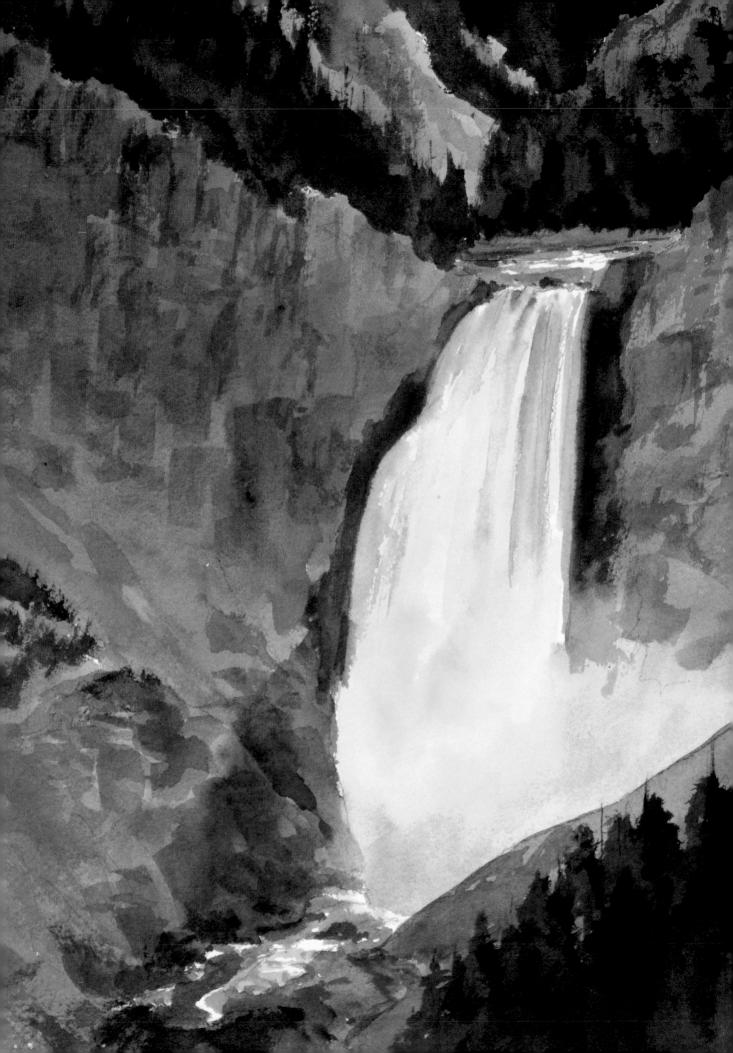

FINISHED PAINTING

All that's left to execute now is the water in the foreground. As soon as you've laid it in, examine the entire painting, looking for areas that seem weak and under-developed. Here the colors of the waterfall were too faint; adding stronger touches of red, yellow, and blue brought it clearly into focus.

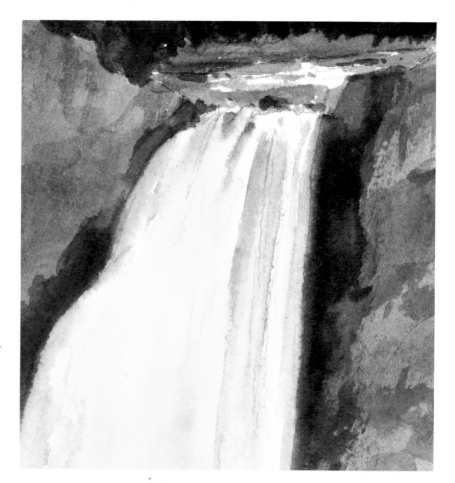

DETAIL

The transparent delicacy of the waterfall is captured as touches of color are dropped onto moistened paper. When you use this ap-proach, add the color sparingly and don't let the yellow run into the blue; if you do, you'll end up with a muddy—and unrealistic—shade of green.

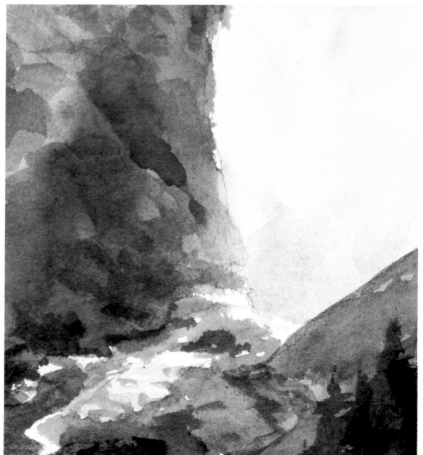

DETAIL

The water in the foreground was executed quickly and impres-sionistically. A dab of bright green paint lies surrounded with darker, blue passages, suggesting the rush of water without detracting from the power of the waterfall.

17

Working with Strong, Clear Blues

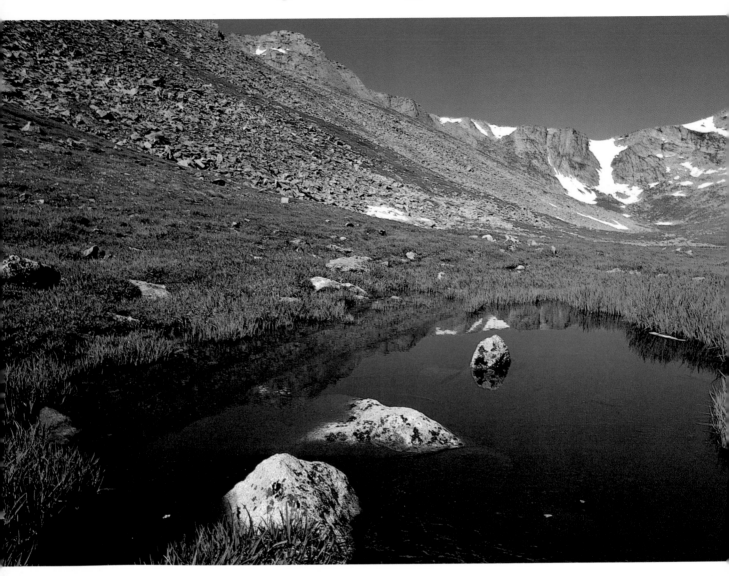

PROBLEM

When water is this brilliant, this clear, and this still, it becomes the center of any painting. You can't play down the power of the blue—it has to be strong.

SOLUTION

To emphasize the dynamic feel of the mountain lake, paint the deep-blue areas first. Once you've captured exactly what you want, move on to the rest of the composition.

*The deep blue water of a quiet
lake stands out against an alpine meadow.*

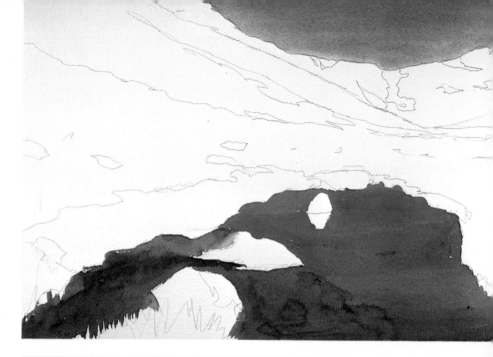

STEP ONE

Quickly sketch the overall scene; then begin to develop the lake. Dip a soft brush into clear water and, working around the rocks, moisten the paper. Next, drop ultramarine blue onto the damp paper. Starting at the top of the lake, gently coax the paint over the paper. As you near the bottom of the lake, darken the blue with mauve and burnt sienna. Now lay in the sky with washes of ultramarine and cerulean blue.

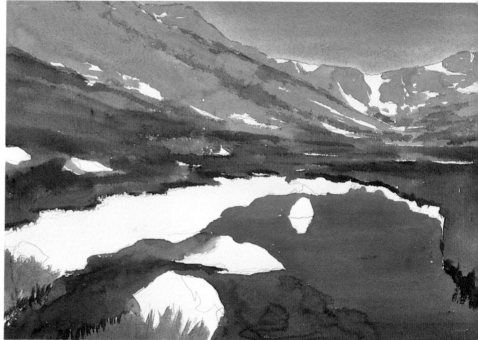

STEP TWO

Build up the rest of the composition. Start with the distant mountains, quickly washing them in with a medium-tone mixture of burnt sienna and mauve. For the grass, use a base of Hooker's green light enlivened with a little yellow ocher and new gamboge. Don't let the grass become too flat; keep your eye on lights and darks.

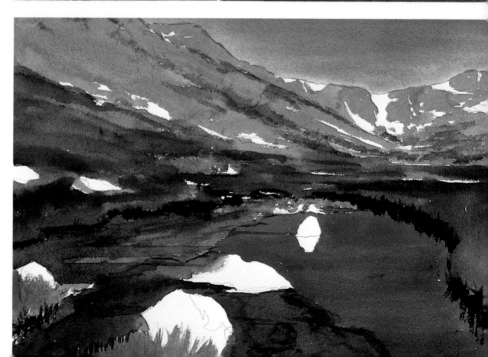

STEP THREE

In Step One, you laid in the bright blue portions of the lake and the shadowy areas toward the bottom of the paper. Now concentrate on the shadows that lie on the left and on the reflections that play upon the water. Make ultramarine your base color—it will relate these dark areas to the brightest passages. Subdue the bright blue slightly with burnt sienna and sepia.

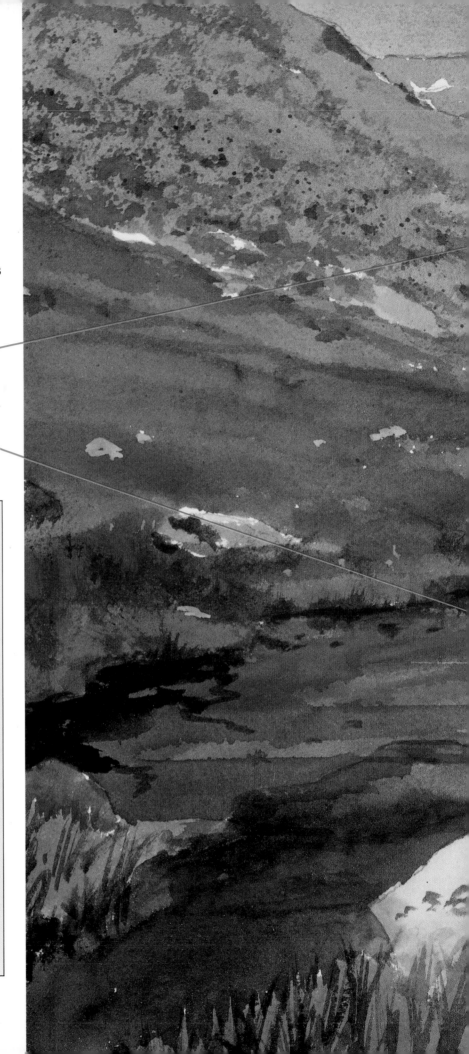

FINISHED PAINTING

Now add detail. Start with the rocks lying in the lake and strewn on the hillside. First render them with a pale wash of yellow ocher; then sculpt out each surface with blue and sepia. Add interest to the hillside on the left by spattering sepia onto the paper. Finally, take a small brush and articulate the grasses around the lake.

In the finished painting, the brilliantly blue lake is just as you intended it: a focal point that pulls the composition together.

Cool, pale mauve dominates the mountains. Mauve is a perfect hue to use when you want to suggest a vast expanse of space. It mimics the way the atmosphere softens and cools forms in the distance.

The top of the lake is rendered with pure ultramarine. Toward the bottom, the blue gives way to mauve and burnt sienna.

ASSIGNMENT

Water isn't always blue. It can be dark, murky brown; brilliant green; or pale gray. As this lesson has shown, even in paintings where blues dominate, other colors come into play.

Experiment with your blues. First take a sheet of watercolor paper and draw a series of squares on it, each of them about 2 inches by 2 inches. Now lay in a wash of ultramarine over the top half of a square. Quickly add a wash of burnt sienna to the bottom of the square, coax it upward, and see what happens when the two colors combine.

In the next square, use a darker wash of burnt sienna and discover what the resulting hue looks like. Continue this experiment with a number of graying agents—Payne's gray, Davy's gray, raw umber, sepia, and any other color you wish. After you complete each square, label it with the colors and their percentages. Later, when you need a particular blue, you can use this sheet as a guide.

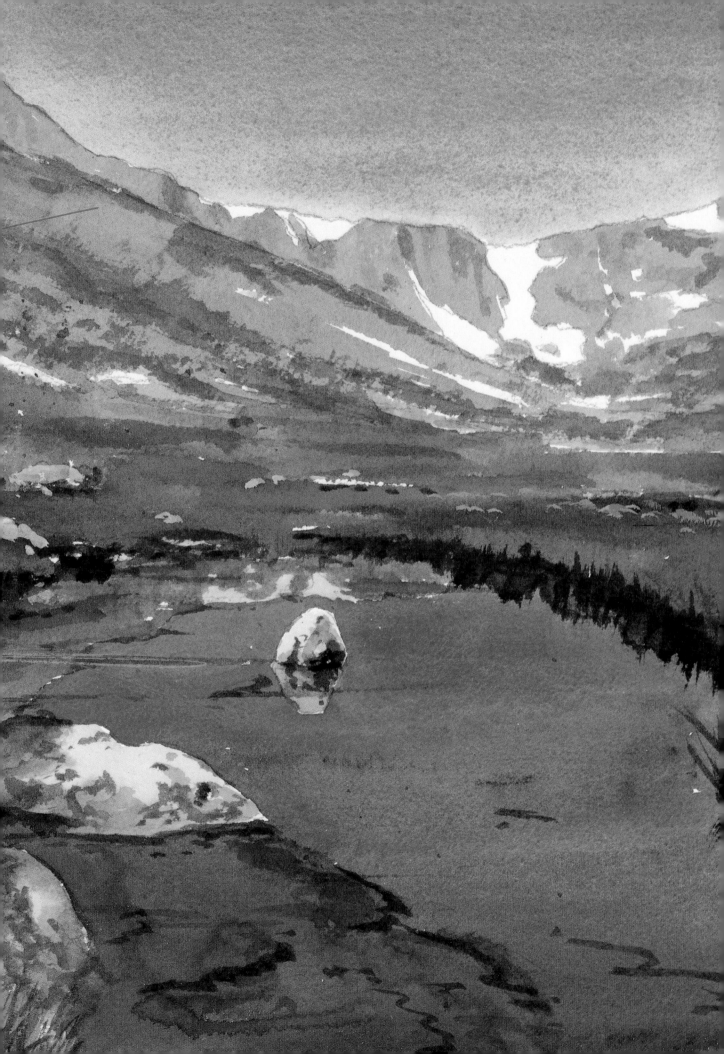

Learning to Handle Closely Related Values

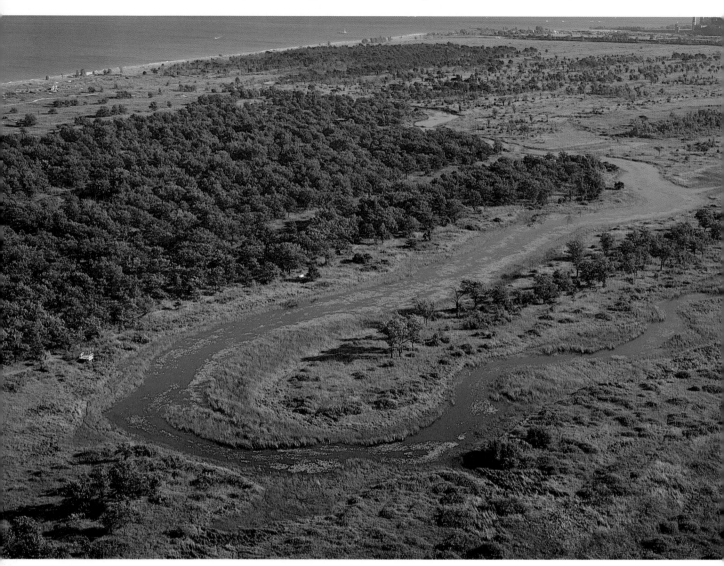

PROBLEM
The blues and greens that domi-
nate this scene are very closely
related in value. The values have
to be controlled carefully if the
river is to stand out against the
rich carpet of trees.

SOLUTION
Paint the land first. Once you've
established its value scheme, it
will be easier to gauge the value
of blue that you need to accentu-
ate the river.

*Viewed from a hillside,
the undulating contours of a river
etch out a gentle, rhythmic pattern.*

STEP ONE
Keep your drawing simple: sketch in the horizon and the pattern that the river forms. Next, analyze the colors that make up the land. At first, the land may simply seem green. Viewed closely, though, you'll see that it contains warm reds and yellows, too. Here it is rendered with washes of Hooker's green light, yellow ocher, mauve, alizarin crimson, and cadmium orange.

STEP TWO
Add definition to what you've begun. Paint the distant trees with ultramarine and burnt sienna. As you move forward in the picture plane, shift to washes made up of Hooker's green light, cerulean blue, and yellow ocher. In this step you are not only defining the shapes of the trees, you are also adjusting the value scheme of the painting.

STEP THREE
Working with the same three colors, further develop the composition as you add the darkest portions of the trees. As you work, don't concentrate too much on any one area; instead keep an eye on the overall pattern you are creating. When you have finished building up the greens, you're ready to tackle the water.

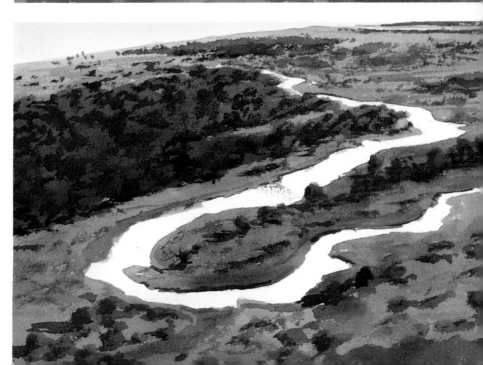

FINISHED PAINTING

Starting at the top of the paper, lay in a graded wash consisting of cerulean blue, yellow ocher, and ultramarine. Continue using the same colors as you turn to the river. In the distance, keep your color fairly light; as you move forward, gradually darken it.

In the finished painting, small passages of white paper shine through the blue of the river. This kind of crisp accent is important in a painting made up of so many dark values.

The strong blue water in the distance is painted with cerulean blue, ultramarine, and yellow ocher. The same hues are used to depict the river.

What seems at first just green is actually composed of many colors—yellow ocher, mauve, cerulean blue, ultramarine, alizarin crimson, and cadmium orange, as well as Hooker's green light.

ASSIGNMENT

Discover how to control values before you attempt to paint a scene filled with rich lights and darks. Work with ultramarine and alizarin crimson, or just one of these hues. Prepare three large puddles of wash, one of them very dark, one a medium tone, and one very light. Now study your subject.

Working from light to dark, begin to lay in the lightest areas of the composition. Let the paper dry, then add the medium tones. Finally, add the darks. Don't try to depict subtle value shifts. By pushing each value to the limit you can learn much more about the importance of values in general. What you are executing is a value study, not a finished painting.

When the darks are down, study what you've done. Have you captured the patterns formed by the lights and darks, and does your painting make sense? If it's hard to read, the chances are that you've over-emphasized one of the values.

Conveying the Feel of Frost

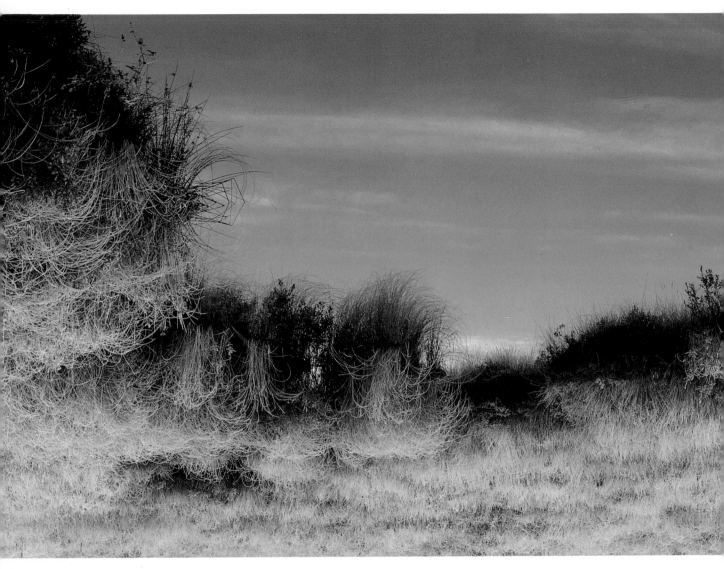

PROBLEM

When working in watercolor, it is extremely difficult to paint small, wispy elements against a dark background—exactly the situation you encounter here.

SOLUTION

Lay in the dark background first; then use opaque gouache to render the frost-coated sedges.

☐ Sketch the scene; then lay in the sky with a graded wash made up of cerulean blue, ultramarine, and yellow ocher. Make the sky darkest at the top, and be sure to indicate the streaks of clouds that break up the blue. When the paper is dry, lay in the complete foreground with a flat wash of yellow ocher, burnt sienna, and cerulean blue.

Now start building up the darks. A drybrush technique is perfect here for re-creating the

In October, masses of sedges lie coated with a thin layer of frost.

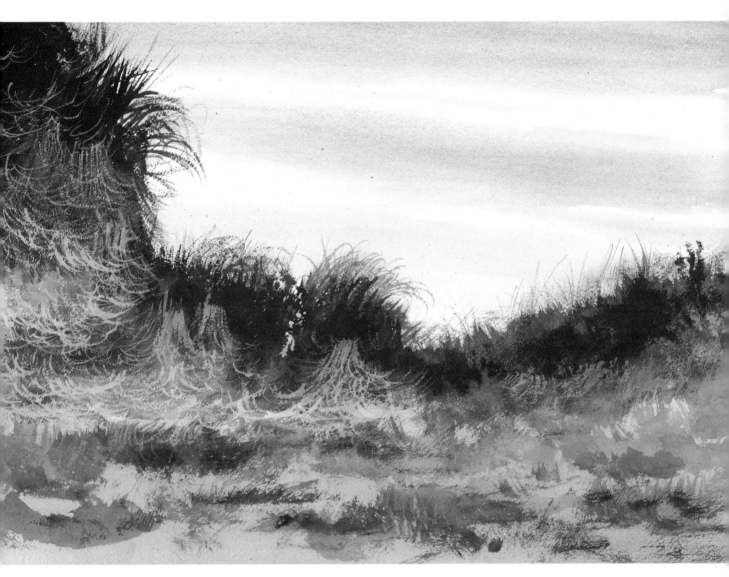

scraggly look of the sedges. Working with sepia, Payne's gray, and ultramarine, begin with the darkest plants—those that lie along the horizon. Slowly work down toward the bottom of the paper, adding touches of dark color to the underlying wash. As you approach the foreground, aim at creating a convincing pattern, one that suggests the way the sedges in the foreground are matted down by the frost.

When you have completed the darks, turn to the frost. Render the frost-covered plants in two shades of gold—one pale and the other medium—using mixtures of white and yellow ocher gouache. Work with a small, pointed brush just barely moistened with pigment and let your strokes overlap to mimic the rich tangle of blades. Use the darker gold to paint the sedges that lie farther back in the picture plane; use the pale gold for the sedges closest to the view. The contrast will give your painting a sense of space and will keep the fine, wispy strokes that you lay in from looking overly decorative.

At the very end, spatter touches of the white and yellow ocher paint over the foreground. To create a fine spray of pigment, dip a toothbrush into the paint; then gently run your thumb along the moistened bristles.

Painting Delicate Ice

THIN GLAZE

PROBLEM

Sometimes what seem to be very simple subjects turn out to be very difficult to paint. On the face of it, this scene is simple, but the success or failure of your painting depends on your ability to lay in a graded wash.

SOLUTION

Analyze the blue of the water carefully before you begin to paint, searching for subtle shifts in value. When you complete the wash, evaluate it critically. If it's not just as you want it to be, start over.

☐ Draw the reeds and lightly indicate the crackles in the ice; then mask out the reeds with liquid frisket. Next moisten the paper with a wet sponge; then begin to drop in color.

At the top of the paper, use ultramarine blue. As you approach the center, lighten the blue and introduce alizarin crimson and yellow ocher. Toward the bottom, make the color darker and richer; slowly eliminate the crimson and the ocher and add more ultramarine.

If the wash works, let the paper dry. If it doesn't, wet a large sponge with clear water, quickly wipe the paint off the paper, and then start over again.

Once the wash is complete and the paint is dry, peel off the frisket. Lay in the reeds with cadmium orange, Hooker's green, and new gamboge. To render the dark reflections, use ultramarine and Payne's gray. Finally, with white gouache add the light crackles that break up the ice, and temper the patches of white with touches of darker paint.

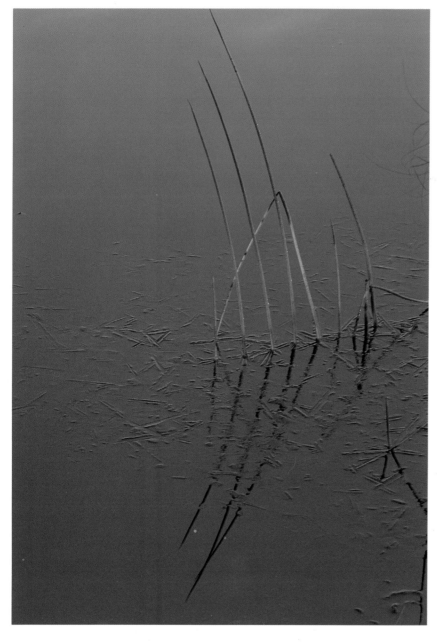

In late October, a thin, delicate coating of ice surrounds a group of reeds.

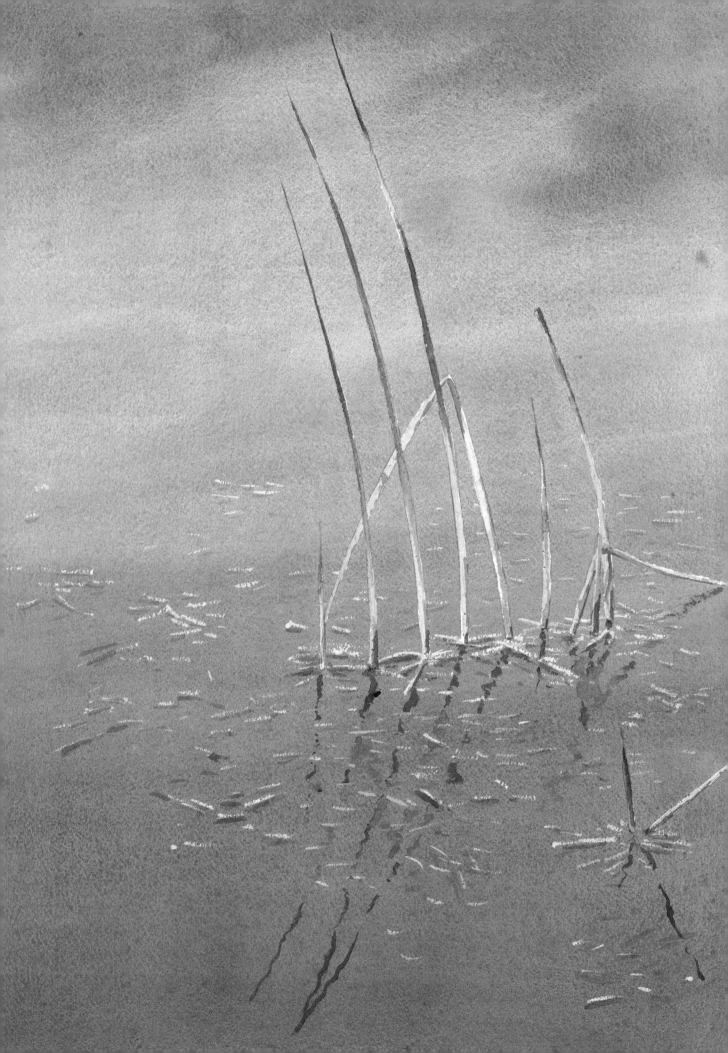

Using Brushstrokes to Separate Sky and Water

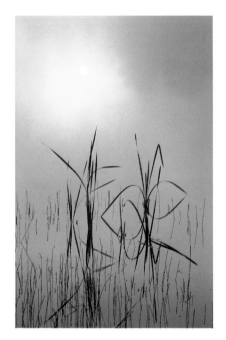

PROBLEM

It is almost impossible to tell where the water ends and the sky begins. Unless you separate them clearly, your painting will be difficult to understand.

SOLUTION

Let your brushstrokes pull apart the water and the sky. Use circular strokes around the sun. Then, when you reach the water, begin to lay in strong horizontal strokes.

The soft, gentle light of early morning washes over a lake.

☐ Sketch the reeds, then cover the lightest area—the sun—with masking tape. Next, wet the entire sheet of paper with a sponge. Starting near the sun, lay in a pale wash of new gamboge and yellow ocher with sweeping, circular strokes. As you move outward, slowly introduce mauve and alizarin crimson.

When you reach the water, begin to use broad, horizontal brushstrokes. At this point, continue to use new gamboge, yellow ocher, alizarin crimson, and mauve. When you near the very bottom of the paper, add ultramarine. Now let the paper dry.

For the reeds you'll need a strong, rich, dark hue—sepia is perfect. Paint the reeds with a small, pointed brush; then turn to the reflections in the water. To render them, shake most of the pigment from your brush and use fine, squiggly lines to mimic the slight movement that runs through the water. Finally, peel the masking tape from the sun.

Rendering Soft, Concentric Ripples

PROBLEM

Although the water is basically still and smooth, movement beneath the surface sends out circles of ripples. To paint the scene convincingly, you'll have to get across the feel of still water and motion simultaneously.

SOLUTION

A classic wet-in-wet approach is your best bet in situations like this one. Using it, you can gradually build up the subtle ripples that break through the still surface of the water.

☐ Execute a simple preliminary drawing; then stop and evaluate the scene. When you are trying to depict subtle motion in water, you often have to exaggerate what you see. That's the case here. If your approach is too literal, the chances are that you won't get across the way the water eddies outward. Right from the start, plan on accentuating the ripples.

Begin by laying in a graded wash. Start at the top with chrome yellow; in the middle shift to yellow ocher; when you near the bottom turn to new gamboge. Move quickly now. While the surface is still wet, begin to work Davy's gray onto the paper to indicate the concentric ripples. Since the paper is still wet, you can create a soft, unstudied effect. When you approach the bottom of the paper, add a little cerulean blue to the gray to make the foreground spring forward.

Let the paper dry thoroughly. While you are waiting, choose the colors you'll use to paint the bird. You want a dark hue, but one that's lively. The easiest way to achieve a lively, dark color is to mix two dark tones together; here the egret is painted with sepia and burnt sienna. The same colors are used to paint the bird's reflected image.

When you have completed the bird, you may find that it seems too harsh against the soft, yellow backdrop. If so, try this: Take a fine brush, dip it into a bright hue (here cadmium orange), and lay in a very fine line of color around the egret. This thin band of bright orange pulls the egret away from the water and suggests the way the light falls on the scene.

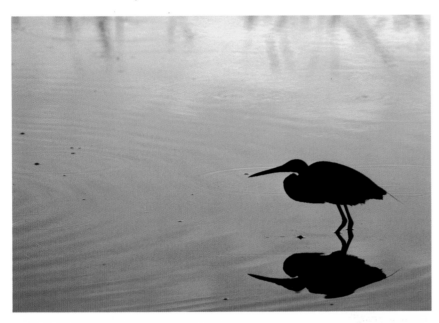

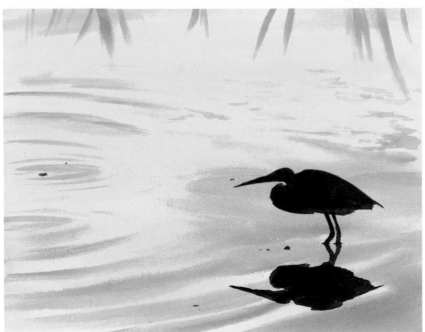

As the sun rises, a lone egret wades warily into the water.

Conveying How Fog Affects Water

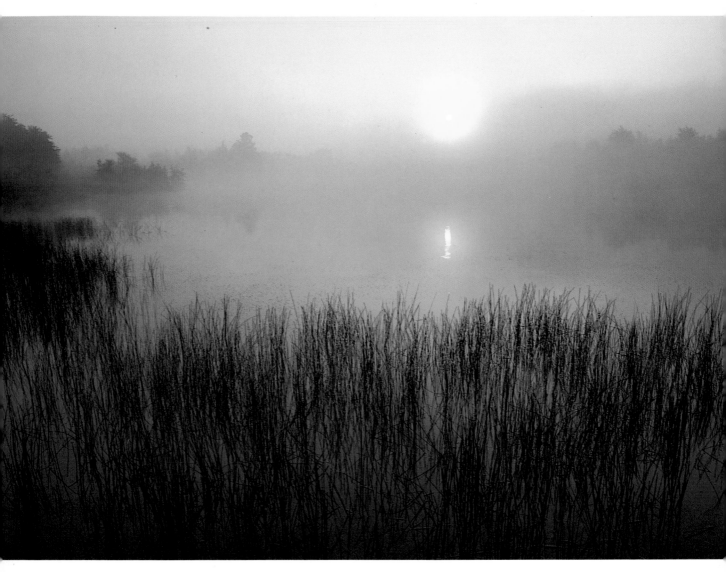

PROBLEM
Two distinctly different forces are at play here. The sun rises brightly over the horizon, but the fog dulls its brilliance and makes the entire scene soft, dull, and diffused.

SOLUTION
Concentrate on either the fog or the sunrise. Here it's the sunrise that is emphasized. To capture its warmth, accentuate the yellows that run through the entire scene. The end effect will be quite different from the actual scene in front of you, but your painting will be focused and dynamic.

In late summer, fog settles down over a lake just as the sun begins its ascent into the sky.

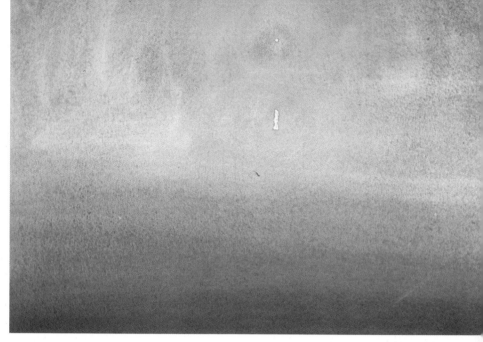

STEP ONE

After you have completed your preliminary drawing, tear off a piece of masking tape and cover the sun and the sun's reflection in the water. Now paint the background rapidly, in one step. Run a wet sponge over the paper and immediately begin to drop in color. Working from the sun outward, apply new gamboge, alizarin crimson, mauve, and then cerulean blue. At the bottom of the paper, drop in ultramarine and work it gently across the surface. Now let the paper dry.

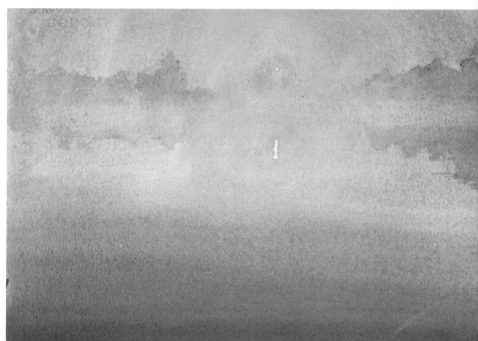

STEP TWO

Once you've established the sky and lake areas, begin to add details. Start by adding the soft trees that lie along the horizon. Here they are rendered with a pale wash of ultramarine and burnt sienna. To separate the trees from their reflections in the water, use a paper towel to blot up the wet paint in that area.

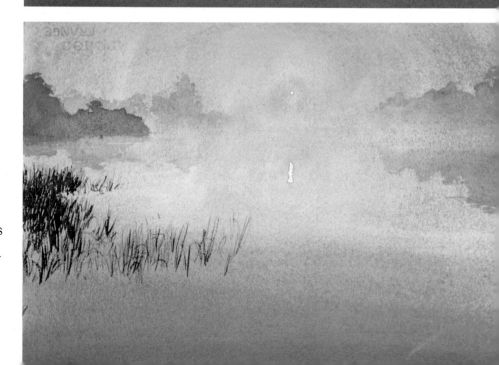

STEP THREE

Working with the same colors, move forward. First lay in the dark trees that lie on the left side of the scene; then begin work on the grasses. Use a drybrush approach, and start with the grasses in the middle ground. Here they are painted with a dark mixture of sepia and ultramarine.

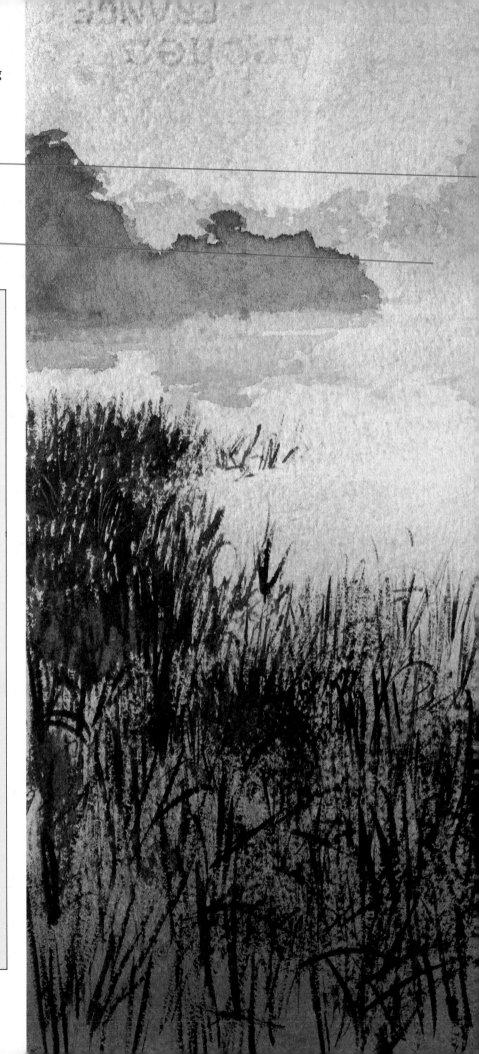

FINISHED PAINTING
Complete your painting by adding the grasses in the foreground.

The colors of the rising sun are laid in with new gamboge, alizarin crimson, mauve, and cerulean blue. The sun and the lightest part of its reflection are masked out before the painting is begun.

The trees along the horizon are rendered with several layers of pale ultramarine and burnt sienna.

ASSIGNMENT
In step one, you worked wet-in-wet, quickly establishing the entire background. This technique is basic—one that every watercolor artist should feel comfortable with. Take the time to experiment with it.

First, run a wet sponge over a sheet of watercolor paper. Don't drench the paper; just make it evenly moist. Now drop in the colors that were used in Step One: new gamboge, alizarin crimson, mauve, cerulean blue, and ultramarine. Start at the top of the paper and gradually work down. As you paint, don't let the blue bleed into the yellow.

Do this part of the assignment several times, until you feel confident of your ability to execute a smooth, graded wash. Then proceed to further experiments.

Try manipulating the color while it is still wet. First, take a paper towel and wipe out sections of the wash with long horizontal motions. Next, wad up a piece of toweling and blot up bits of color.

Finally, let the paper dry; then moisten a portion of it with clear water, and blot up some of the paint with a piece of toweling. Next, moisten another area of the dried paper and drop color onto it.

As you experiment, try working on very wet paper, damp paper, and paper that is almost dry. You'll be amazed at the variety of effects you can achieve—effects that you can put to good use in your watercolors.

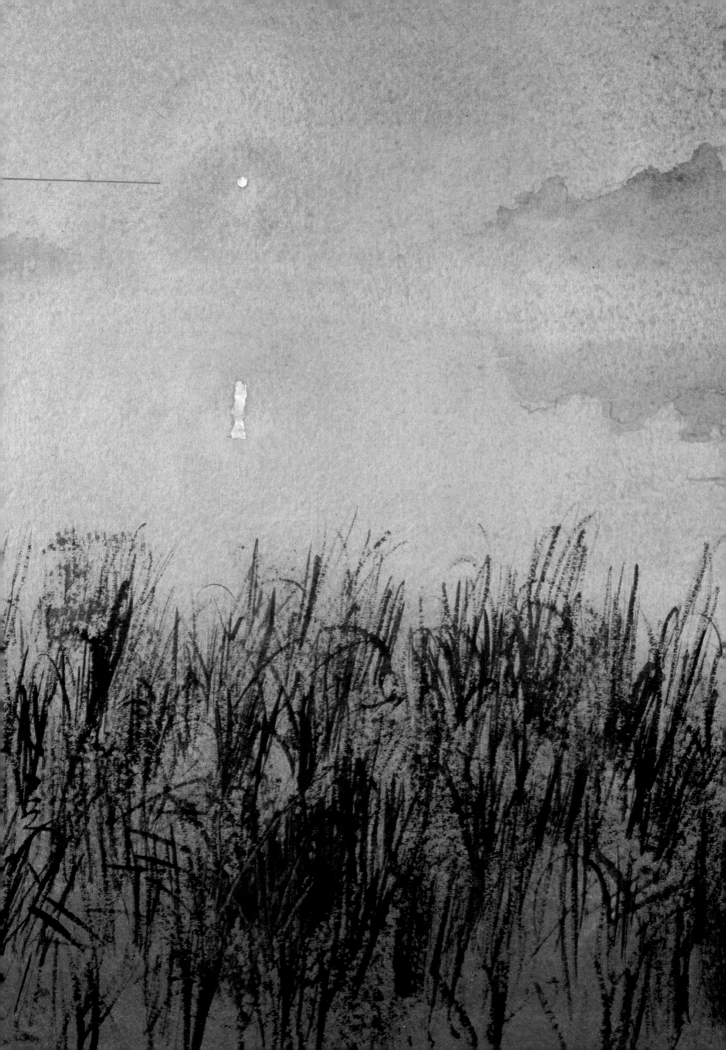

Controlling the Brilliance of Sunset over Water

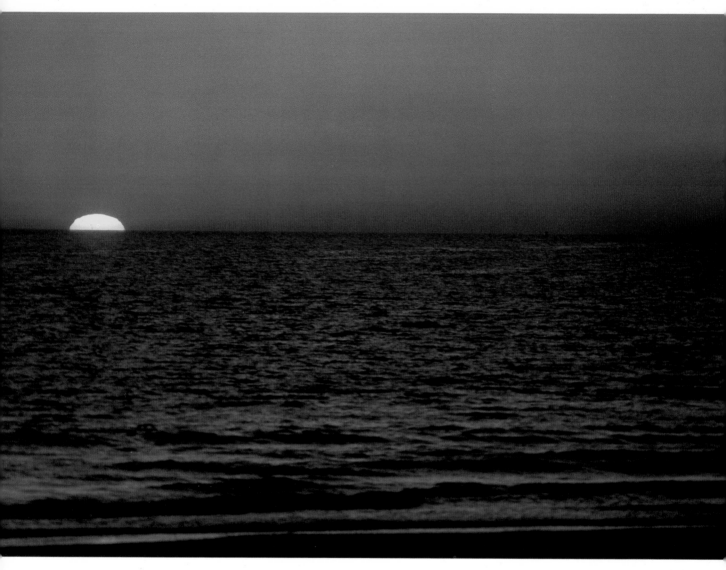

PROBLEM

It would be easy to make the water too light and too bright. To capture the feeling of sunset, you have to suggest how darkness is stealing over the scene.

SOLUTION

Cover the entire paper with a warm, rich underpainting; then add the dark waves.

☐ Sketch the horizon line and the sun; then mask the sun out with liquid frisket or a piece of masking tape. Next, lay in a graded wash. Use a large brush, and don't bother wetting the paper first—the wash doesn't have to be perfectly smooth. Start at the top of the paper, using mauve, alizarin crimson, cadmium red, and cadmium orange.

When you approach the water, eliminate mauve from your pal-

As the sun sets over a lake, its brilliance floods the sky and tinges the water below a deep, dramatic orange.

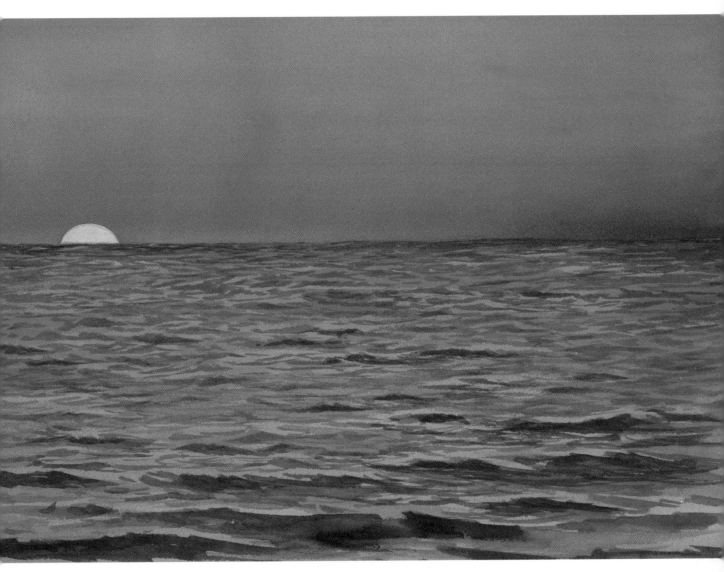

ette; you want the water to be slightly lighter than the sky, since you'll soon be adding the dark waves. To render the waves, use a middle-value mixture of ultramarine and burnt sienna. Along the horizon and in the immediate foreground, add a touch of alizarin crimson and Payne's gray. Render the waves with short, choppy, horizontal strokes to indicate a feeling of movement.

Even in simple scenes like this one, perspective matters. The waves in the distance should be much smaller than those in the middle ground. Those in the foreground should be fairly large. As you work, keep your eye on the overall pattern you are forming and don't let your brushstrokes become too regular. As a final touch, remove the mask from the sun, and paint in the sun with new gamboge.

Experimenting with Neon Reflections

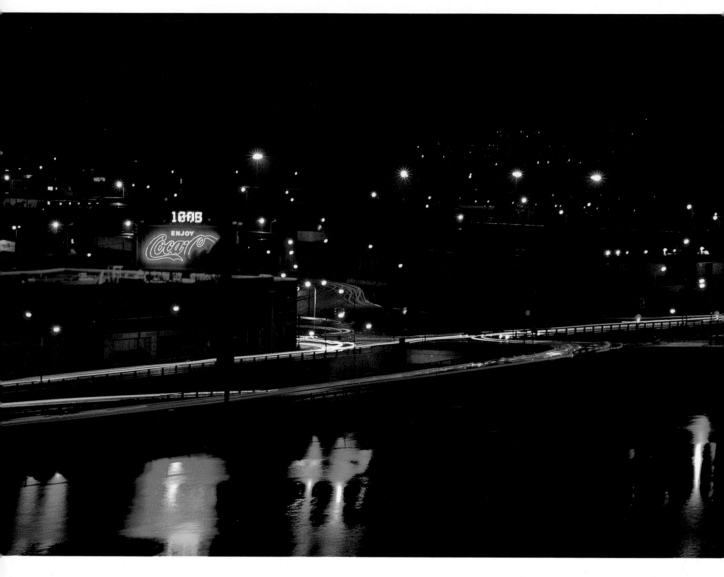

PROBLEM
A scene as dark as this one is extremely difficult to paint in watercolor. Yet its power and drama are tremendously appealing—appealing enough to overcome whatever problems lie ahead.

SOLUTION
Mask out the brightest, lightest passages; then make the rest of the composition really dark. Before you begin to lay in the darks, develop any areas that have even a hint of color.

The raucous, busy nightlife of a city is mirrored in the river that runs through it.

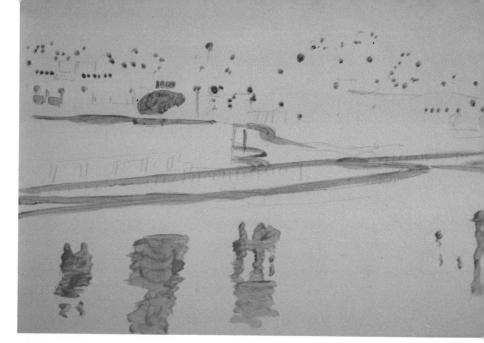

STEP ONE

Carefully sketch the scene; then paint in all the bright lights with liquid frisket. Masking these areas out is important. You must first develop all the subtle touches of color that run through the composition, and then establish all the darks, before you can peel the frisket off and paint the very brightest passages.

STEP TWO

Now turn to those portions of the scene that have some color, but not the brilliance of the areas you masked out. Before you start to paint, study the composition. Search for every spot that *isn't* dark—any spot that even a sub-dued color runs through. Now lay those colors in.

STEP THREE

Using Payne's gray, ultramarine, and alizarin crimson, lay in the dark background, making it as dark as possible. In the center of the scene, where you've carefully developed your underpainting, make your darks a little lighter: You want the color you've already established to show through.

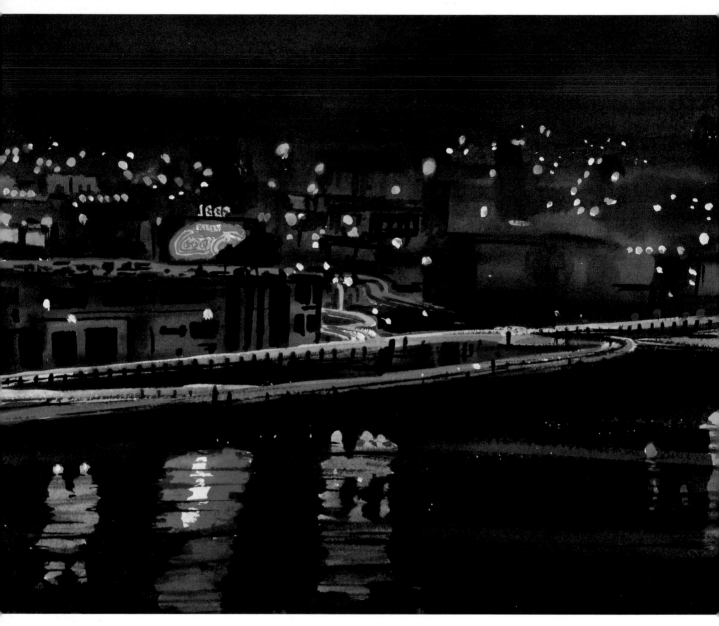

FINISHED PAINTING

In scenes like this one, the most important touches come at the very end. It's now that you'll drop in all the bright, vibrant colors that will give your painting life.

First, peel off the frisket. Next, prepare your palette with strong, vivid yellows, oranges, and reds, plus bright blues and greens. Dilute the pigments slightly; then go to work.

Use strong, fluid brushstrokes as you lay in these brights; you want to capture the immediacy of the scene, and if your strokes are too tentative, the gutsy feeling that drew you to this spot in the first place will all be lost.

DETAIL

The brilliant neon lights and their reflections were masked out in Step One and were executed only after the rest of the painting had been developed. They aren't the only touches of color, though. Note the dull greens that shine through the darks of the buildings and the subdued orange glow beneath the bright red reflection in the water.

ASSIGNMENT

There's a lot more to watercolor painting than brushes and paint. All around your home you can find miscellaneous tools that will enhance your work.

Start with simple table salt. Lay in a wash of color on a piece of paper, then sprinkle a little salt randomly over the surface. Watch what happens: As the paint dries, the salt will pull the water and pigment toward it, creating an interesting, mottled effect.

Now experiment with paper towels. Lay in a wash, and then use toweling to blot up some of the pigment. When the background paper is still very wet, you'll find that you can pick up most of the color; as the paper dries, more and more of the pigment adheres to it, so that less color can be removed.

Finally, experiment with an eraser. Lay in a wash and let the surface dry completely. When it's dry, carefully pull the eraser over the paper. You'll discover that—pulled hard enough—the eraser can pick up a good amount of color.

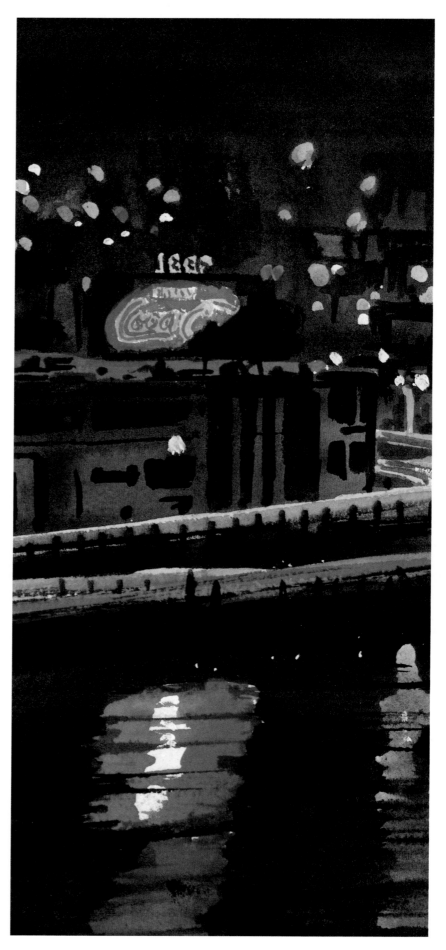

Animating a Dark, Still Stream

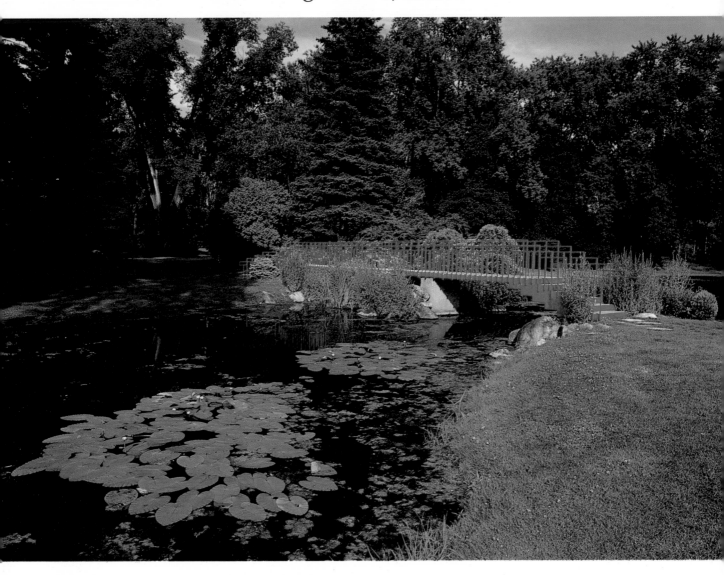

PROBLEM

This scene is filled with brilliant color—the red of the bridge and the green of the lilies and foliage. In fact, everything except the water is bright, interesting, and full of life.

SOLUTION

Exaggerate the reflections that spill into the water; this will make the stream come alive. Work in a traditional light-to-dark manner to control the value scheme.

A brilliant red bridge spans a quiet lily-covered stream.

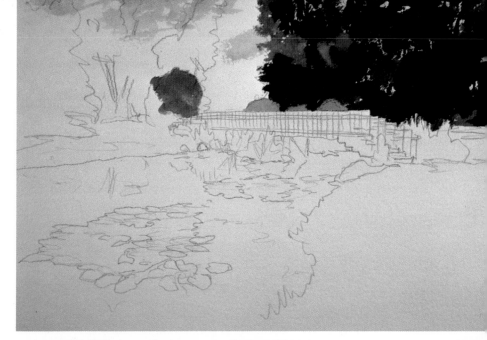

STEP ONE

Execute a preliminary drawing; then lay in the sky with a pale wash of cerulean blue. As soon as it's down, turn to the trees in the background. Simplify them: Render them loosely, working with three values—one light, one medium tone, and one dark. Here they are made up of Hooker's green light, Payne's gray, cerulean blue, ultramarine, and new gamboge.

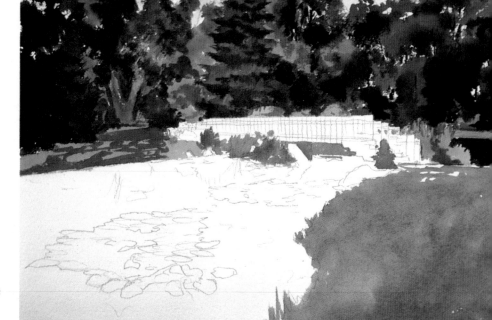

STEP TWO

Finish the background. Continue working with the same colors and continue simplifying what you see. The point is to have close control of the value scheme and to have the background hang together as a unit. Before you move in on the water, lay in the swatch of green in the lower-right corner.

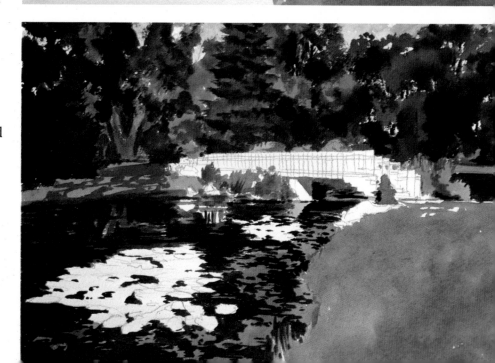

STEP THREE

Stop and analyze the water. It's made up of three distinct values: the light lilies, the dark water, and the middle-tone reflections and vegetation. Start with the middle tone. Render the reflections and vegetation with a mixture of yellow ocher, burnt sienna, and sepia. Next, lay in the water. You want a dark, steely hue: Try using sepia, ultramarine, and Payne's gray.

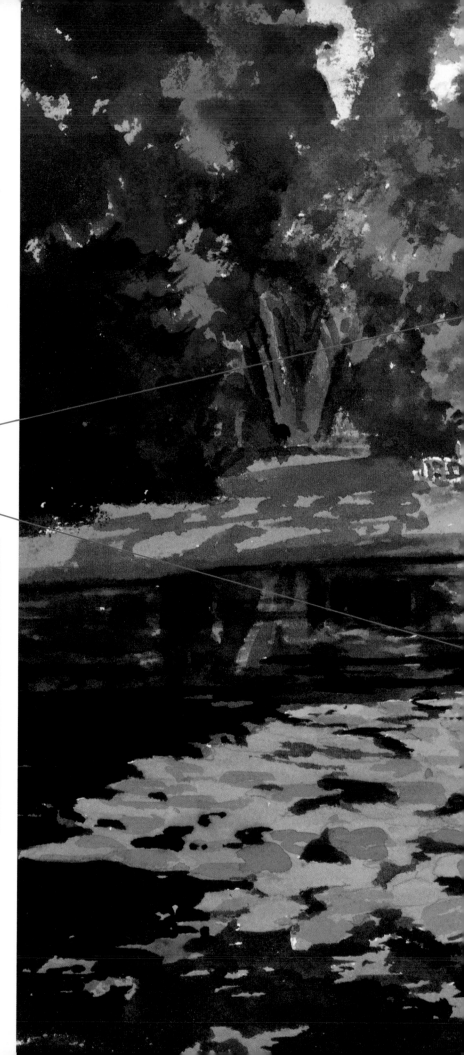

FINISHED PAINTING

Two important elements still have to be added: the bright green water lilies and the brilliant red bridge. They are what make this scene so special. Use a bright, vivid green for the lily pads; here a mixture of Hooker's green light and new gamboge is used. As you paint, vary the strength of the green and the yellow to create a lively, variegated effect.

Finally, turn to the bridge. If you make it as bright and strong as it really is, it will destroy your painting's unity. Instead, use a medium-tone wash of cadmium red; even diluted, the red will be strong enough to spring out against the rest of the elements.

The masses of trees that line the background are simplified and are developed by using three distinct values. This simplified approach puts emphasis on what's really important, the bridge and the water.

The dark water comes alive as reflections and floating vegetation break up its surface.

ASSIGNMENT

To paint effective landscapes, you needn't travel far. Search your neighborhood for an interesting site; a lake shore, pond, or stream is perfect. Study the site over a period of months.

Paint the site at dawn, midday, and dusk, and as the seasons change. If you begin work in the spring, your paintings will trace the progress of trees bursting into leaf and the effect the vegetation has on the water.

Try working from different angles, too, and at different distances. The familiarity you gain as you explore your site can enrich your paintings.

Early on, you'll solve basic compositional problems, and you will have the freedom to concentrate on issues that are more important—the movement of the water, the feel that steals over the scene at certain times of day, and the way the site is transformed as seasons change.

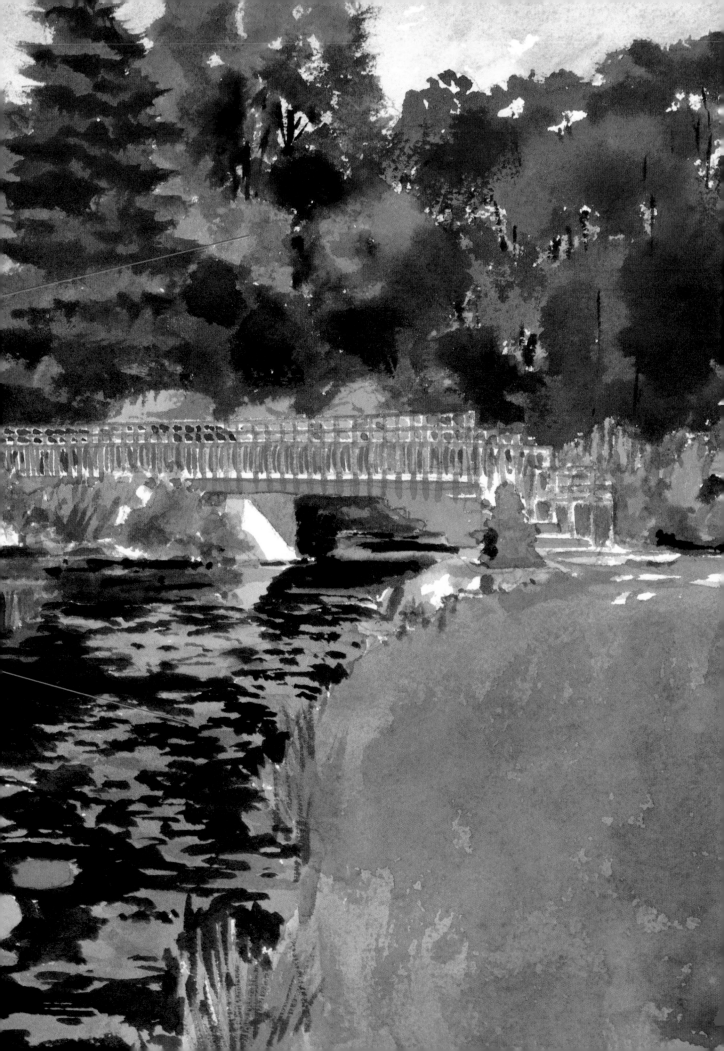

Picking out the Patterns Formed by Floating Vegetation

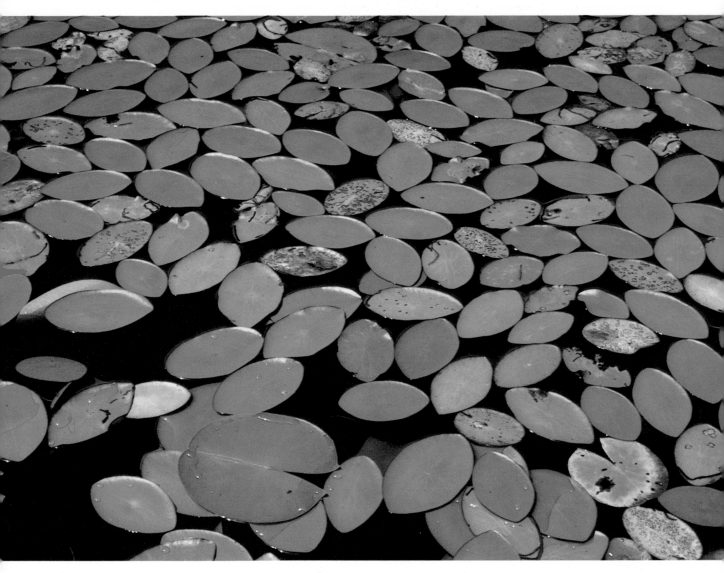

PROBLEM

Here the water is so dark that it really becomes unimportant; it simply serves as a backdrop for the rich pattern of leaves. Pulling the leaves into focus and making them work presents the challenge.

SOLUTION

Execute a careful, detailed sketch; then lay in all of the dark areas first. Once they are down, concentrate on making the leaves varied and interesting.

☐ After you have sketched the scene, begin to lay in the darks. Here they are rendered with Payne's gray and ultramarine blue. Let the surface dry thoroughly; then turn to the leaves.

Figure out your plan of attack before you begin. Aim for an overall sense of design—a lively interplay between warm and cool tones and lights and darks. Start with all the leaves that aren't green—those that are orange, yellow, or even mauve. Once they are down, turn to the greens.

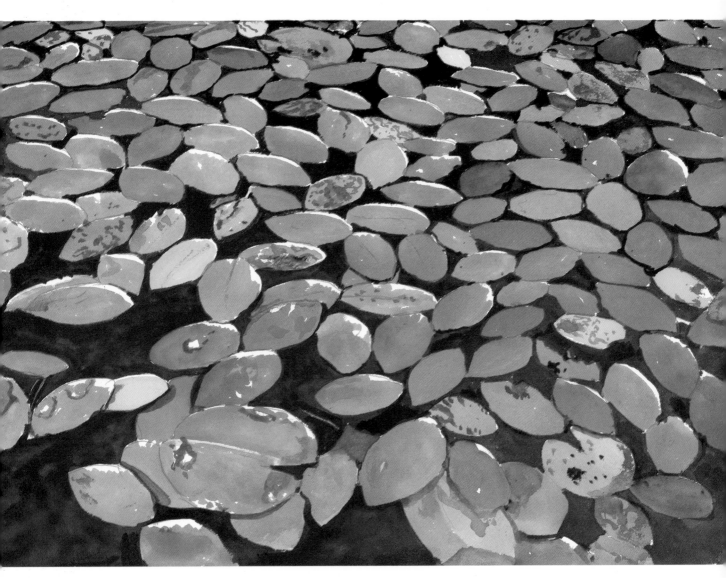

In a scene as complex as this one, try to work in an orderly fashion; if you don't, the chances are that you'll get lost in detail. Begin in the upper-left corner and slowly work across the surface of the paper and then down. As you work, concentrate on variety: Make some leaves warm and some cool; make some bright and some grayed down. From time to time, let the white of the paper stand for the highlights that flicker on the edges of the leaves.

Here Hooker's green light and new gamboge form the basis for most of the leaves. The hues and values are varied, though, with touches of cerulean blue, ultramarine, mauve, and even chrome yellow.

When you've completed all of the leaves, look at your painting critically. You'll probably want to add texture to some of the leaves. Note here how the golden leaves are tempered with touches of brown, and how some of the green leaves are broken up with touches of darker, denser color.

Mastering a Complex Close-up

PROBLEM

This is an incredibly complex subject, one that will be difficult to paint. Three layers are involved: the vegetation, the web, and then the water.

SOLUTION

Develop the underlying layers first; then use opaque gouache to render the raindrops.

☐ In your drawing, concentrate on the brightly colored areas in the background, and keep the shapes simple. When the drawing is done, lay in the entire background. Begin with the brightest elements, the seaweeds and leaves. Here the greens and browns are made up of new gamboge, ultramarine, Payne's gray, and a touch of burnt umber. The red leaves are painted with cadmium red, alizarin crimson, and mauve.

Allow the bright areas to dry; then concentrate on the dusky areas that surround them. Use dark colors—Payne's gray, ultramarine, mauve, sepia, and burn sienna—and paint loosely. Don't get caught up in too much detail.

Now it's time to paint the most difficult element, the raindrops. Dilute a good amount of white gouache with water; you are aiming for a translucent look. If the gouache is too thick, it will cover the background, which you want to shine through the white paint.

As you begin work, follow your subject carefully. You can't paint every drop, but you should try to capture the pattern the drops form on the web. First lay in vague, circular shapes. When they are all down, go back and reinforce their edges with touches of thicker gouache.

At the very end, dab small touches of pure white gouache onto the paper; here you can see them at the bottom of the painting. These small splashes of brilliant white clearly pull the raindrops away from the dark background and accentuate the spatial relationships that you have set up.

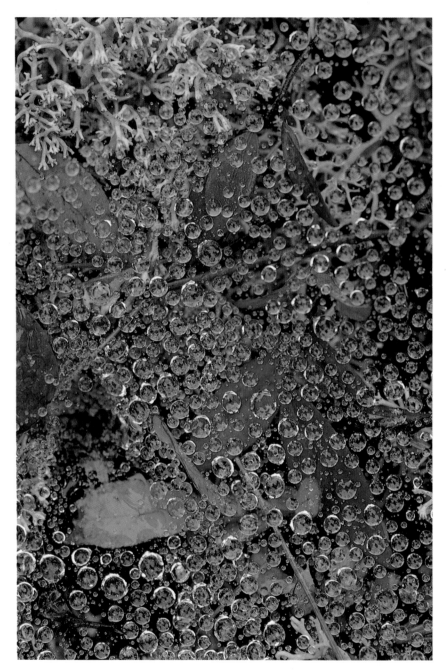

Raindrops hover on a delicately woven spider's web suspended above seaweeds and fallen leaves.

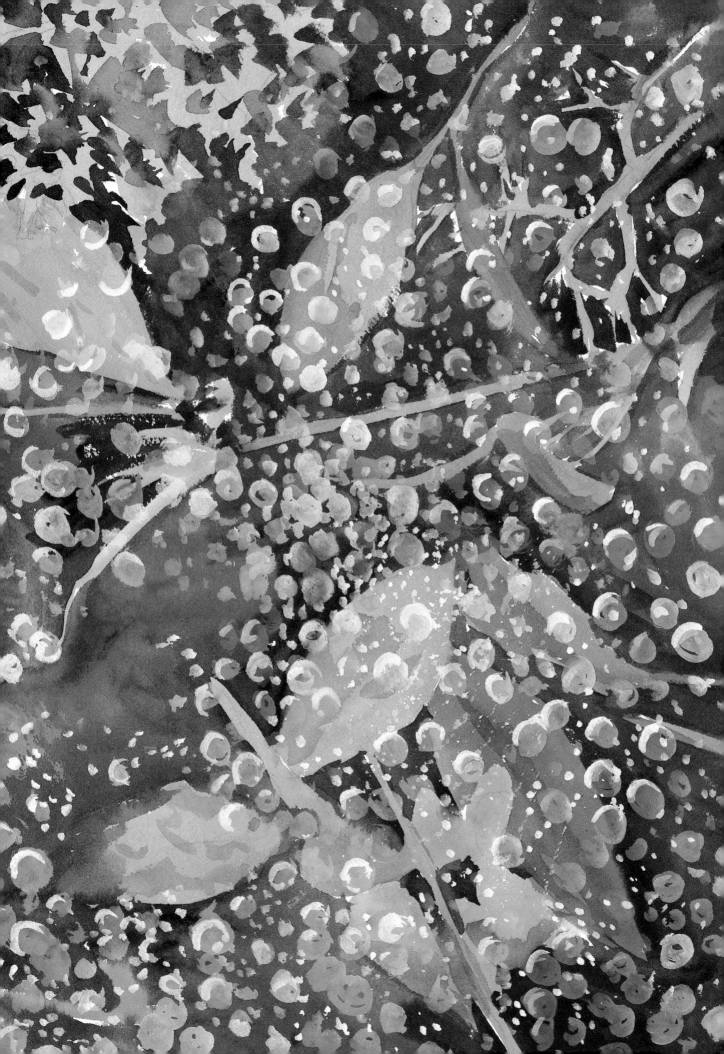

Balancing Strong and Subtle Elements

PROBLEM

Two quite different elements are at play in this composition—the crisp, colorful grasses and the subtly patterned ice. Both have to be painted convincingly.

SOLUTION

Start out with the most difficult area, the ice. To capture its complex surface, wipe out bits of the wet paint with a rag.

☐ Sketch the scene; then lay in the ice with a middle tone made up of Payne's gray, cerulean blue, and yellow ocher. Concentrate on the portions of the ice that are decorated with crystals, and while the paint is still wet, take a rag and blot up some of the gray tone, to lighten the crystallized areas. Then reinforce the dark areas by adding a touch of alizarin crimson to your mixture of gray, ocher, and blue, and scumbling the paint over the paper.

Let the paper dry thoroughly; then turn to the grasses in the center of the composition. First, render the green blades with new gamboge and Hooker's green light. For the brown blades, use rich earth tones—yellow ocher and burnt sienna.

In the finished painting, the ice and the grasses sit comfortably together. Their spatial relationship is obvious and the sharp, crisp feel of the vegetation balances the soft, diffused look of the ice.

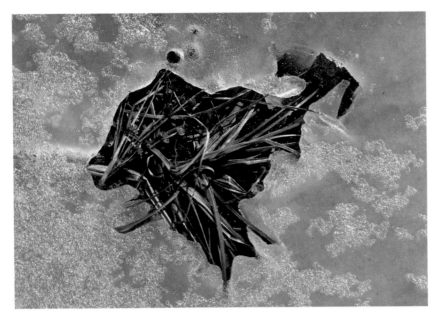

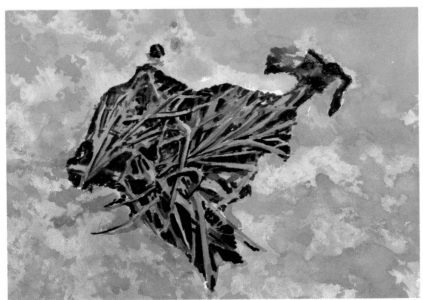

In March, as the days become balmier, grasses that have lain hidden for months break through a thick crust of ice.

Analyzing the Color, Value, and Texture of Ice

PROBLEM

It is the ice, not what lies on top of it, that presents a challenge to the painter. The rich, complex surface is marked by subtle shifts in color and value.

SOLUTION

Pretend it is the ice alone that you are out to capture. When you are completely satisfied with it, move on to the leaves and twigs.

☐ Execute a simple preliminary drawing; then cover the entire paper with a light-gray tone made up of Payne's gray, yellow ocher, and cerulean blue. While the surface is still wet, spatter darker grays all over the paper; then blot up bits of the dark paint with a paper towel.

Repeatedly spatter and blot, trying a variety of approaches. To produce a fine spray of paint, use a toothbrush. Dip it in your color; then run your thumb along the bristles. Next, use a medium-size brush and splash larger drops of color onto the paper. Let the paper dry.

Before rendering the leaves and twigs, prepare your palette with yellow ocher, burnt sienna, sepia, cadmium orange, Hooker's green light, and lemon yellow. Now take a medium-size brush and lay in the greens and browns.

At the very end, go back to your gray-based mixture and accentuate some of the dark, shadowy portions of the ice. Here, for example, the cracks and depressions that break up the surface of the ice were added last.

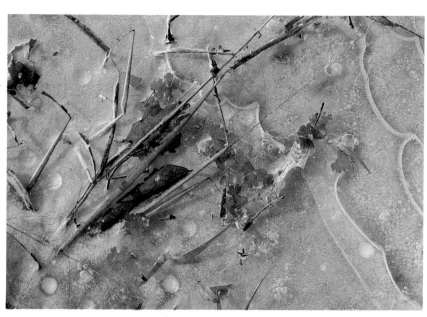

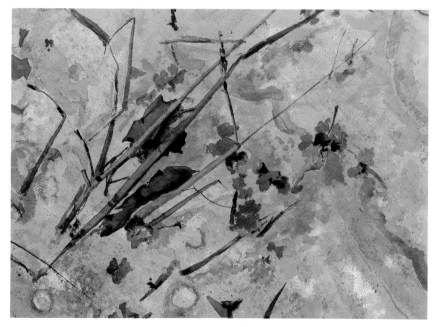

An interesting assortment of dead twigs and green leaves rests on a richly, mottled sheet of ice.

Painting Thick, Heavy Ice

PROBLEM

Because it is late afternoon, the ice is a rich shade of blue. It will be difficult to make the ice look like what it really is and not just like a pool of water.

SOLUTION

The key to dealing with this kind of situation is to develop texture; so concentrate on the pebble-like quality of the ice.

☐ Draw the leaf; then begin planning your color scheme. A mixture of ultramarine and Payne's gray, animated with just a touch of alizarin crimson, will set the painting's color mood. Lay an uneven wash over the paper, working around the leaf. While the paint is still wet, begin to blot up small, light notes with a paper towel.

Now spatter the paper's surface with slightly darker color, and again blot up bits of the paint. Continue spattering and blotting, progressively using darker and darker tones until your painting is packed with minute touches of color.

Finally, paint the leaf. Here it is rendered with yellow ocher, burnt sienna, mauve, and cadmium red. First, lay in a general wash of golden brown; then go back and add detail—the veins and the shadows.

If your painting seems too dark, spatter opaque white on the lightest highlights; then dab diluted white gouache on, to suggest the largest ice crystals.

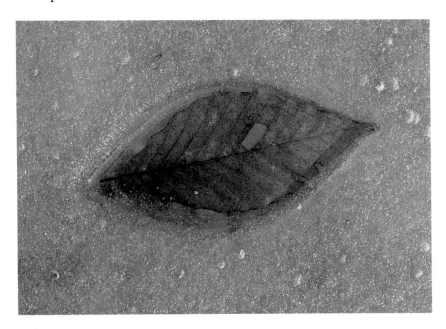

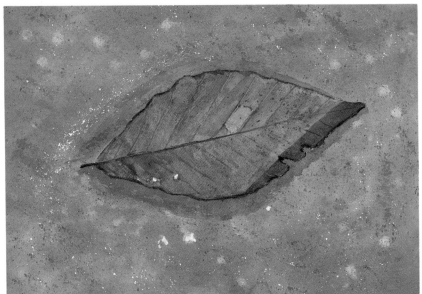

In the late afternoon in the dead of winter, a beech leaf lies captured in a bed of ice.

Using a Light-to-Dark Approach on an Abstract Subject

PROBLEM

You may be drawn to a subject like this one because of its abstract beauty. To render it, you must focus in on what you actually see.

SOLUTION

Use a traditonal light-to-dark watercolor approach and work wet-in-wet. Stick as closely as possible to what you see.

☐ No drawing is necessary here—there's nothing to catch hold of. Instead, begin by sponging down the paper with clear water. When you encounter an abstract subject like this one—a composition full of loose, amorphous shapes—plan on tying your painting together with color. Choose just a few hues—here ultramarine, cerulean blue, yellow ocher, and alizarin crimson—and stick to them.

Concentrate on slight shifts in tone, value, and warmth. At first, lay in very light washes; then gradually turn to darker color. Since the paper will becoming increasingly dry as you work, when you are ready to paint the clearest, sharpest, darkest areas, the colors you put down will not bleed into surrounding areas.

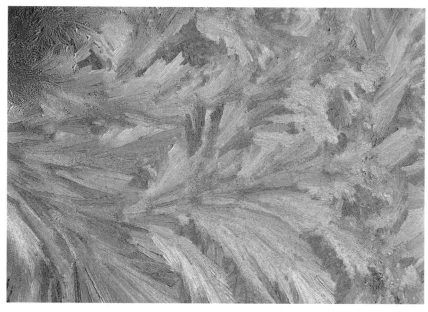

As the temperature dips, feathery crystals of frost are frozen on a window.

Capturing Soft, Frosty Whites

PROBLEM

At first glance, this scene seems straightforward. The colors are clear and the values are easy to decipher. But developing the whites—and they are the most important element here—may prove difficult.

SOLUTION

You may be tempted to use gouache and add the whites at the very end. Don't—the opaque paint would destroy the scene's soft feel. Instead, work wet-in-wet and let the white of the paper stand for the frost.

☐ Carefully sketch the scene; then wet the entire paper with clear water. Now stroke in the sky with ultramarine, cerulean blue, and a touch of yellow ocher. As you lay in the sky, use strokes that move away from the sun to show how the light radiates outward. Don't let the blues move down too close to the trees. You want to leave the tree tops white.

While the paper is still wet, go in with light-toned washes of ultramarine and mauve, and pick out the pale clusters of color formed by the branches just below the topmost part of the trees. Next, quickly begin developing the ground with yellow ocher and alizarin crimson.

Let the paper dry; then switch to slightly darker colors. First, paint the shadowy areas of the frosty, clustered branches—again with ultramarine and mauve. When you finish these areas, move on to the darker, more definite tree trunks. Here they are rendered with sepia and burnt sienna.

Once the tree trunks are dry, mix a little burnt sienna into olive green, dilute the pigment, and then lay in swatches of greenish-brown in the middle ground to suggest the masses of twigs.

Now, add the dark shadows that radiate outward from the trees. Keeping your eye on perspective, put down these shadows with ultramarine, cerulean blue, and alizarin crimson. Use loose strokes and be careful not to cover up too much of the snowy ground. As a final step, spatter touches of burnt sienna and olive green over the foreground to break up the snow and shadows.

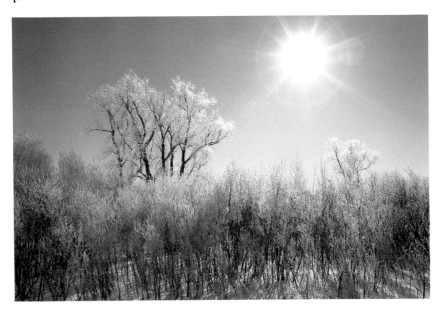

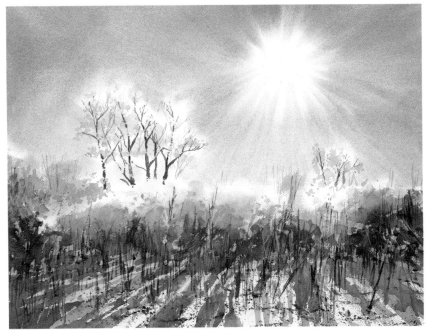

On a crisp, brilliant March morning, frost transforms a wooded area.

Handling Sharp Geometric Patterns

PROBLEM

Watercolor can be difficult to control—it splashes, bleeds, and runs over the paper easily. And when you are focusing in on crisp, sharp details, control is especially important.

SOLUTION

First, rely on a good, clear drawing. Next, make sure the paper is thoroughly dry each time you begin work on a new area.

☐ Execute a careful preliminary sketch; then lay in a flat wash of light blue over the entire paper. Use ultramarine and cerulean blue, and wait until the paper is completely dry before you move on to the next step.

While you are waiting for the paper to dry, study the crystals. You'll see that they are made up of four values: two darks, one medium tone, and one light. When you begin to paint, start with the medium-tone blue, and lay it in over the interior of each snowflake. Once again, let the paper dry. Then turn to the darks.

First mix a shade of blue slightly darker than your medium-tone hue, using ultramarine and just a little cerulean blue. With a small brush, carefully indicate the lines that etch out the structure of each snowflake. Now add the darkest passages with pure ultramarine.

You will get a sharp, dramatic effect if you scratch out your lights with a razor blade. Wait until the paper is totally dry; then rapidly pull the razor over the paper, picking up bits of the blue. If you want stronger highlights, try using white gouache.

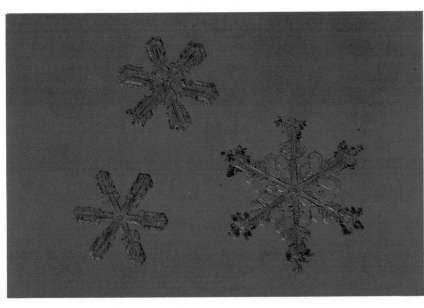

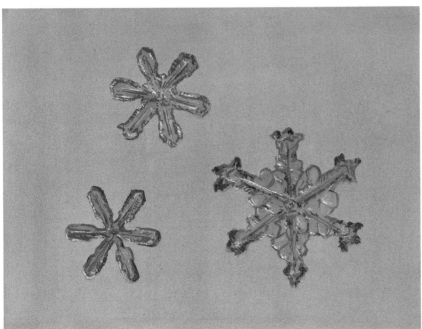

The remarkable crystalline structure of snowflakes stands out against a deep-blue ground.

Simplifying Difficult Patterns

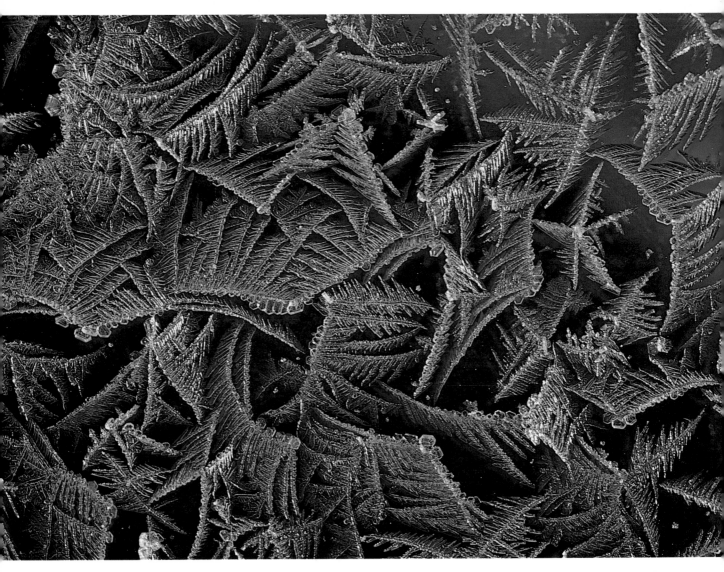

PROBLEM
It is the complexity of this subject that will make it difficult to render. Each crystal is made up of many fine details, and together the details seem to be almost overwhelming.

SOLUTION
Simplify the subject as much as possible. Paint all the darks first; then go back and add the medium tones. To capture the lights, scratch them out with a razor.

☐ Sketch the major lines of the composition; then mix a wash of deep blue, using ultramarine and Payne's gray.

With a medium-size brush, begin stroking the dark paint onto the paper. Move all over the composition, keeping your eye on the largest, boldest patches of dark blue.

Now turn to the middle values. Mix a big puddle of medium-tone wash, using ultramarine and cerulean blue. With a large brush, lay the wash over the entire

Magnification reveals the intricacy and elegance of frost crystals captured on a sheet of glass.

paper. You'll find that it softens the darks you've already established and also unifies the composition.

Before you move on to the lights, the paper has to dry completely. If it's even slightly damp, the razor will shred the paper, and your painting will be lost. When you begin to pick out the lights with the razor, you'll discover that it skips over the rough watercolor paper, creating the interesting, jagged effect you see here.

Sorting Out a Maze of Snow-Covered Branches

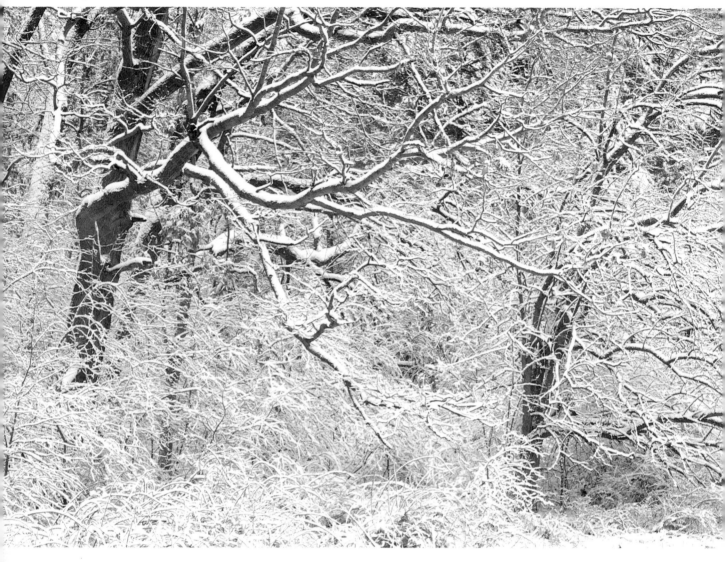

PROBLEM
When virtually everything in a scene is light, it becomes difficult to see the very whitest passages. Yet they are what give a composition like this one punch.

SOLUTION
Lay in the darkest values first—here the major tree trunks—then slowly build your painting up by working from light to dark. From the start, let the white of the paper represent the most important lights.

Deep in a forest, snow and ice cling to the trees, creating a subtle pattern of whites.

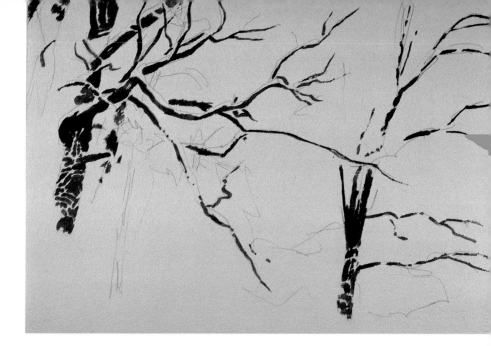

STEP ONE
In your preliminary drawing, concentrate on the two large trees that dominate the composition. Get down on paper the way their branches twist and bend, and lightly indicate the lines of the dark tree trunk in the background. Now loosely paint in the dark trees with burnt sienna and sepia. Be careful—right from the start, work around the whites.

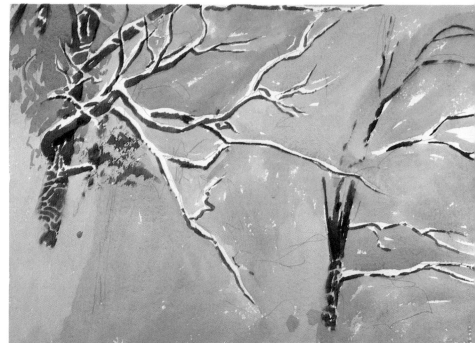

STEP TWO
Continue working around the lights as you lay in the background. Here it's made up of cerulean blue and Davy's gray. Use a fairly light hue; there will be plenty of time to add darker accents. Let the paper dry; then add swatches of a slightly darker gray to suggest shadowy areas. Finally, loosely stroke on a touch of burnt sienna and yellow ocher to indicate the leaves that cling to the tree in the foreground.

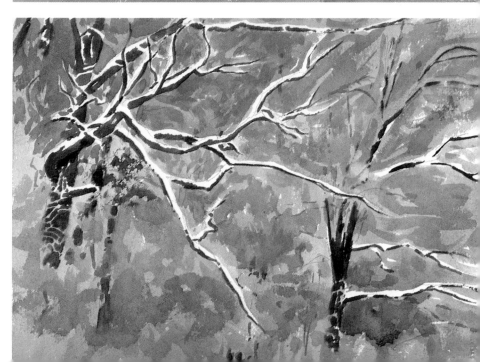

STEP THREE
Mix several pools made up of cerulean blue and Davy's gray, making each pool that you prepare slightly darker than the previous one. Your washes prepared, go to work on the background. Search the scene for shadows and slight shifts in value as you develop the flickering pattern of darks and lights formed by the snow and ice. With your darkest wash, begin to suggest the trunks and branches in the distance.

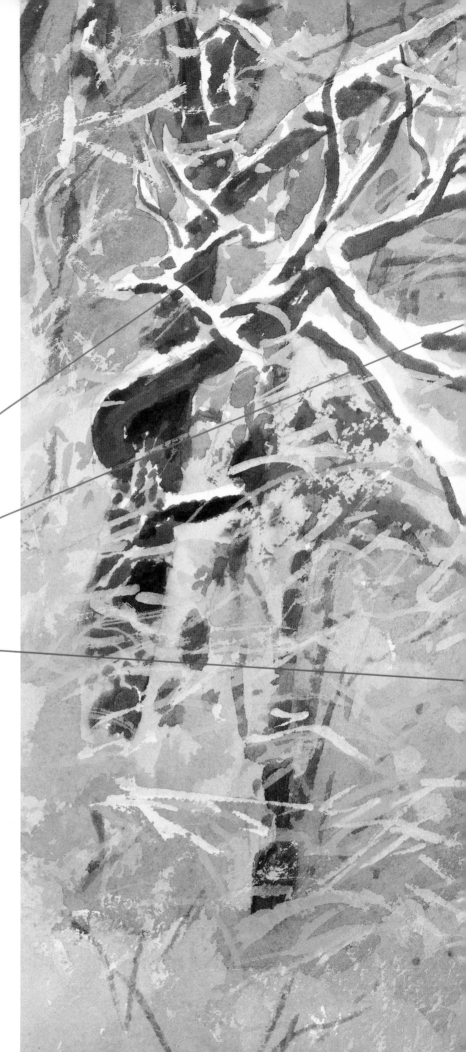

FINISHED PAINTING

At this point, what the painting needs is focus. Working with a small, rounded brush, gently stroke paint onto the paper, searching for minor branches that will give additional structure to the scene. Even now, be careful not to intrude on the bright whites that you established when you first began; they're the real key to making a painting like this one work.

In the finished painting, the cold, icy feel of the scene is definitely captured, yet without an overload of detail. In fact, the work looks much more detailed than it actually is because of the subtle shifts between lights and darks.

Painted first, with burnt sienna and sepia, the main trees and branches make up the darkest value in the painting. They were rendered carefully, by working around the whites.

Overlapping layers of cerulean blue and Davy's gray make up the tangle of lights and darks that fill the background. Although very few details are included, in the finished painting these layers of color suggest a maze of trees.

The white of the watercolor paper is preserved throughout the entire painting process. In the final painting, the whites stand out boldly against the blues, browns, and grays.

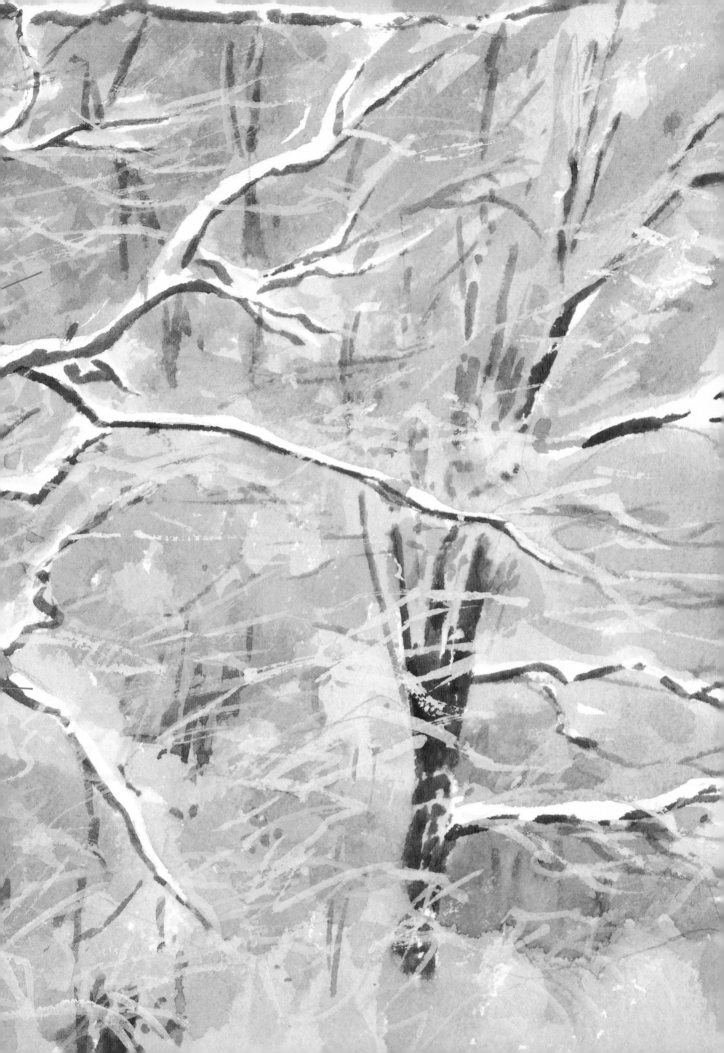

Using Opaque Gouache to Render Frost

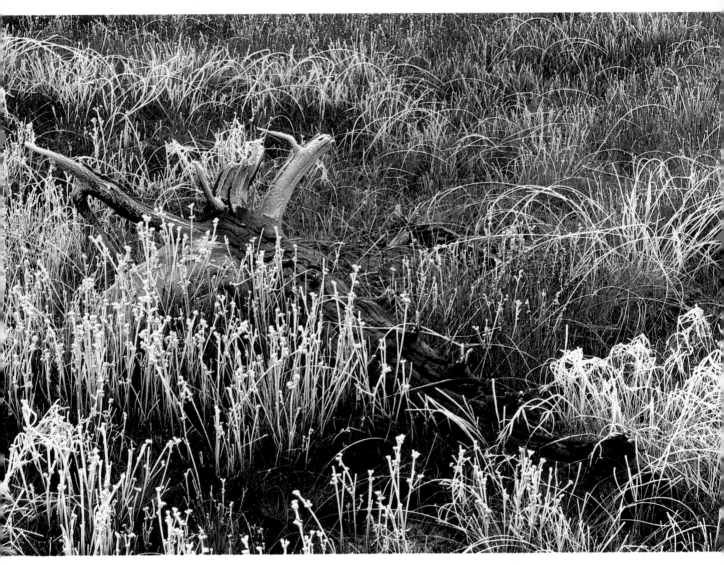

PROBLEM

Capturing a white pattern when it's set against a middle-tone background is difficult, especially when the pattern is this rich.

SOLUTION

Don't try to paint around the whites or even to mask them out. Instead, develop the rest of the composition first; then add the frost-tipped grasses with opaque gouache.

☐ In sketching the scene, concentrate on the fallen tree trunk. Then begin work on the brownish background color. Prepare your palette with two basic earth tones—yellow ocher and burnt sienna—and with mauve. You'll find mauve invaluable for rendering the shadowy areas in the composition.

Now, working around the fallen tree trunk, lay in the field of grass. Use several values of brown made from the yellow ocher and burnt sienna, and use a good-size brush. Don't let your work become too flat. As you apply the paint to the paper, look

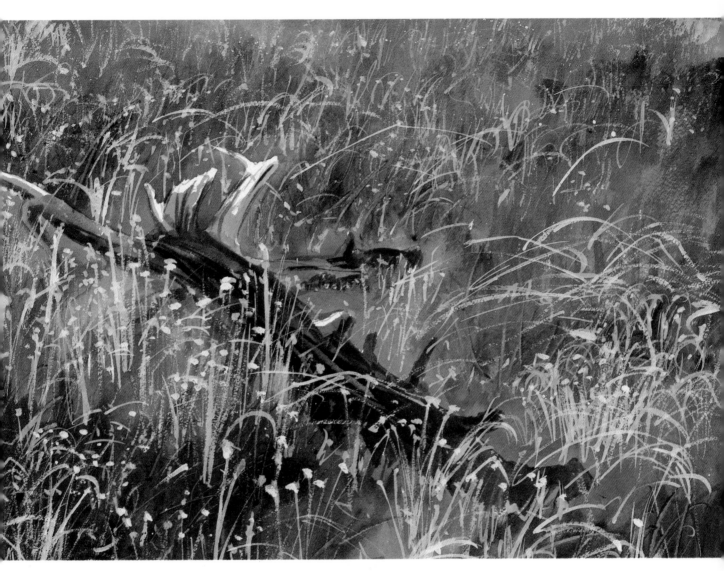

for little variations in value to break up the field. Next add mauve to the ocher and sienna and concentrate on the shadow areas of the grass.

The tree trunk is the next step. Here it is rendered with yellow ocher, Payne's gray, and ultramarine. Let the white of the paper stand for the highlights that fall on the wood.

Before you add the frost, let the paper dry completely. Pure-white gouache will be too bright; temper it with a touch of yellow ocher. The yellow ocher will not only tone down the white, it will also relate the frosty passages to

the ocher-based background.

Working with a small, rounded brush, quickly add the frost. As you paint, search for the overall pattern that the frost forms. Use soft, thin strokes in the background and stronger, more definite ones in the foreground. This technique will help you establish movement into space. The stronger strokes will pull the foreground out toward the viewer; the softer ones in the background will make the distant grasses seem farther back in the picture plane.

Finally, add small dabs of white to suggest how the frost clings to the top of the grass.

Establishing Mood Through Underpainting

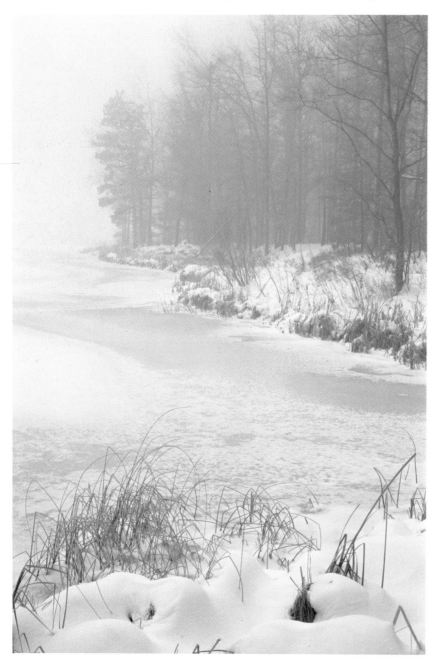

PROBLEM

Fog transforms color and softens shapes. On a clear day, this scene would be filled with crisp whites and definite edges. Under fog, it is grayed down and all the forms are soft and diffused.

SOLUTION

To capture the soft, grayness that dominates this scene, lay in a preliminary grayish wash over the entire paper. When you begin to build up your painting, keep all the values very light, except for those in the foreground.

STEP ONE

Begin with a light drawing indicating the shape of the shoreline and the basic lines of the trees in the background. Next, mix a light-tone wash of Payne's gray and yellow ocher, plus a touch of alizarin crimson, and cover the entire paper with it. Let this underpainting dry.

On an early morning in December,
a light fog envelopes a lake shore.

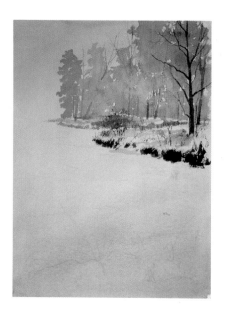

STEP TWO

Execute the background with two basic washes. Mix one from cerulean blue and Payne's gray and the other from cadmium orange and burnt sienna. The grayish-blue wash is great for rendering the most distant trees; the orange one breaks up what could become a solid wall of gray.

Use stronger color to depict the middle-ground grasses that hug the distant shore. Here they are painted with sepia, yellow ocher, and burnt sienna.

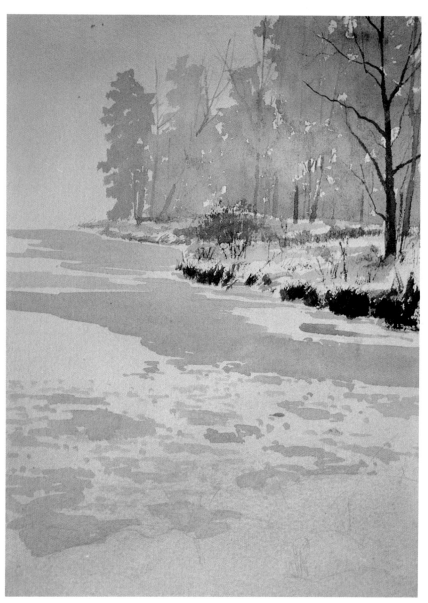

STEP THREE

When you approach the icy lake, look for large areas of dark and light. If you add too much detail, you'll lose the softening effect of the fog. Here three colors come into play: Payne's gray, cerulean blue, and yellow ocher. In the background and middle ground, pull out large flat areas. In the foreground, use small strokes to indicate the texture of the lake.

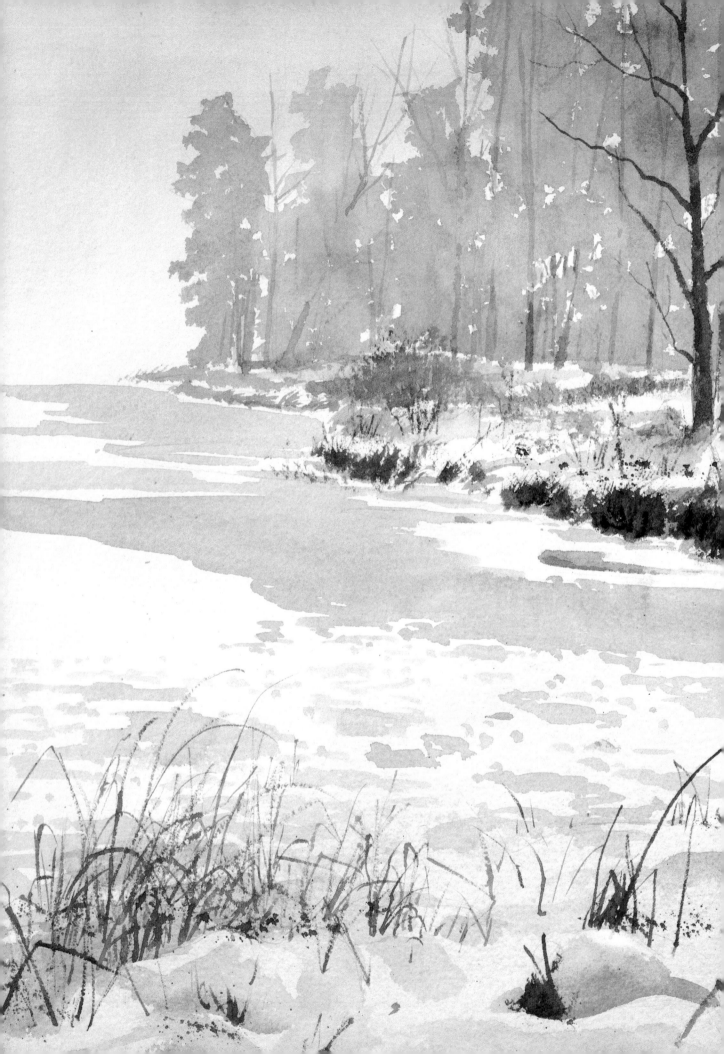

FINISHED PAINTING

Continue using a gray-based wash to complete the ice and snow in the foreground; then turn to the grasses. Paint them with strong, definite colors—sepia, burnt sienna, and yellow ocher—using a drybrush technique. As a final step, spatter bits of your dark-brown colors around the base of the grasses to anchor them in the snow.

DETAIL

Painted with soft washes of color, the distant trees seem muffled by the fog. The passages painted with cadmium orange and burnt sienna not only break up the grays, they also help pull the trees in the middle ground away from those in the distance.

DETAIL

In the immediate foreground, the ice and snow are rendered mostly with cerulean blue. The blue pushes the foreground forward, away from the grayer passages farther back. The blue passages are also painted more boldly than those in the middle ground and background, to further accentuate what lies at the very front of the picture plane.

Painting Water on an Overcast Day

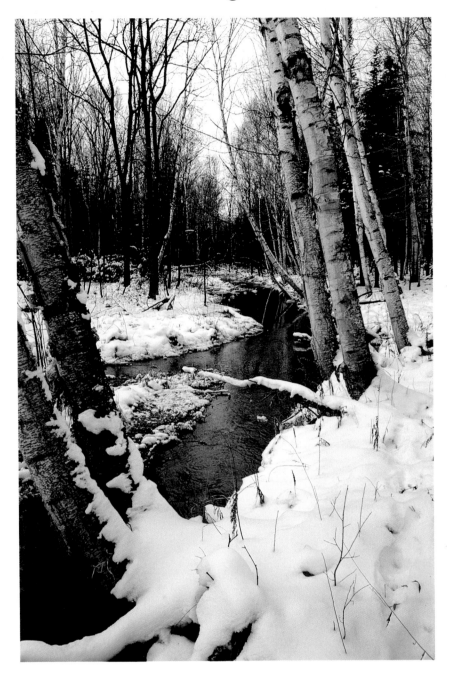

PROBLEM

On overcast days, water often seems dark—so dark, in fact, that it may be difficult to see the reflections cast in it and the ripples that run through it. But if they are ignored, your painting will seem flat and dull, and the stream will look unrealistic.

SOLUTION

Simplify the trees in the background and make the snow and the water the focus of your painting. Lay the water in before you develop the foreground, and exaggerate the reflections.

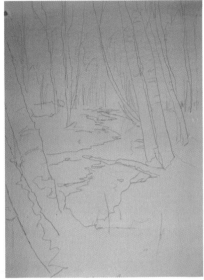

STEP ONE

When a scene is packed with detail, a careful, detailed drawing is a must. Sketch what you see carefully; then cover the paper with a wash of color, one that will set the painting's color mood. Wet the paper with clear water; then, starting at the top, drop in a wash of ultramarine blue. As you near the horizon, lighten the tone and gradually add a touch of alizarin crimson.

In late afternoon on a dark, overcast December day,
a stream courses through a snow-covered woods.

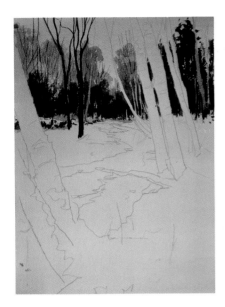

STEP TWO
Let the paper dry; then begin work on the background. The tree tops in the distance are rendered with light tones of Hooker's green light, Payne's gray, and new gamboge. The darker trees are made up of the same hues plus alizarin crimson. To suggest the scraggly branches that fill the scene, use a drybrush technique.

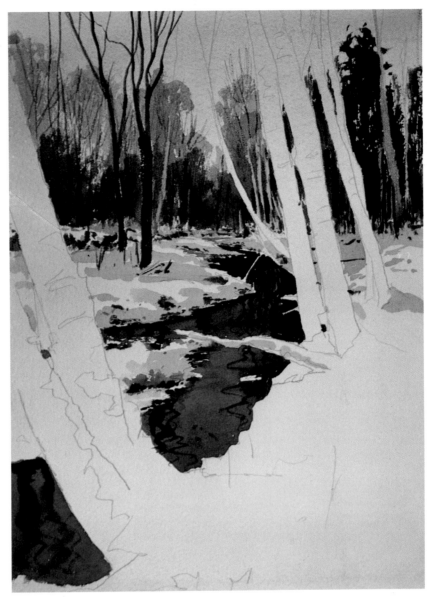

STEP THREE
Before you turn to the foreground, lay in the water. It forms the darkest value in the painting, so once it's down, it will be easy to adjust the rest of the value scheme. Using a dark mixture of ultramarine and Payne's gray, carefully stroke the color onto the paper. Let the paper dry slightly; then add the reflections, exaggerating them slightly. When the water is done, add gray shadows to the snow in the middle ground.

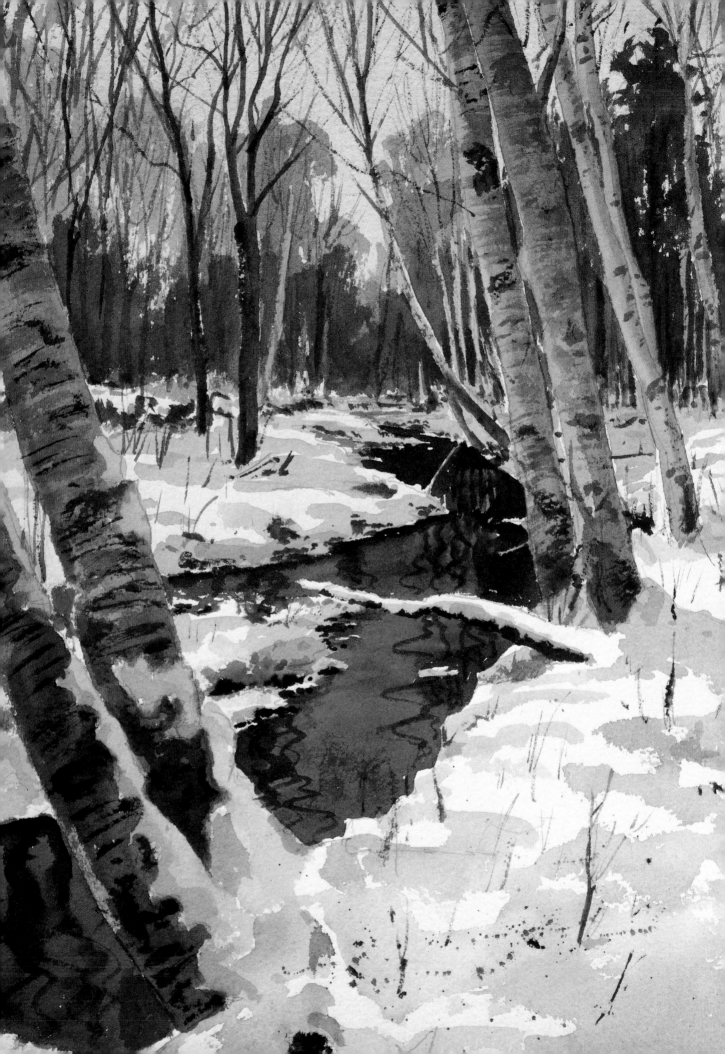

FINISHED PAINTING

To capture the rosy tinge that colors the trees on the right, paint them with alizarin crimson, ultramarine, and burnt sienna. The cooler trees in the immediate foreground are rendered with alizarin crimson, ultramarine, Payne's gray, and Hooker's green.

Now lay in the shadows that spill over the snowy foreground, using a wash of alizarin crimson and ultramarine. As a final touch, use burnt sienna to suggest the growth that shoots out from the snow; then spatter touches of brown onto the foreground.

DETAIL

Deep, rich, and dramatic when set against the white snow, the blue of the stream is composed of ultramarine and Payne's gray. The reflections are rendered with an even darker hue. To capture a sense of how the water moves, exaggerate the reflections as you lay them in.

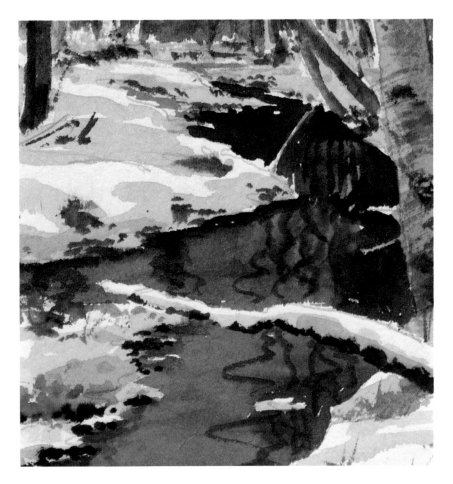

DETAIL

Before the painting was begun, the paper was toned with a very pale wash of ultramarine and alizarin crimson. The blue adds a cool, subdued feel to the snow, while the alizarin crimson suggests the light of the late afternoon sun.

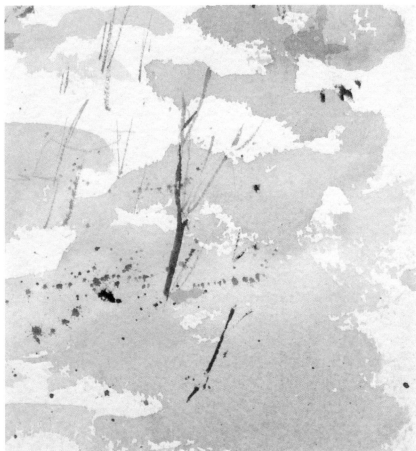

Finding Clarity in an Obscure Pattern

PROBLEM
It's hard to tell what's going on here. The ice is a confusing blend of colors and patterns, and there isn't any strong, clearly defined area.

SOLUTION
Treat the scene as an abstract subject. Search for the whites that run through the composition and use them to anchor your painting.

☐ Without trying to capture too much detail, put down the major lines of the composition in your drawing. Since it is the whites that are going to form the backbone of your painting, analyze where they are before you start to paint.

Prepare your palette with the colors you will need: ultramarine, cerulean blue, Payne's gray, and alizarin crimson. For the bits of wood and vegetation, work with burnt sienna and yellow ocher.

Now start laying down the darks, working around the white areas that you want to preserve. Don't be afraid to use really dense paint; what you are aiming for is a very deep blue. While the paint is still wet, wipe out portions of it to capture the softer middle values.

Gradually build up the rest of the middle tones, breaking them up with touches of darker paint. Vary the blues that you use. In some areas, let ultramarine dominate. In others, make cerulean blue the strongest hue.

Once you have worked out a pleasing pattern in blue, add the brownish-gold areas. Lay them in loosely, without too much detail.

At the very end, study the whites. If they are too strong, break them up with thin washes of blue or texture them with a drybrush technique.

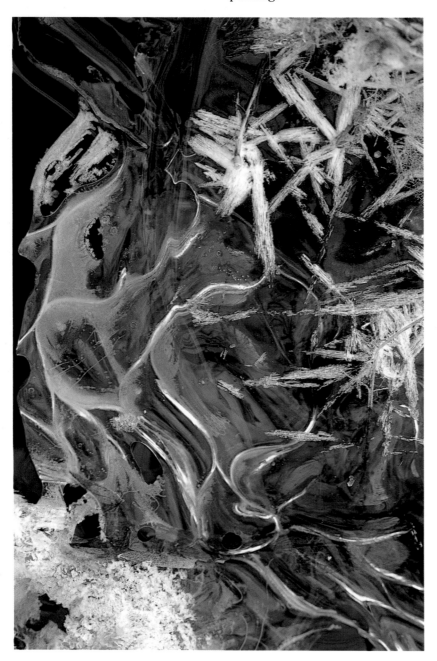

A sheet of thick, clear ice is cracked, fissured, and patterned with ice crystals.

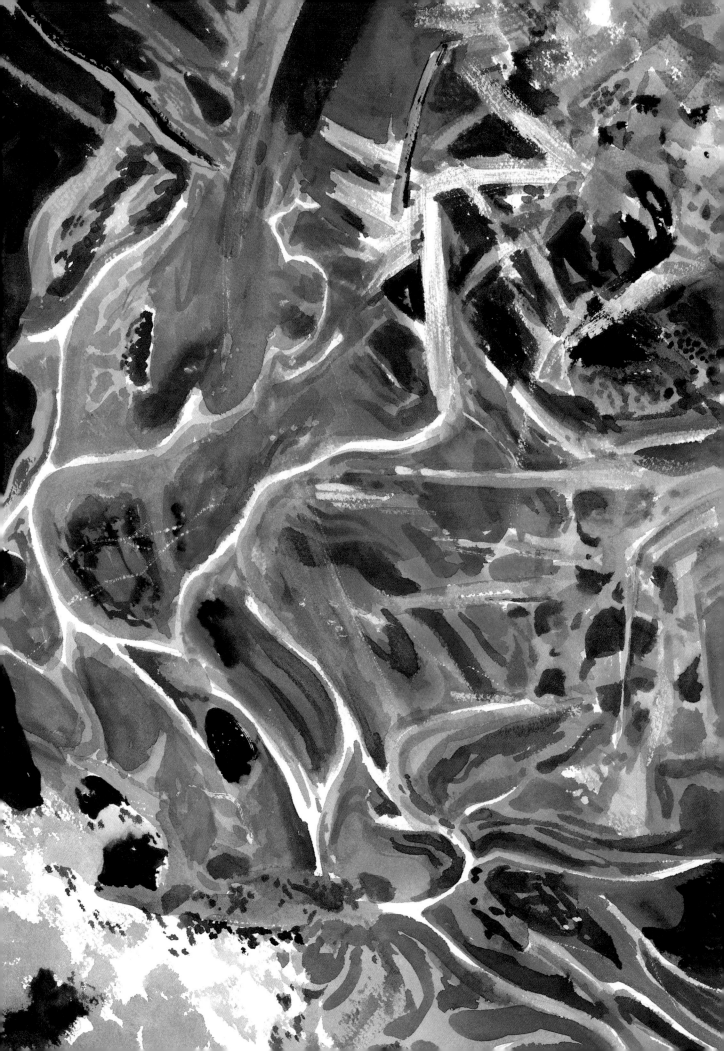

Exaggerating the Contrast Between Lights and Darks

PROBLEM

Seen up close, these ice-coated blades of grass take on a strange, bizarre look. To capture the look realistically, you'll have to show how the ice clings to the grass.

SOLUTION

Exaggerate the contrast between the foreground and the background. If the thick blue coat of ice in the background is dark enough, the ice-coated grass will spring into focus.

☐ Sketch the scene carefully, concentrating on the foreground. Now turn to the background and choose the colors you will use to render it. A flat blue won't do here; there is too much variety present. Instead, work with two blues—Prussian blue and ultramarine—and break them up with touches of alizarin crimson and Hooker's green.

Use all four hues as you lay in a modulated wash over the upper half of the paper. Be sure to work around the ice-coated blades of grass. Let the paper dry slightly; then go back and lay in the dark ridges and bumps that texture the background's icy surface.

When you have finished the dark background, turn to the brown and green grasses—the ones that aren't covered with ice. To paint them, use Hooker's green, yellow ocher, burnt sienna, sepia, and mauve.

With all the darks and medium tones down, you can concentrate on the focus of the painting, the ice-covered grass. To capture the cool feel of ice, choose ultramarine and cerulean blue, plus a dab of alizarin crimson. Start with a very pale wash of color, and remember to leave the top edges of the blades pure white. Let the paper dry and then add the shadows that play over the ice, using darker values of your wash.

Only one element is missing now—the green blades that are caught inside the ice. With a small, rounded brush, carefully paint the sharp-edged blades of grass with Hooker's green and yellow ocher.

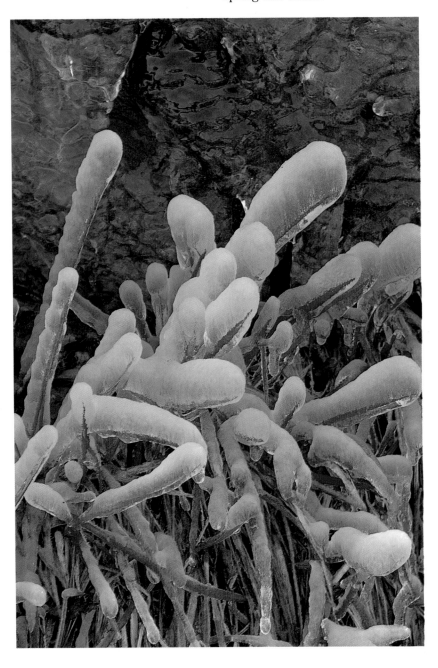

A thick coat of ice transforms slender blades of grass into swollen, fingerlike projections.

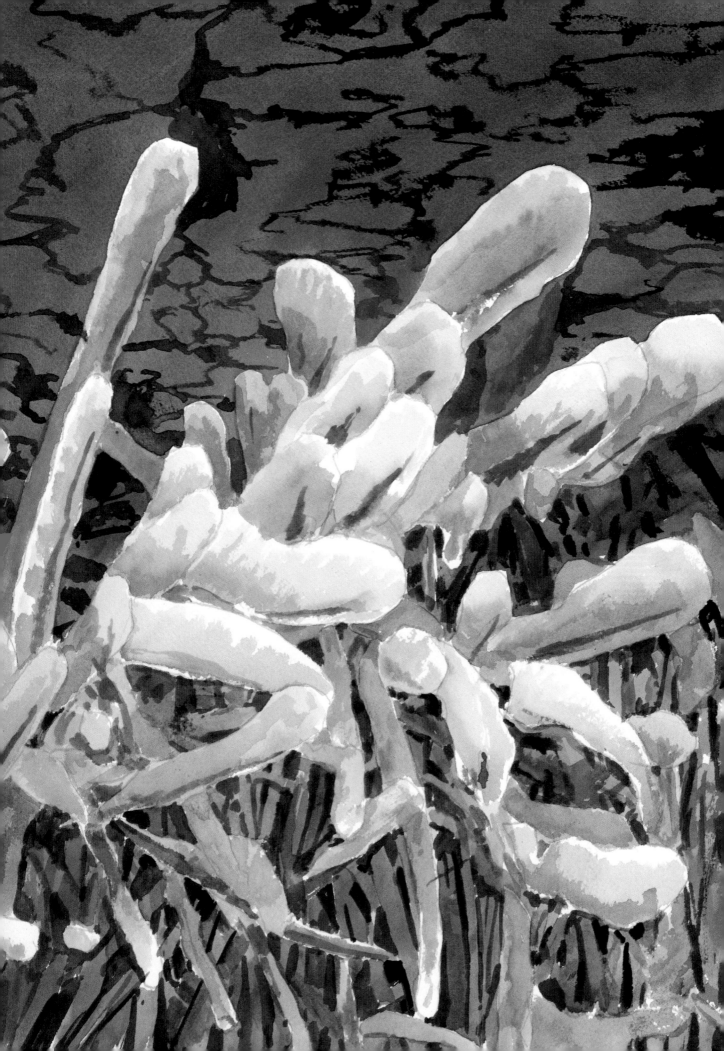

Depicting Dramatic Reflections Cast on a Lake

PROBLEM

Few scenes rival this one in its power. Quiet, mirrorlike, deep-blue water reflects a dramatic, cloud-filled sky. Depicting the white clouds realistically can be difficult, especially when they are reflected in such dark-blue water.

SOLUTION

Opaque gouache is your best bet here. Using it, you'll be able to develop the scene in a traditional light-to-dark fashion and then, at the last moment, render the reflected cloud formations.

Magnificent cloud formations are reflected on the tranquil surface of a lake.

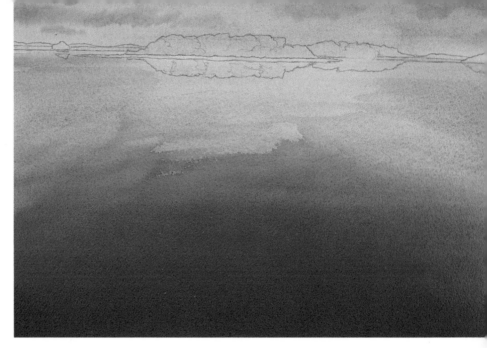

STEP ONE

Sketch the island in the middle of the lake and add the horizon line. Now lay in the sky with a pale wash of cerulean blue, indicating the underside of the clouds with a light mixture of cerulean blue and ultramarine.

Next paint the water with a mixture of cerulean blue, ultramarine, and yellow ocher. Note how the lake is pale near the horizon line, and how it quickly becomes much darker. As you shift to darker color, work around the reflection of the large cloud right beneath the island.

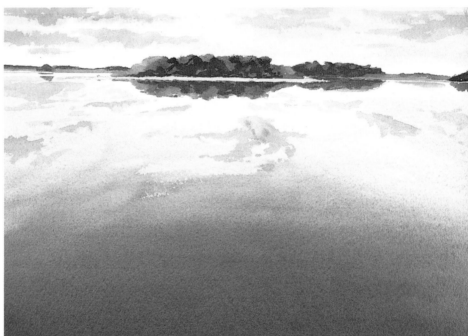

STEP TWO

Strike in the dark-green trees and their green reflections now; once they are down, you'll be able to adjust the rest of your values. Here they are rendered with Hooker's green and Payne's gray; the sandy shore is painted with yellow ocher.

Right away you'll notice how much lighter the sky and water look when set against the dark green. Now, with a wash of ultramarine and alizarin crimson, increase the strength of the cloud formations in the sky and begin to paint the dark portions of the clouds that are reflected in the water.

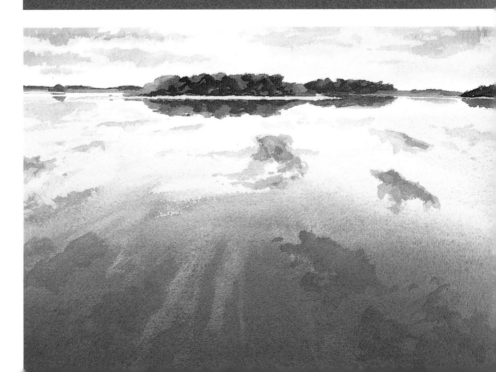

STEP THREE

To capture the pale streaks of light that radiate outward in the water, dip a brush into clear water, stroke it over the entire lake, and use a clean rag to pull some of the color from the lake's surface. While the paper is still damp, drop in ultramarine and alizarin crimson to indicate the darkest portions of the reflected clouds.

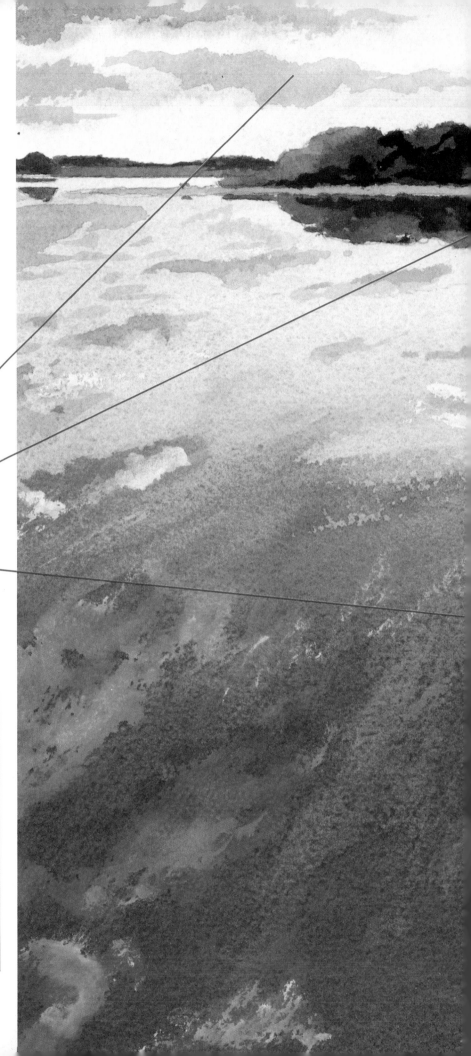

FINISHED PAINTING

All that's left now are the whites of the reflected clouds. Don't make them too bright; add just a touch of yellow ocher to the white gouache to tone it down, and dilute the gouache slightly to make it less powerful. Carefully paint the clouds; then let the paper dry.

To soften the effect of the opaque paint, try this: Take a large brush, dip it into clear water, and then run it over the passages that you've painted with gouache. Right away they will become softer and less distinct— perfect for capturing the gentle feel of clouds.

The clouds that streak the sky are painted in two steps. First they are laid in with a very pale wash. Once that's dry, they are reinforced with a slightly deeper hue.

The trees and their reflections are painted with just two colors, Hooker's green and Payne's gray. Rendered simply, without much detail, they fit easily into the picture.

The reflected clouds are built up gradually, from light to dark. The brightest areas, however, are painted last, with white gouache that has been tempered with a touch of yellow ocher.

ASSIGNMENT

If you've never worked with opaque gouache, experiment to find out what it can do. You'll soon discover that it handles much like transparent watercolor.

Load your brush with gouache and practice laying the pigment onto a sheet of watercolor paper. First work with the flat edge and then the tip of a wet brush. Next, experiment with a dry-brush technique.

Now try putting the paint down thickly; then try diluting it with clear water, and see the effects you achieve. Finally, practice spattering it.

Once you feel comfortable with the medium, use it in one of your paintings. It's great for depicting highlights or reflections.

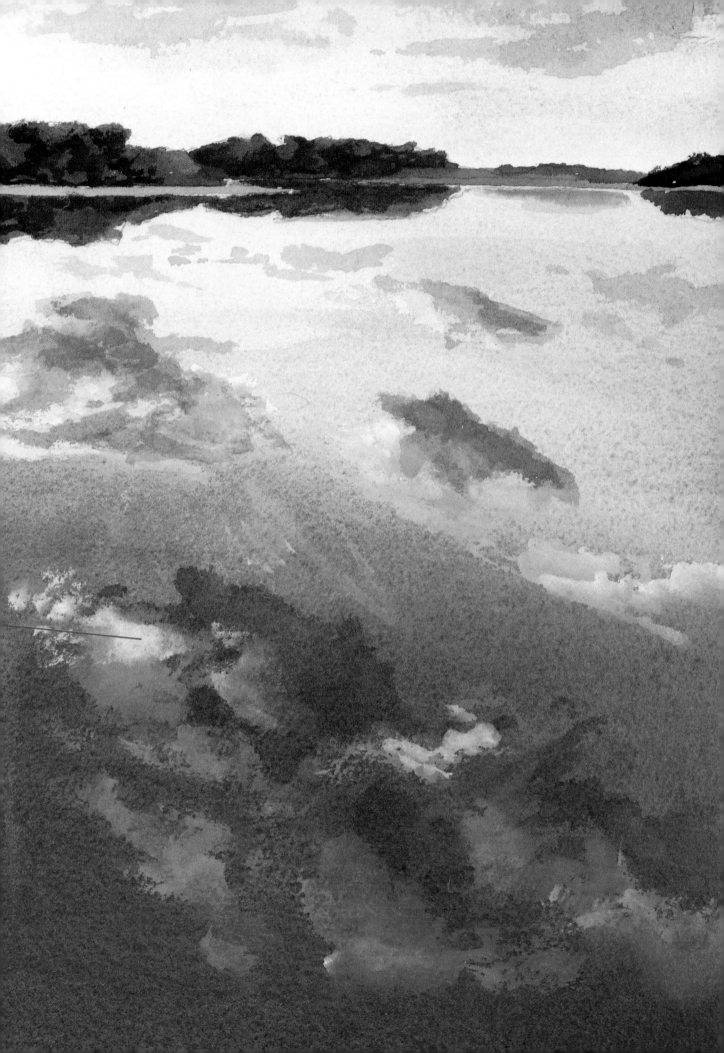

Manipulating Color and Light

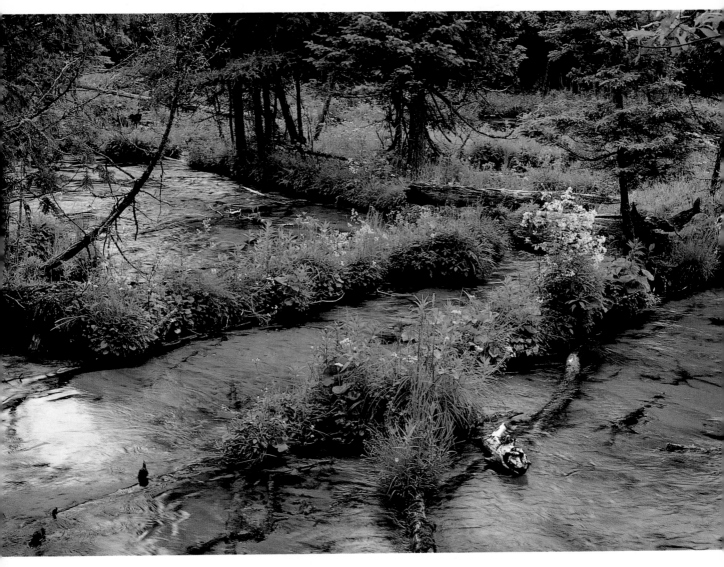

PROBLEM

This scene is extraordinarily complicated. It's packed with greens that are closely related in value. What's more, the river itself is dark and tinged with green.

SOLUTION

Emphasize the light that strikes the water and make the water bluer than it actually is. By doing this, you'll break up the wall of greens and give your painting a few crisp accents.

Fallen logs, thick with vegetation, lie across a shallow, swiftly moving river.

STEP ONE

Loosely sketch the scene; then figure out your plan of attack. Since the scene is so complicated, start with the most difficult area first—the water. If you run into trouble, you can always start over.

Working with yellow ocher and sepia, paint the shadows that run along the bottom of the logs. Next, lay in the shadowy portions of the water with the same two hues. Finally, paint the ripples in the water with cerulean blue.

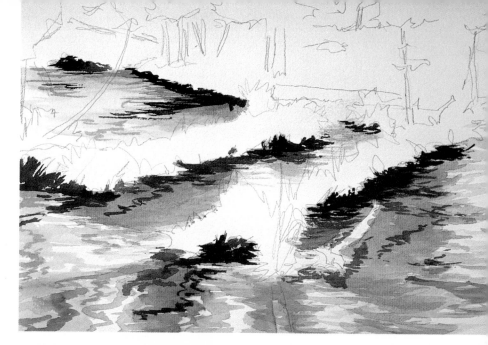

STEP TWO

Start to build up the greens. Working from the top of the paper down, lay in the trees and grasses with a variety of flat green washes. Here they are made up of Hooker's green light, Payne's gray, and new gamboge. Once these areas are established, develop the dark, shadowy areas of green with the same colors plus alizarin crimson. Before you move on, add the dark tree trunks with Payne's gray and sepia.

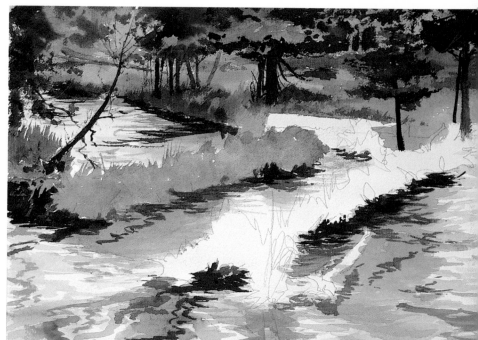

STEP THREE

Finish the greens that lie in the foreground, again beginning with flat washes of color. Let the washes dry; then put down the dark shadows and details that articulate the vegetation on the logs.

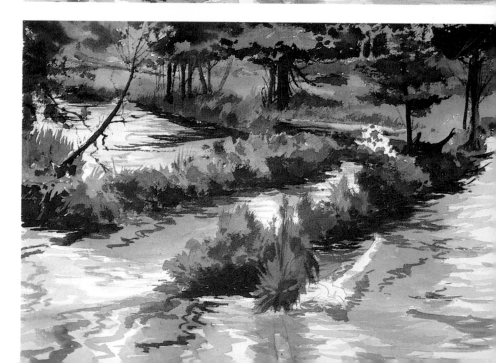

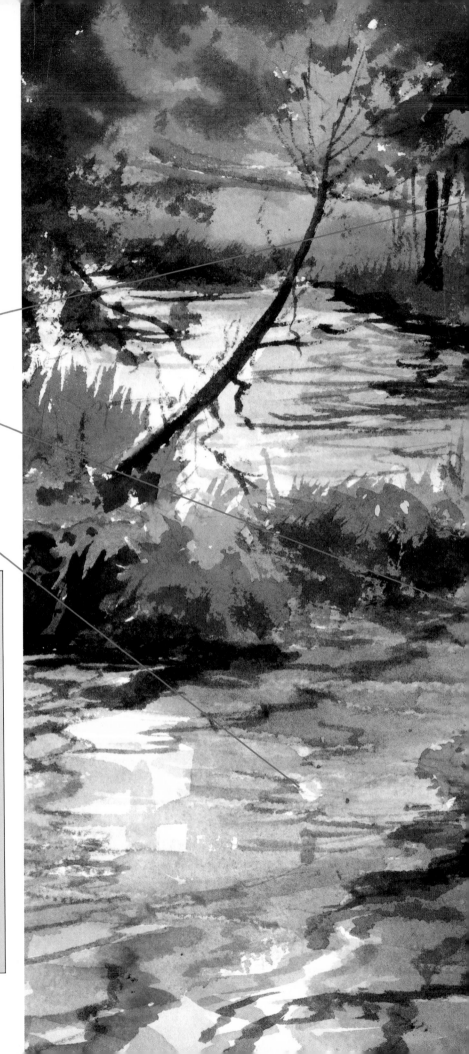

FINISHED PAINTING

In the final stages of this painting, it became clear that the water was too bright and was broken into too many areas. To pull the water together, and to tone it down by one-half of a value, a light wash of ultramarine blue was pulled over most of the water. As a finishing touch, additional reflections were added with dark ultramarine, and dabs of bright yellow were laid in to suggest the flowers growing on the logs.

To simplify this overly complicated scene, the trees were laid in with simple, flat washes of greens. Once the washes dried, darker greens were worked into them to depict their shadowy undersides.

Yellow ocher and and sepia may seem unlikely colors for water, but they work perfectly here. In the final stages of the painting, a pale wash of ultramarine was pulled over these areas, uniting them with the blue areas that surround them.

The ripples that play upon the surface of the water are strongly horizontal and balance all the strong verticals formed by the trees. The soft, diffuse ripples were worked wet-in-wet.

ASSIGNMENT

One of the most challenging aspects of painting water concerns its very nature. Water is constantly moving and changing; how, then, can an artist render it realistically?

Photographs are an invaluable aid. Next time you scout for painting locations, take along a camera. When you find a likely site, photograph it from a number of angles; try to capture all the visual information you will need when you paint.

Even if you decide to execute a painting on the spot, these photographs won't go to waste. Establish a file for them, arranged according to time of day, the seasons, and so forth; then refer to the file when you want to capture a particular situation—calm water, turbulent water, crashing waves, gentle streams, an ice-coated pond.

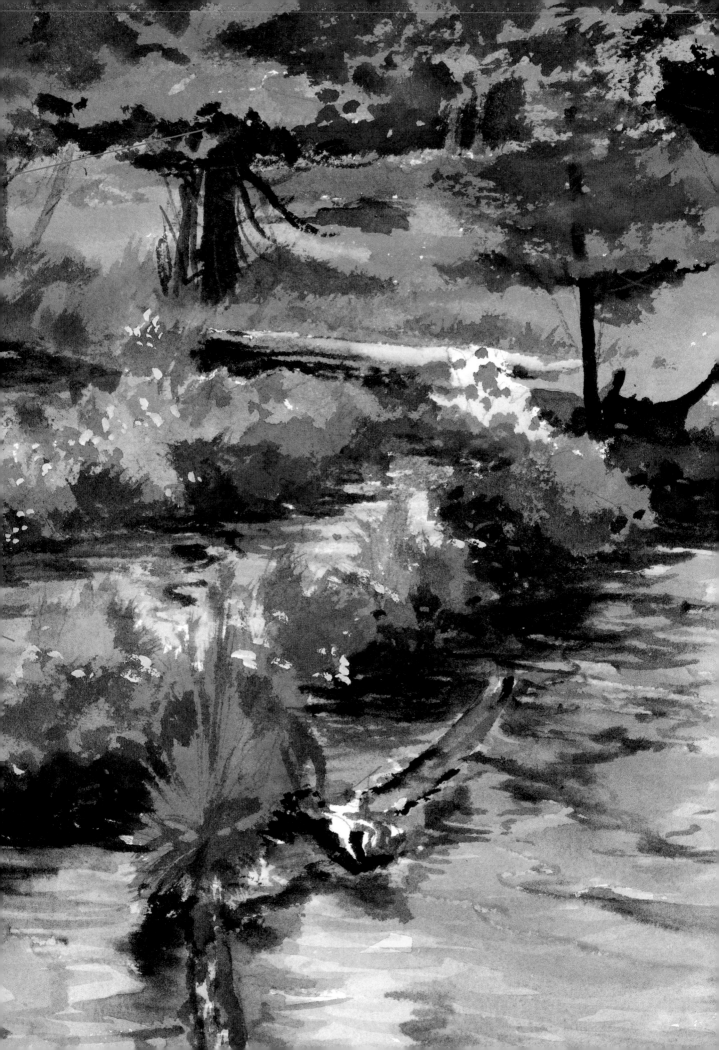

Highlighting a Quickly Moving Stream

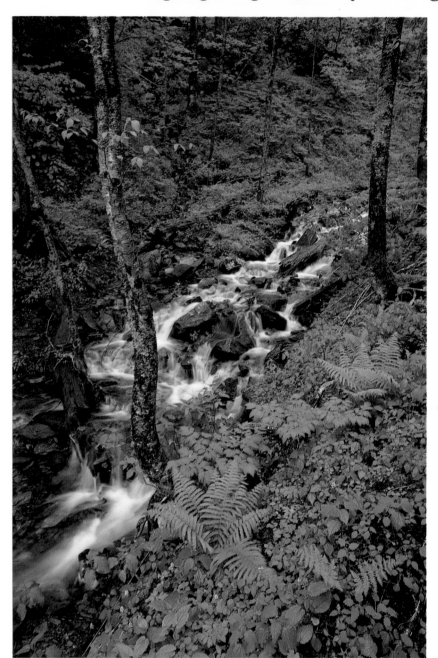

PROBLEM

The rocky stream is a complex jangle of forms and colors, and the trees and ferns form an intricate maze. It will be difficult sorting out what you see.

SOLUTION

To make the stream stand out clearly in your painting, simplify it and make it lighter than it actually is. To capture just the right value, paint it last, after all the greens are down.

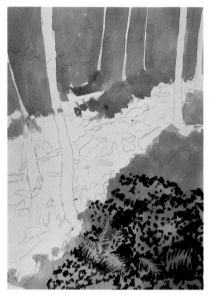

STEP ONE

Start simplifying the scene in your preliminary sketch; don't get involved in details. Immediately begin to lay in the background with Hooker's green, new gamboge, and Payne's gray. At this stage keep the greens fairly light so that you can come in later and add details with a darker hue. To set up your value scheme, paint a few of the darks that lie in the immediate foreground.

In the Smoky Mountains, surging white water rushes over a rocky bed.

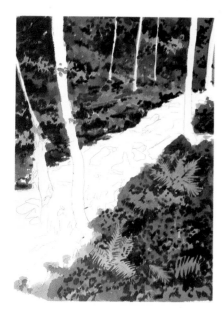

STEP TWO
For the shadowy areas, you'll
need burnt sienna, sepia, and
mauve. Working all over the sur-
face of the paper, lay in these
very dark touches. When they are
dry, work back over the surface
with an intermediate-value green.
At this point all of the greens
should be down.

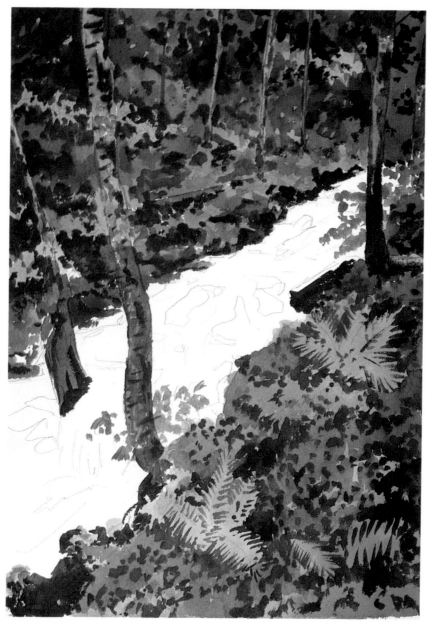

STEP THREE
Paint the trees, keeping them
fairly dark; if they are too light,
they'll stand out sharply against
the greens and steal attention
from the stream. Render them
with sepia, burnt sienna, and
Payne's gray. Finally, add the
touches of vegetation that grow
around the tree trunks.

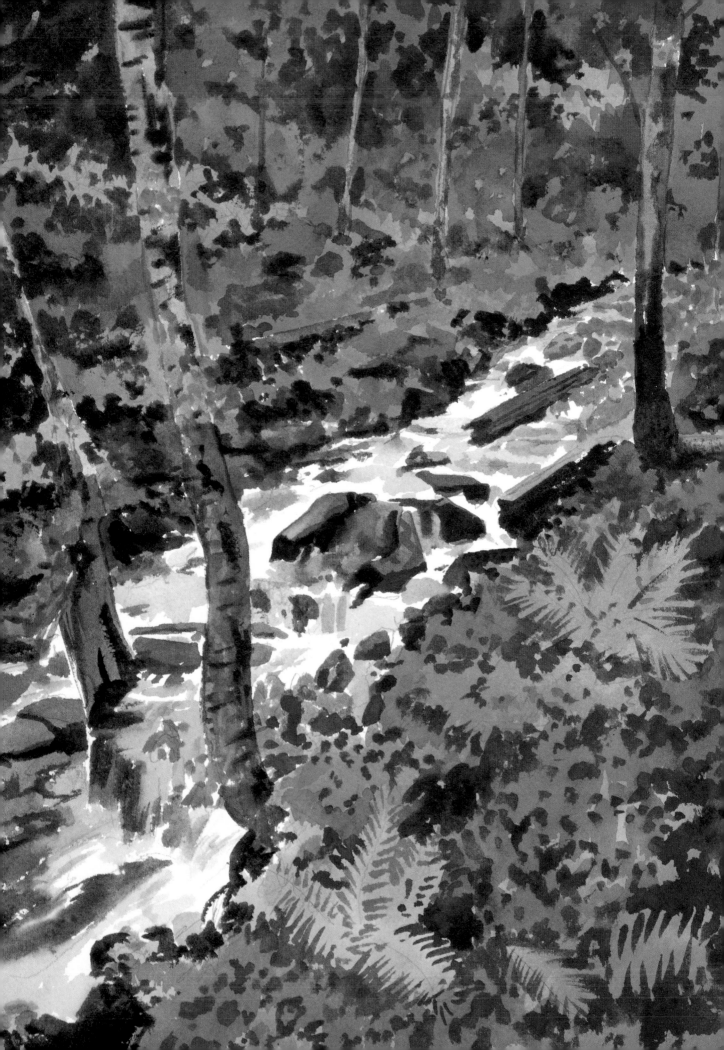

FINISHED PAINTING

All that remains now is the rocky stream. Using sepia, burnt sienna, yellow ocher, and cerulean blue, paint the rocks. Simplicity is the key to success here; don't paint every rock you see, and simplify the ones you do paint.

While the paper is drying, select the colors you'll use for the water. Here cerulean blue is the basic hue; touches of yellow ocher and sepia tone the blue down and give it a steely cast.

Now paint the water with short, choppy strokes. Most important, work around the lightest, brightest passages; the crisp white of the watercolor paper will form the highlights.

DETAIL

The quickly moving water stands out clearly against the wall of vegetation. Note how the stream is bordered by a band of deep, dark brown, further separating it from the greens.

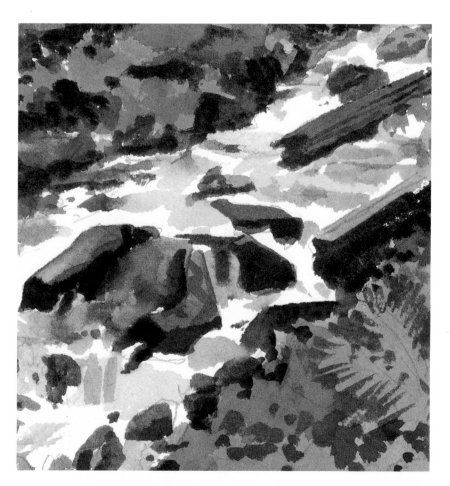

DETAIL

The water is rendered with short, quick strokes. Made up of cerulean blue, yellow ocher, and sepia, it is cool enough—and toned down enough—to fit in easily among all the strong greens.

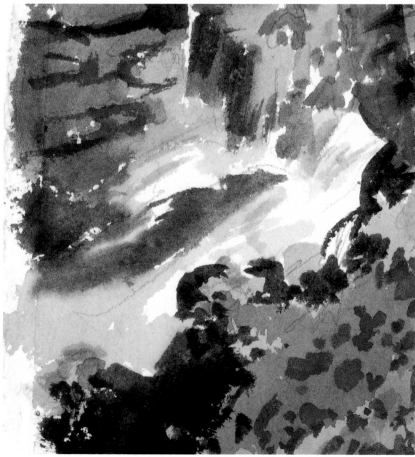

Exploring Reflections and Light

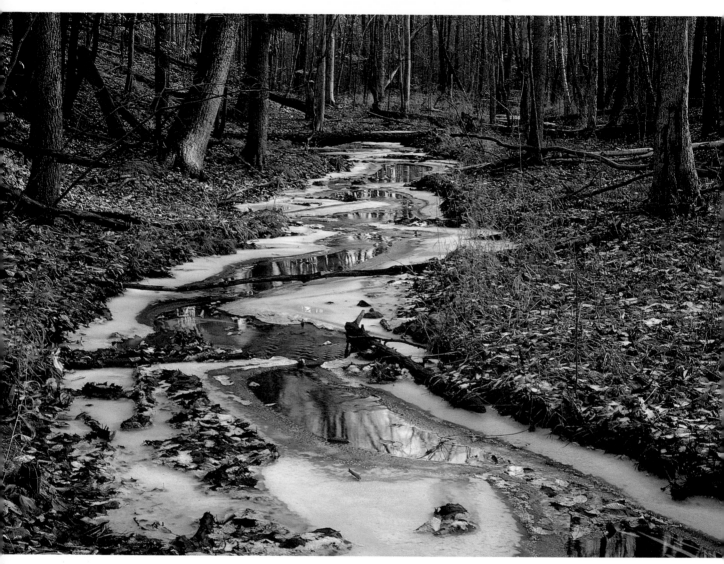

PROBLEM

One thing makes this scene special: the transparent, sparkling water set against the opaqueness of the ice. You have to capture the play of light on the newly formed ice and the flickering reflections that dance through the water.

SOLUTION

Develop the background before you tackle the water. When you turn to the stream, exaggerate the ice, the highlights, and the shimmering reflections of the trees.

*Deep within a forest,
ice begins to form on a shallow,
meandering stream.*

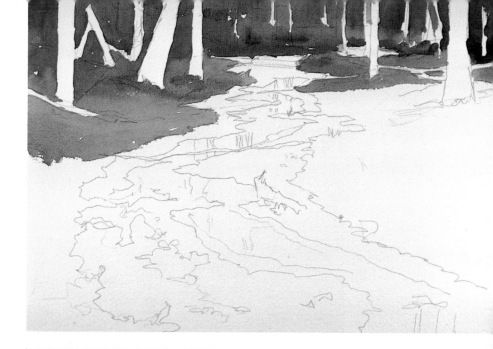

STEP ONE
In your preliminary drawing, sketch the major trees and the contours of the stream and ice. Begin to develop the background, working with mauve, yellow ocher, Hooker's green, burnt sienna, and cadmium orange. Use mauve to depict the most distant trees; you'll find that the purple creates a strong sense of distance. As you move forward, switch to the warmer hues.

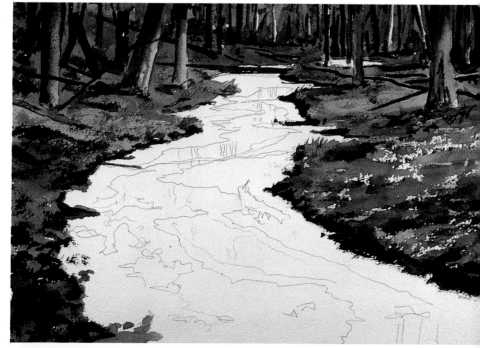

STEP TWO
Just as soon as the background dries, put in the trees. Before you start to paint, though, note how the light falls on the right side of each trunk; keep these areas light. Browns and grays are dominant here—mixed from sepia, Payne's gray, and burnt sienna, with a touch of Hooker's green. Let the trees dry; then add the grass and the leaves, using a drybrush technique and the same colors you used to build up the trees.

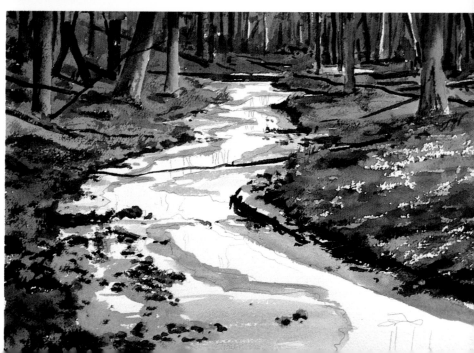

STEP THREE
Gradually introduce color into the icy edges of the stream. Cerulean blue and ultramarine make up the shadowy areas of ice; the white of the paper is left as highlights. Sepia and burnt sienna furnish just the right color note for the fallen leaves and twigs. Don't go overboard painting the leaves, though. Add just a few of them— if you depict too many, you'll make it more difficult to complete your painting.

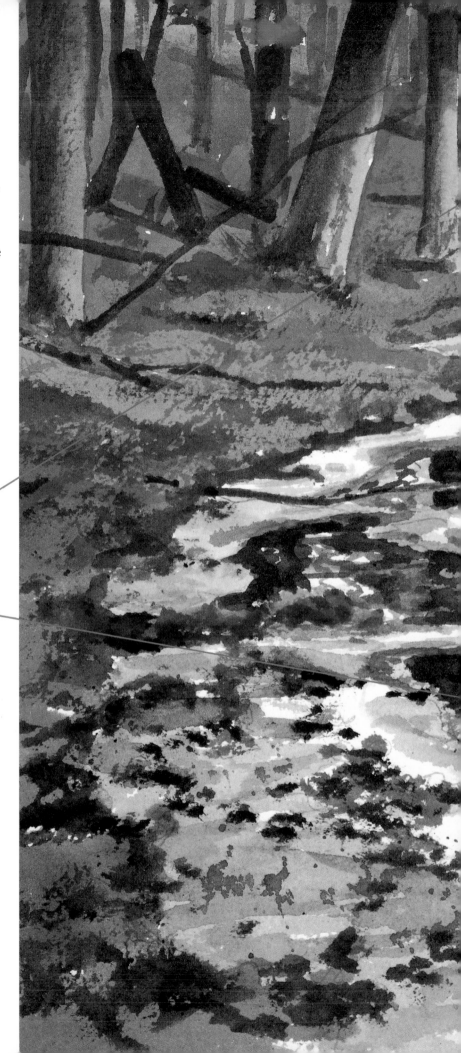

FINISHED PAINTING

Until now, you've worked fairly
cautiously, developing the setting
with a traditional light-to-dark ap-
proach. Now, as you turn to the
transparent water, it's time for
drama.

Exaggerate what you see.
Working with cerulean blue, ultra-
marine, Payne's gray, and sepia,
make the reflections darker than
they actually are, and make them
more lively, too. Begin toward the
back of the stream with long,
slightly undulating strokes. As
you move forward, use darker
paint and more dynamic, cal-
ligraphic brushwork.

In the finished painting, the
stream clearly dominates the
scene. Packed with color and
movement, it stands out boldly
against the golden-brown forest
floor and the dull brownish-gray
trees.

*The trees in the background are rich
with color, yet understated enough
to act as a backdrop for the stream.
The following colors make up the
trees: mauve, yellow ocher, burnt
sienna, cadmium orange, Payne's
gray, and Hooker's green.*

*In the finished painting, the water
is clearly the focal point. Crisp
white ice gives way to dark blue
water, where lively reflections
sparkle.*

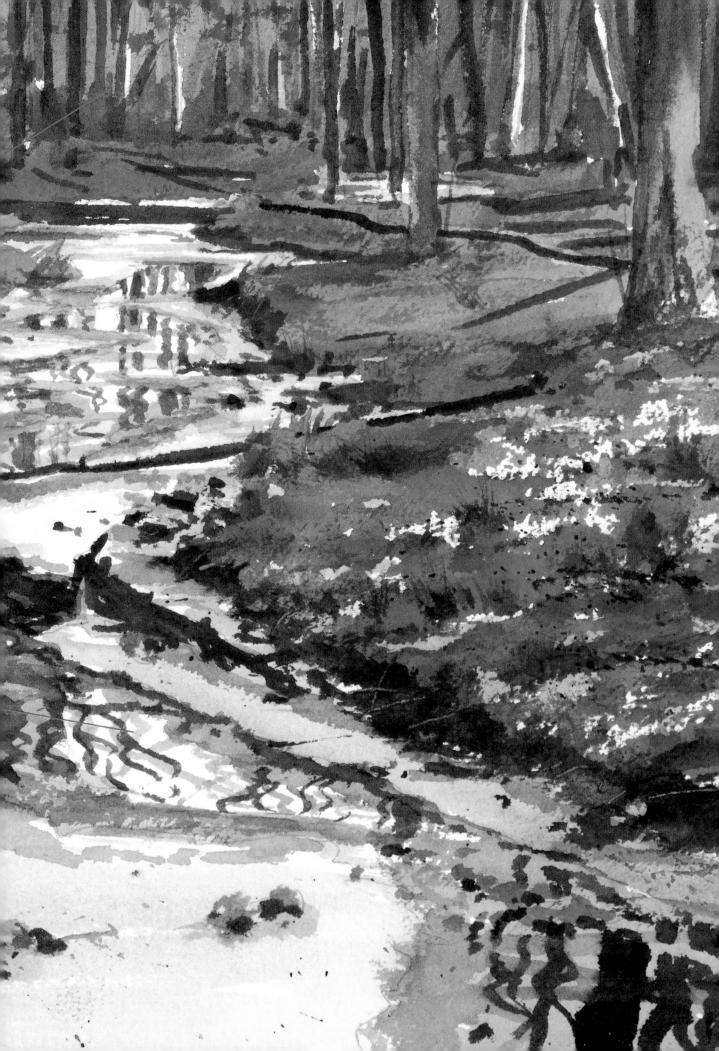

Rendering the Soft Feel of Spray

PROBLEM

As it tumbles over the rocks, the water breaks into soft spray. It's essential that you capture the contrast between the soft water and the hard rocks.

SOLUTION

Paint the rocks right away, establishing their shape and their color. Later on, when you turn to the water, use simple brushstrokes and pale washes to convey the soft patterns the water forms as it pulses over the rocks.

☐ Before you begin to sketch, study the scene. Note how the rocks in the background are set closely together. If you paint the scene literally, these close-set rocks will break up the flow of water with dark horizontals. To avoid this problem, in your drawing place the rocks farther apart than they actually are.

Working with ultramarine and sepia, begin to paint the dark, shadowy portions of the rocks. Let the paint dry; then strike in the lighter surfaces with yellow ocher, sepia, mauve, and Hooker's green light. As you work, paint around the leaves that lie on the boulders.

Once again, let the surface dry; then lay in all the green leaves and all the orange leaves. Here they are rendered with Hooker's green light, yellow ocher, and cadmium orange. To break up the rich wall of color you are creating, let some small sparkles of white remain. To develop the darks that lie in the background, use sepia and ultramarine.

At this point, all that remains to be done is the water. Prepare your palette with ultramarine, alizarin crimson, and Payne's gray; then go to work. Let the white of the paper represent the highlights, and use pale washes of color for the darks. Right from the start, set up a lively pattern of alternating darks and lights—and don't get caught up in detail. For the soft—yet bold—treatment that this stream deserves, put the paint down with large, simple brushstrokes.

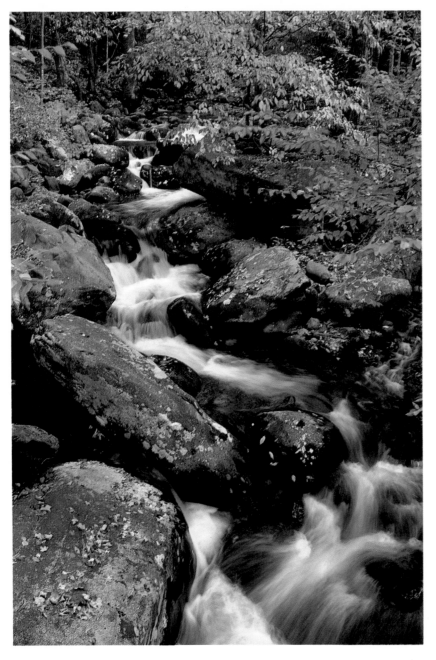

Water cascades over steely gray rocks, while autumnal leaves add bright splashes of color.

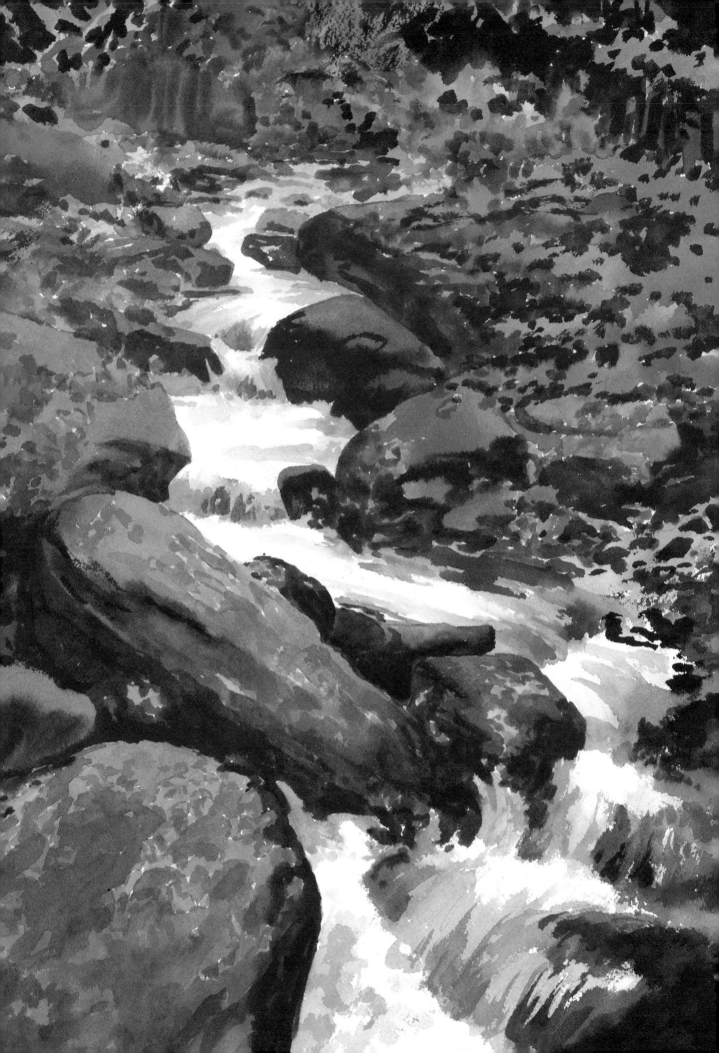

Painting Rapidly Flowing Water

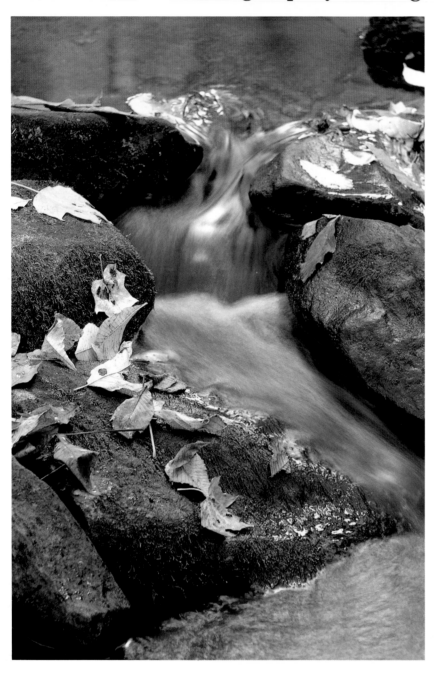

In autumn, a stream of water eddies rapidly over moss-covered rocks.

PROBLEM

The real subject here is the nature of flowing water. At the top of the scene, the water is still and green; as it rushes over the rocks, it becomes soft and un-focused; at the bottom, it is filled with subtle ripples.

SOLUTION

Concentrate on the most dramatic part of the composition, the point where the water spills over the rocks. Paint the water first, and if you fail to capture its mood, start over.

STEP ONE

Sketch the rocks and the leaves, then begin to lay in the water. You'll want it to be infused with a soft feel, so work wet-in-wet. First "paint" the stream with clear water; then begin to drop in color. Here the rich green area is made up of olive green, yellow ocher, and burnt sienna. Note how the reflections are exaggerated to break up what could become a dull expanse of dark color. For the rushing water, try using cerulean blue and ultramarine mixed with just a touch of yellow ocher.

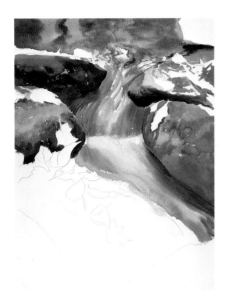

STEP TWO

Next execute the rocks that surround the rushing water, but work around the fallen leaves that lie on top of them. These rocks form the darkest value in the composition, so once they are down, you can tune the rest of your painting to work harmoniously with them. Render them with ultramarine, cerulean blue, Payne's gray, sepia, and Hooker's green light. To hold the soft feel established earlier, continue to work wet-in-wet.

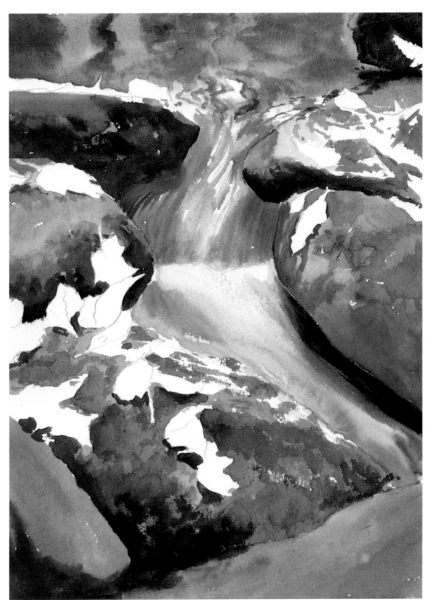

STEP THREE

Working with the same colors, complete the rocks; then lay in the water at the bottom of the scene. Now go back and add textural details to the rocks.

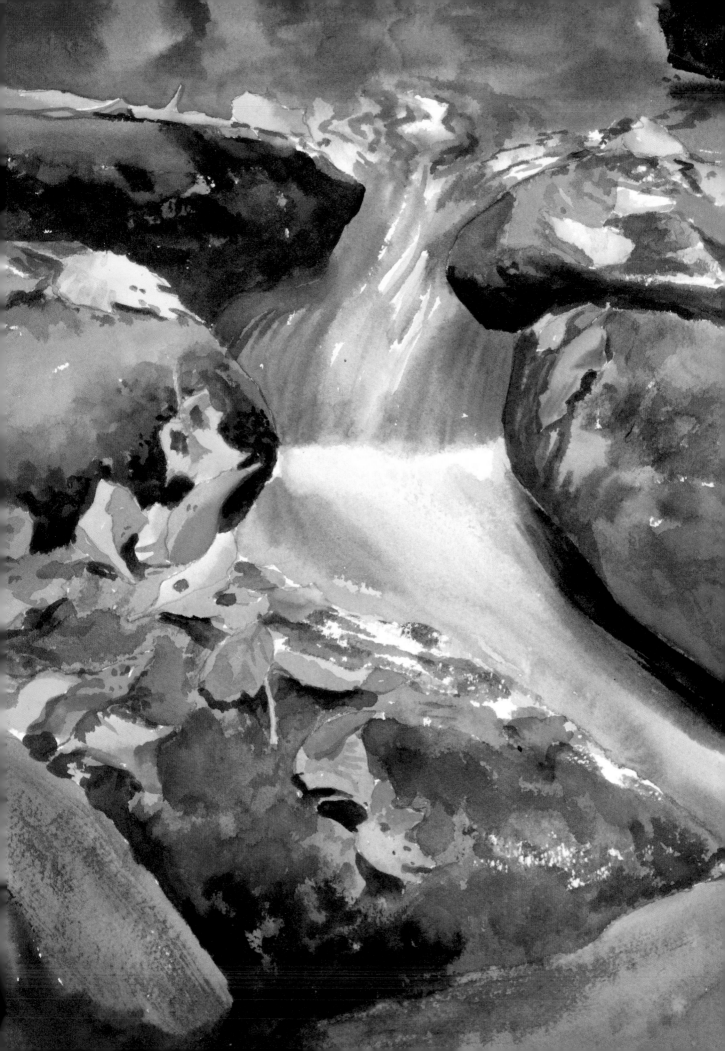

FINISHED PAINTING

The brightly colored autumn
leaves could easily detract from
the focal point of your painting,
the water. Tone down their bril-
liance by using pale washes of
color; you'll find that thin, trans-
parent color also helps build up a
soft overall feel. Lay the leaves in
with a variety of hues—cadmium
orange, cadmium red, new gam-
boge, mauve, cadmium yellow,
alizarin crimson, and Hooker's
green light. To render each leaf,
lay in a flat wash, then go back
and emphasize its structure.

DETAIL

Painted wet-in-wet, the still green
water looks soft and unfocused.
To break up the surface of the
water, the reflections are exag-
gerated. Note the small cal-
ligraphic strokes that connect the
green water to the rushing blue
water that cascades over the
rocks; they act as a visual bridge
between the two areas.

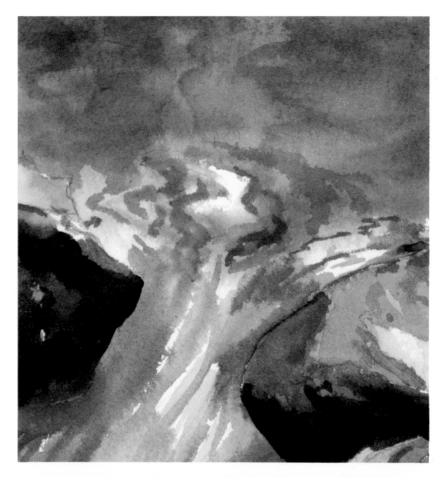

DETAIL

The leaf-covered rocks surround-
ing the stream are rendered with
ultramarine, cerulean blue,
Payne's gray, sepia, and Hooker's
green light. Like the water, they
are worked wet-in-wet to main-
tain the painting's soft feel. The
leaves are laid in with pale washes
of color. Were they painted with
stronger hues, they would pull
attention away from the rushing
water.

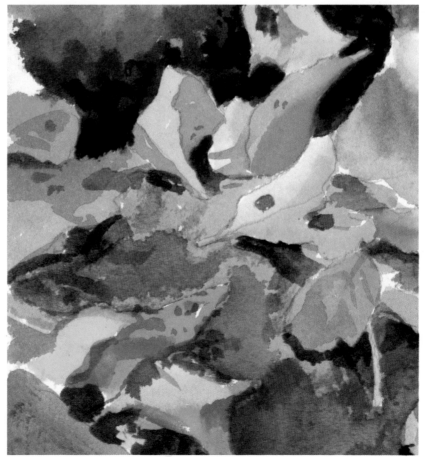

Moving In on Detail

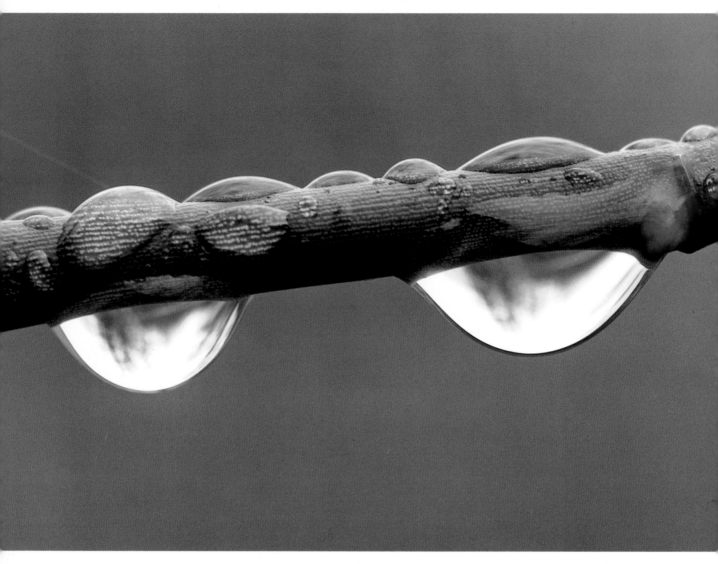

PROBLEM
What at first may seem simple in this composition is really fairly complex. If you can capture the minute details as well as all of the color notes found in the rain-drops, you will build an exciting and unusual still life.

SOLUTION
To make the drops of water stand out clearly, paint the background with a rich, dark tone. That done, concentrate on detail.

☐ Execute a careful preliminary drawing first. Then moisten the background area with clear water so that you can lay in a soft middle-tone. At the top, work with ultramarine, cerulean blue, and burnt sienna. Toward the bottom, add a hint of alizarin crimson.

Paint the basic colorations of the twig next, working around each drop of water. Here the washes are made up of alizarin

A fascinating world filled with color and detail lies hidden in a few simple drops of rain.

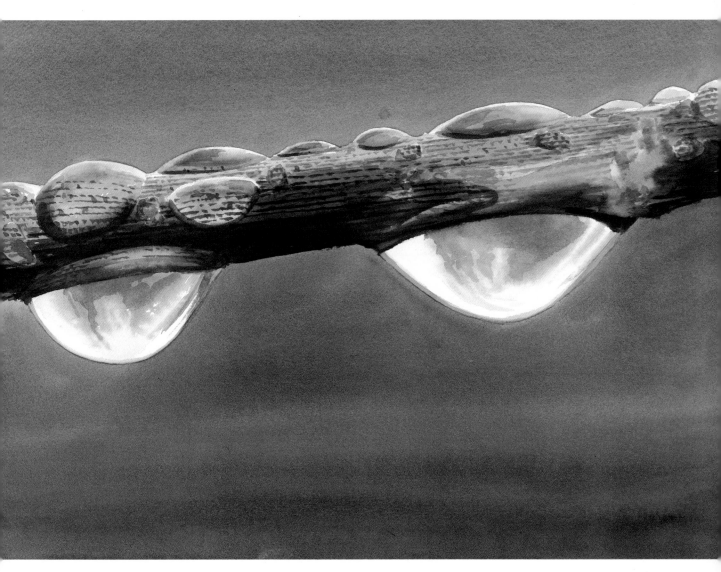

crimson, ultramarine, Hooker's green, sepia, and cerulean blue. When the paper is dry, add the thin lines that run down over the twig.

For the raindrops, use the same basic hues, but add cadmium yellow. First moisten the paper with water; then apply your colors, mixing the rainbowlike hues right on the paper. At the very end, go back and add the details of the striated lines.

Learning How to Paint Transparent Drops of Water

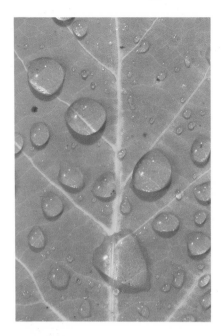

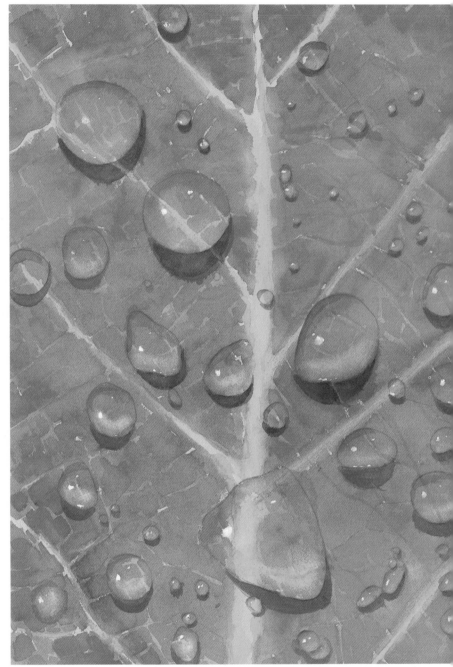

PROBLEM

Shimmering, transparent water can be difficult to paint, especially when it's set against a vivid backdrop. Capturing the three-dimensionality of the raindrops presents a special challenge.

SOLUTION

Let a strong drawing set up the structure of the leaf and the position of the raindrops. When you begin to paint, concentrate on the highlights that brighten the drops of water.

☐ Sketch each drop of water and each vein in the leaf; then stain the paper with a solid wash of cadmium orange and new gamboge. Let the paper dry.

Using cadmium red and cadmium orange, lay in the deep reddish-orange portions of the leaf. As you paint, work around the veins and the highlights. Once the paper is dry, go back and soften the veins by adding touches of the reddish wash to them. If any passages of gold seem too strong, work clear water over them to lighten the color.

Now paint the shadows under the raindrops with cadmium red, alizarin crimson, and mauve. On the side opposite the shadow, introduce a lighter tone of the same wash. As a final step, wet the bottom of each raindrop and wipe up some of the color; then add the shimmering highlights with touches of opaque white gouache.

Crystal-clear raindrops hover on a golden-orange aspen leaf.

Masking Out Highlights

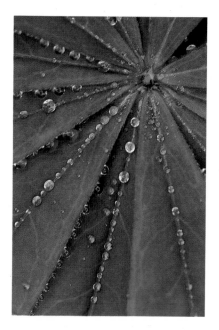

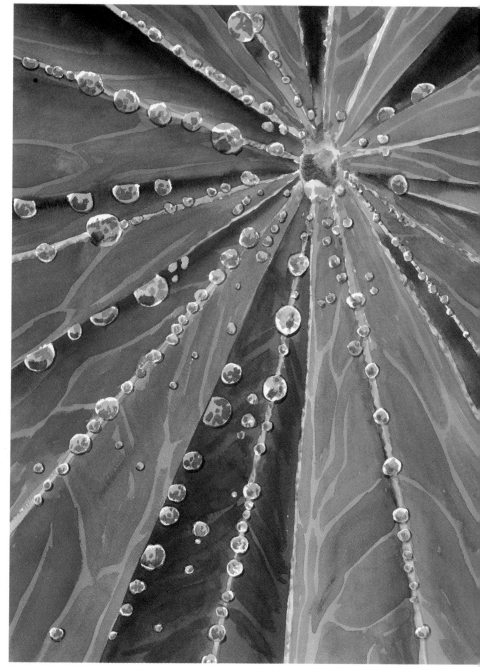

PROBLEM
It's the crisp, bright drops of water that make this subject sparkle. You'll have to emphasize them to create a lively, interesting painting.

SOLUTION
Mask out the raindrops with liquid frisket, and you'll be able to hold your whites. More than that, the frisket will give you the freedom you need to execute the background boldly.

☐ Draw the leaves and the raindrops; then carefully mask each drop of water out with liquid frisket. Lay Hooker's green light, Payne's gray, and new gamboge on your palette; mix a wash and then begin to lay in the darkest leaves. Once they are down, paint the rest of the leaves with lighter washes, varying their tones slightly. Here they are rendered with Hooker's green light and new gamboge.

Let the paper dry; then working with a wash one value darker than the underlying washes— overlay the leaves so that the lighter values delineate the radiating veins.

Now peel off the frisket and begin to paint the raindrops with Hooker's green light, new gamboge, and cerulean blue. To make them pop out, leave a narrow rim of white around most of the drops.

Clear, brilliant drops of water shimmer atop the leaves of a lupine.

101

Maintaining a Flat, Decorative Look

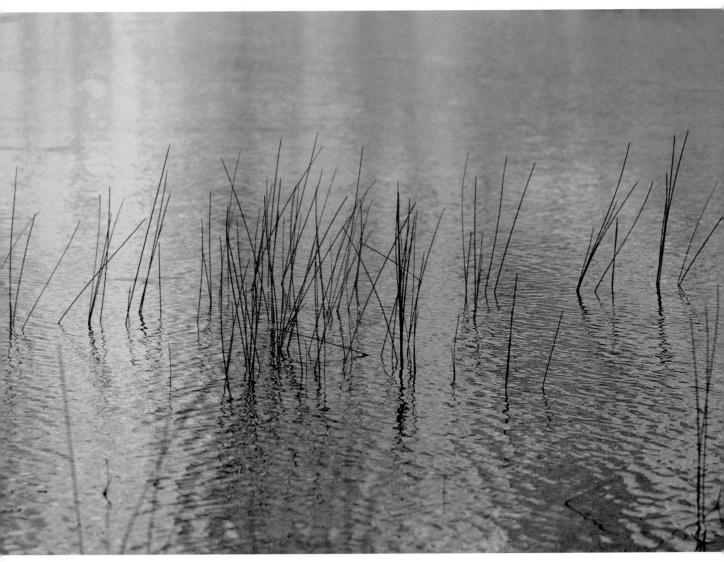

PROBLEM

The beauty of this autumn scene rests in its flat, decorative feel. Maintaining a decorative, almost abstract look, is essential.

SOLUTION

Look beyond the obvious vertical bands of color and stress the horizontals that run through the water. The interplay between the verticals and horizontals will capture the decorative look you are after.

☐ Prepare your palette with strong, vivid hues: new gamboge, cadmium yellow, cadmium orange, cadmium red, and Hooker's green. Now mix a wash of new gamboge and cadmium orange and lay the color in over the entire sheet of paper. While this wash is still wet, stroke in vertical bands of cadmium red, cadmium orange, and Hooker's green, using a 1½-inch brush and horizontal strokes. Let the paper dry.

The brilliant colors of autumn foliage lie reflected in a quiet lake.

Next begin to work with a small, round brush as you lay in the ripples that run through the water. Two values of Hooker's green make up these ripples; the ripples are bold at the bottom of the paper, and gradually become finer and softer toward the top.

Make sure the paper is thoroughly dry before you move on to the reeds; any moisture will soften your strokes and break up the decorative pattern you want.

With a small, fine brush, carefully render the reeds with sepia and Hooker's green. Finally, lay in a few rapid, calligraphic strokes to suggest how the reeds are reflected in the water.

In the finished painting, the horizontal brushstrokes and ripples are poised against the vertical bands of color. Together these elements provide a simple but colorful backdrop for the graceful patterns of the reeds.

Mastering Soft, Unfocused Reflections

PROBLEM

A canopy of leaves shields this stream from direct sunlight, softening and blurring the reflections cast in it. And while the water is unfocused, the trees themselves are clearly and crisply defined.

SOLUTION

When you encounter soft, hazy, reflections, use a wet-in-wet approach. The strokes you lay down on damp paper will bleed outward, creating the effect you want. For the trees, work on dry paper and keep the edges sharp.

☐ Sketch the scene carefully; then lay in the upper portion of the painting. First stroke a wash of new gamboge over the top of the paper, extending down to the shoreline, and let the paper dry. Next paint the greens that fill the background. Use Hooker's green, cerulean blue, and new gamboge; since the underpainting will brighten up your green, don't use too much new gamboge.

To render the dark ground, try using sepia and ultramarine blue; for the patch of sunlight that spills through the trees, use cadmium orange. Finally, paint the trees with sepia.

It's now that the fun starts. Wet the entire lower half of the paper and drop color onto all but the very bottom of the moistened surface. To unify your painting, use the same hues that you employed in the upper portion of your composition—new gamboge, cadmium orange, and Hooker's green. Let the colors swirl about; then, at the bottom of the paper, drop in touches of cerulean blue to suggest the sky. Beneath the shoreline, add sepia and ultramarine to the wet paper. Keep the blue away from the new gamboge, or you'll end up with a muddy green.

Working quickly, moisten a small brush with sepia and run the brush up and down over the paper to depict the reflections of the tree trunks. Because the paper is still damp, the paint will bleed softly outward.

In the finished painting, the reflections are soft and muted, yet still made up of strong color. The thin band of white that separates the cerulean blue from the other colors in the water adds a crisp accent note. Without this band of white, the water could easily become dark and oppressive.

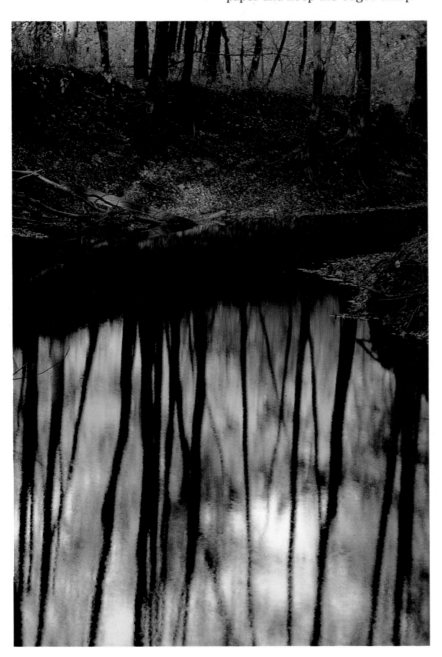

Tall tree trunks, golden foliage, and patches of pale blue sky are mirrored in a dark, still stream.

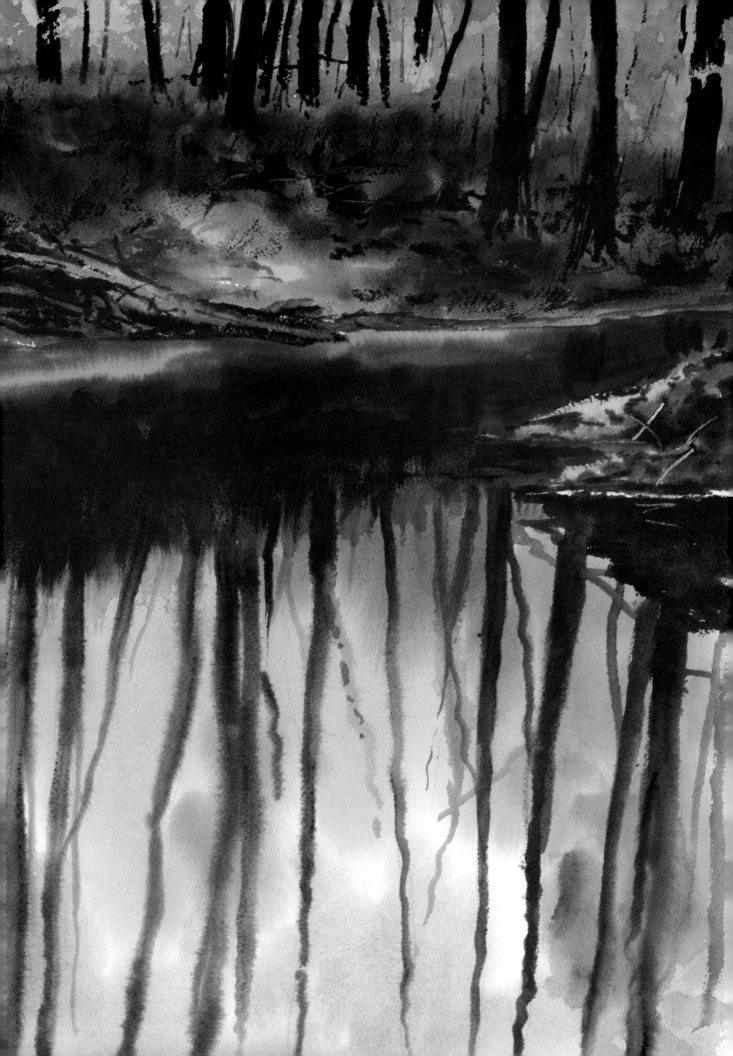

Rendering Bold, Brilliant Reflections

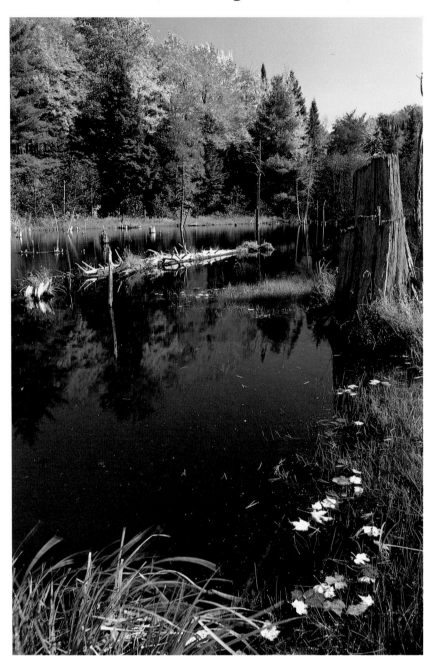

PROBLEM

When you render a dazzling scene like this one, it's easy to make colors too strong and too bright. Water dulls reflected color significantly; if your reflections are too vivid, your painting will look artificial.

SOLUTION

Paint the actual foliage first and use it as a key in balancing the strength of the reflections. Paint the reflections and the deep blue water in one step, to assure that they will work together.

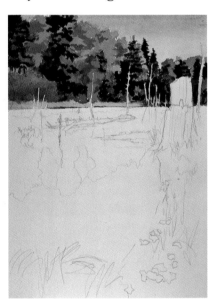

STEP ONE

Quickly sketch the scene; then lay in the sky with a pale wash of cerulean blue. Now turn to the foliage. Begin with flat washes of Hooker's green, cadmium red, cadmium orange, and new gamboge; then let the paper dry. Next, render the shadowy portions of the trees, adding mauve, cadmium red, and alizarin crimson to your palette.

The deep blue water of a lake takes on the strong, brilliant golds and reds of autumn.

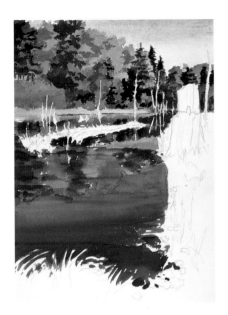

STEP TWO

Now it's time to establish the most difficult portion of the painting, the water. Begin by wetting the surface; then drop in the colors that make up the reflections—using the same hues that you relied upon in Step One.

While the paper is drying, mix a big pool of ultramarine. With a large brush, sweep a pale wash of the blue over the reflections, using strong horizontal strokes. Finally, paint in the clear blue water, making the color increasingly darker as you near the bottom of the paper.

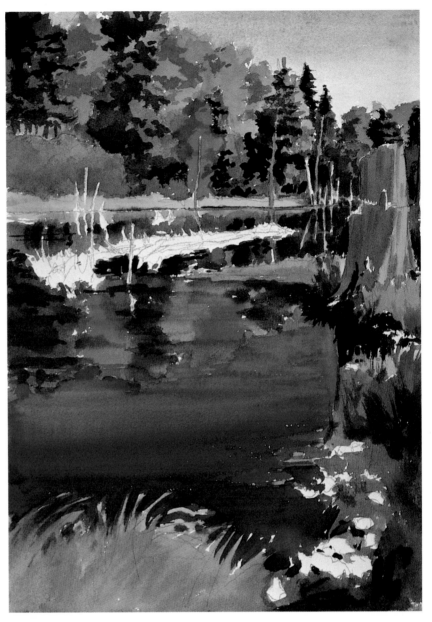

STEP THREE

Develop the foreground with warm, rich color—yellow ocher, Hooker's green light, mauve, cadmium red, and cadmium orange. Work around the leaves that are floating in the water; you'll add them later. Next, render the tree trunks and twigs, working with Payne's gray, sepia, and Hooker's green light.

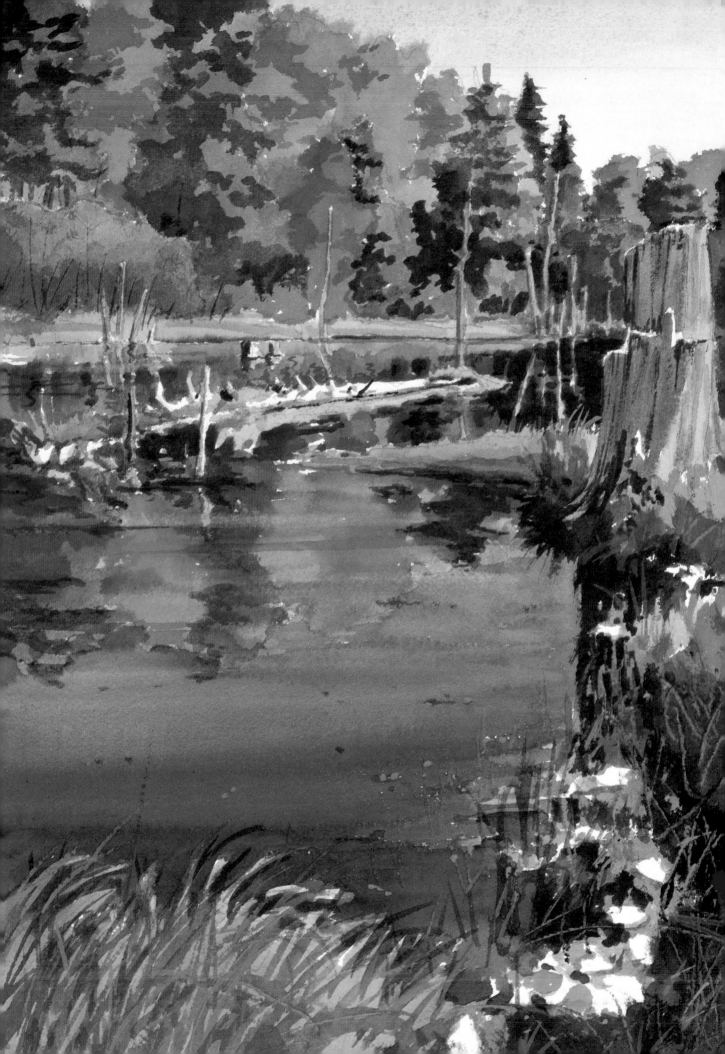

FINISHED PAINTING

At this point you are ready to fine-tune your painting. Start in the immediate foreground by enlivening the grasses with darker strokes of green. Next, lay in a few of the brightly colored leaves and break up the water with small touches of green. Finally, paint the grass-covered log midstream.

Now evaluate your painting. Here the water was too flat and too bright a blue. To break it up, try this: Take a medium-size brush, dip it into clear water, and then run the brush over the water with strong, horizontal strokes. Next, take a piece of paper toweling and gently run it over the moistened area. You'll find that this treatment removes just a trace of the color and suggests how light reflects off the water.

DETAIL

To subdue the reflections, a pale wash of ultramarine blue was swept over the paper as soon as the reflections had dried.

DETAIL

Strong, bold blue makes the foreground spring into focus. The horizontal strokes that break up the blue were added last. Clear water was applied horizontally to the blue water, then paper toweling was run gently over the surface, picking up bits of color. The end result: a lively variation in value that animates the entire foreground.

Using Diluted Gouache to Depict Translucent Water

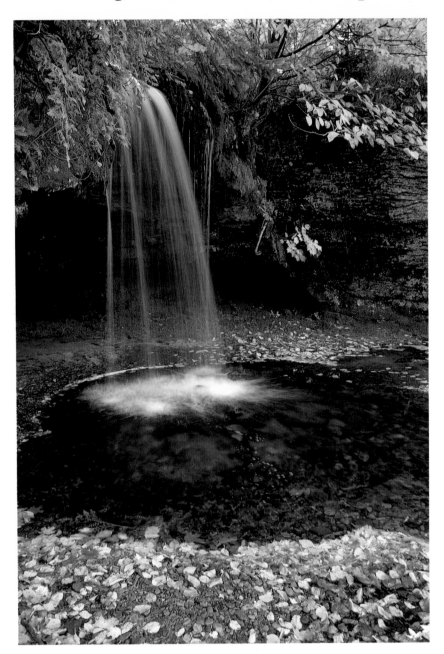

PROBLEM

Some of the dark rocks and green vegetation that make up the background shine through the soft jets of water. Your challenge lies in depicting the translucent nature of the water.

SOLUTION

Diluted gouache is perfect in situations like this one. You can develop the background as freely as you like before you go back and define the waterfall with the opaque paint.

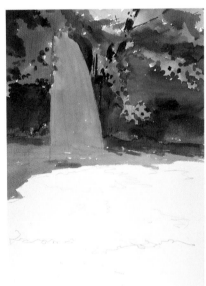

STEP ONE

Sketch the scene; then begin work on the background of rocks and vegetation. Don't bother working around the waterfall; instead, lay it in with a dull wash of grayish-green. Later you can add darks and lights to pick out its structure. Here the background is painted with cadmium orange, cadmium red, Hooker's green light, Payne's gray, and mauve.

In early autumn, jets of water spray over the rocks and fall gently into a still pond.

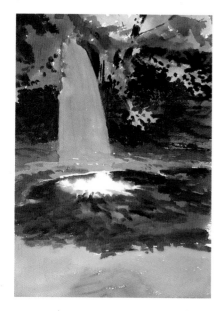

STEP TWO
Working around the bright white spot where the falling water hits the pond, paint the foreground. Use dark, dull colors—Payne's gray, sepia, and ultramarine—for the pool of water, and break the water up with short, jagged strokes that radiate outward from the center of the pool. To render the leaf-covered ground in the immediate foreground, lay in a soft wash of cadmium red and orange darkened with a touch of mauve. Keep this area simple so that it won't detract from the waterfall.

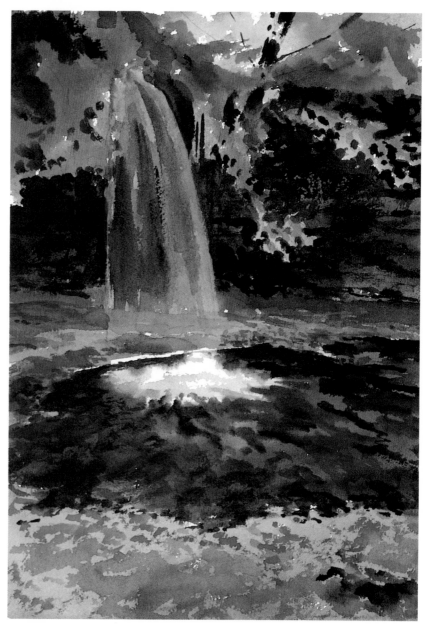

STEP THREE
Now break up the surface of the waterfall with long strokes of Payne's gray and Hooker's green light; you need these dark touches to make the lights stand out clearly against the rock. Next, with a thin wash of mauve, add touches of color to the white area of the pool. Then animate the foreground with dashes of cadmium red and orange.

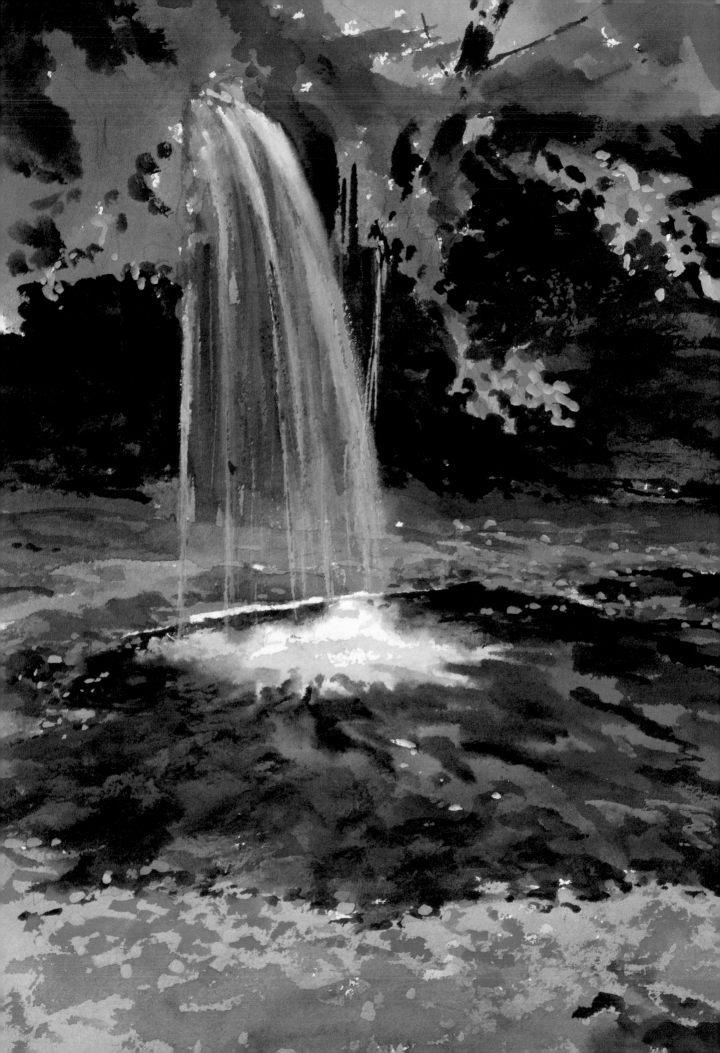

FINISHED PAINTING

The shift that occurs in the final stages of this work is subtle, but it makes a big difference in the final painting. First mix together opaque white with a touch of mauve and accentuate the lightest areas in the waterfall. Once the white is down, go back and soften it with a brush that has been dipped in clear water. As a final step, dab bits of golden gouache around the edges of the pool to suggest the leaves that litter the ground.

DETAIL

The waterfall is built up gradually. First a medium-value wash of greenish-gray is laid in to form its base. Next streaks of dark greenish-gray paint are added to break up the solid curtain of color. To accentuate the white jets of water, opaque gouache—in a mixture of white and mauve—is applied to the brightest areas. Finally, the gouache is softened with clear water.

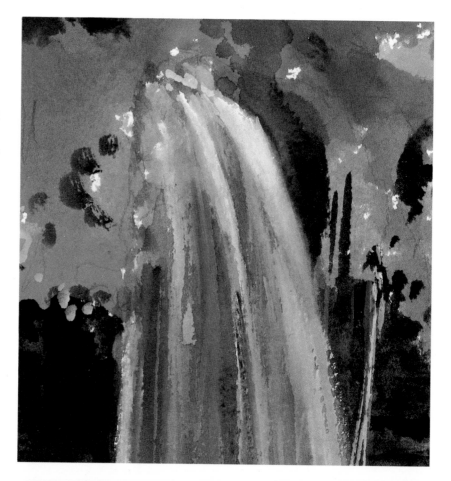

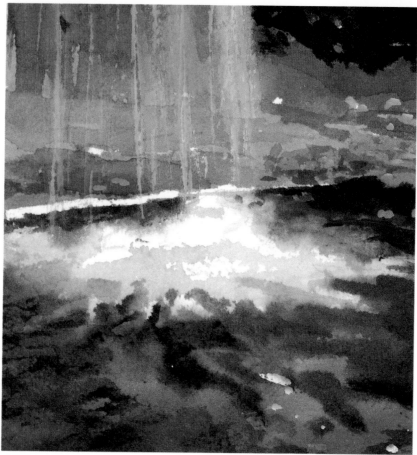

DETAIL

The bright white of the watercolor paper gets across the feeling of surging water perfectly. Touches of pale mauve suggest the shadows formed as the falling water meets the pond. All around this bright white area, dark strokes of color radiate outward.

Working with Soft, Diffuse Patterns

PROBLEM

This subject is extremely difficult to paint. The wall of water is so soft and so light that there isn't much to hold on to.

SOLUTION

Lay in the rocks that lie behind the waterfall first; then wipe out some of the color to suggest the jets of water. If you start with too dark a tone and can't wipe up enough of the color, start over again with a paler hue.

☐ Mix a good-size pool of yellow ocher and Payne's gray and lay the color in over the top portion of the paper. Let the color dry; then pick out the texture of the rocky backdrop with the same two hues—but two values darker. Once again, let the paper dry.

Next, take a natural sponge, dip it into clear water, and wipe out the vertical bands that make up the curtain of water. Pull the sponge over the paper with strong, definite strokes, and clean it in clear water repeatedly as you work. Use the same technique to pull out the pale diagonal area where the falling water meets the water below. Now evaluate what you've accomplished. If your colors and values satisfy you, move on to the foreground.

Here the foreground is made up of cerulean blue, Payne's gray, and burnt sienna. The color is applied with large, abstract strokes that mimic the dark patterns formed by the rushing water. In the immediate foreground, the color is strong and bold; this dark passage leads the viewer into the painting and toward the center of attention, the waterfall.

At the very end, you may want to go back and add touches of opaque white to the waterfall. If you do, proceed cautiously; soften the opaque paint with clear water, or it may stand out too sharply, destroying the subtle balance of color that you have achieved.

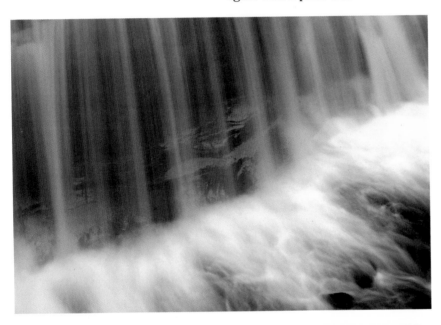

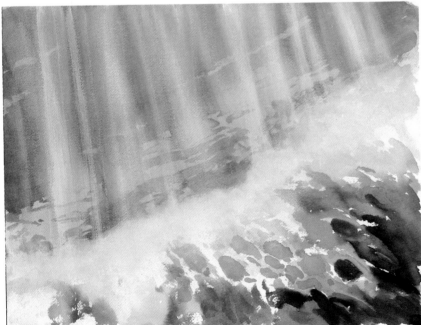

The base of a torrential waterfall pounds against the rocks, forming a solid curtain of cool blue.

Controlling Color and Value

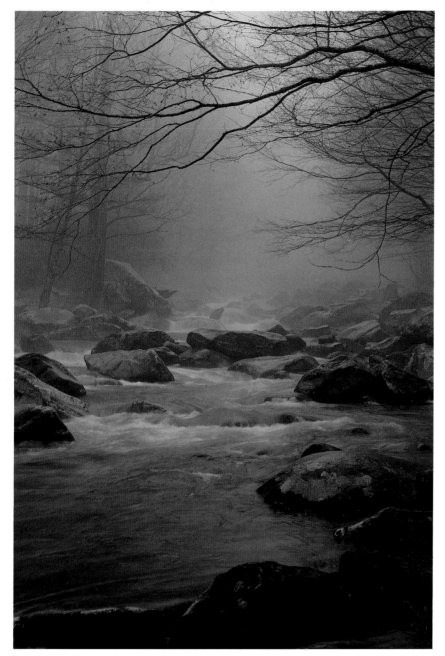

PROBLEM

The fog is so thick and so heavy that it muffles color and value. What's more, it makes even the sharp rocks in the background soft and unfocused.

SOLUTION

To control color and value, build your painting up slowly, using a traditional light-to-dark approach. And don't follow exactly what you see; make the water bluer than it actually is, to add a little life to your work.

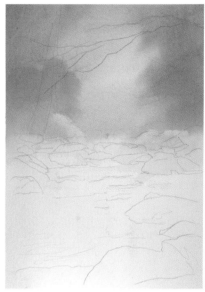

STEP ONE

Execute a careful preliminary sketch; then begin to develop the background. Lay in a light wash made up of cerulean blue, alizarin crimson, yellow ocher, and Payne's gray, and make the wash lightest in the center of the paper. While the paper is still slightly wet, lay in a wash of Payne's gray and yellow ocher to indicate the trees in the background. Now let the paper dry.

In early winter, thick gray fog presses down over a rocky stream.

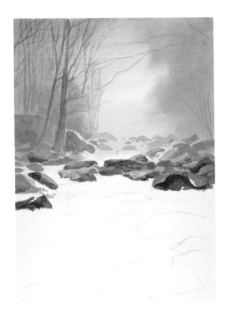

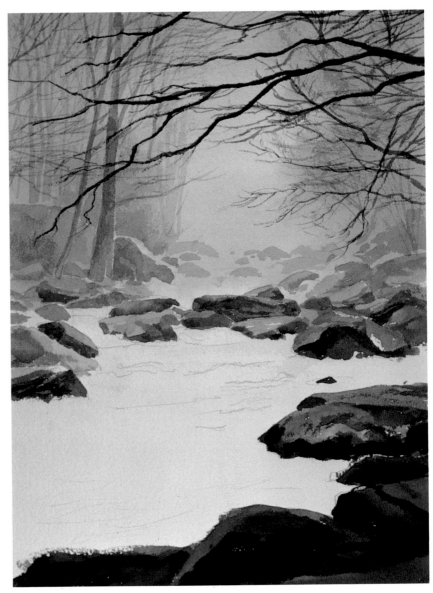

STEP TWO
Working with cool grayed-down hues, build up the background and middle ground. Here the trees are rendered with a very light mixture of Payne's gray, burnt sienna, and ultramarine blue. Using the same colors, paint the rocks; note how those in the background are much lighter than those in the middle ground.

STEP THREE
Before you tackle the water, finish the rest of the rocks and the trees. The rocks that lie in the immediate foreground should be rich with dark hues. Try painting them with sepia, burnt sienna, yellow ocher, and ultramarine blue. Use the same colors to depict the scraggly tree branches that stretch across the stream.

FINISHED PAINTING
Study your painting before you move on. Even though it looks muted and filled with a variety of grays, you know that it is packed with understated color—yellow, red, blue, and brown as well as gray. Treat the water in the same fashion, rendering it with cerulean blue and yellow ocher. The yellow ocher warms the blue and makes it more lively and interesting. First lay in a very pale wash of color; then slowly introduce darker tones. Let the white of the paper stand for the surging water in the middle ground. As a final step, add long, fluid horizontal brushstrokes to the water in the foreground.

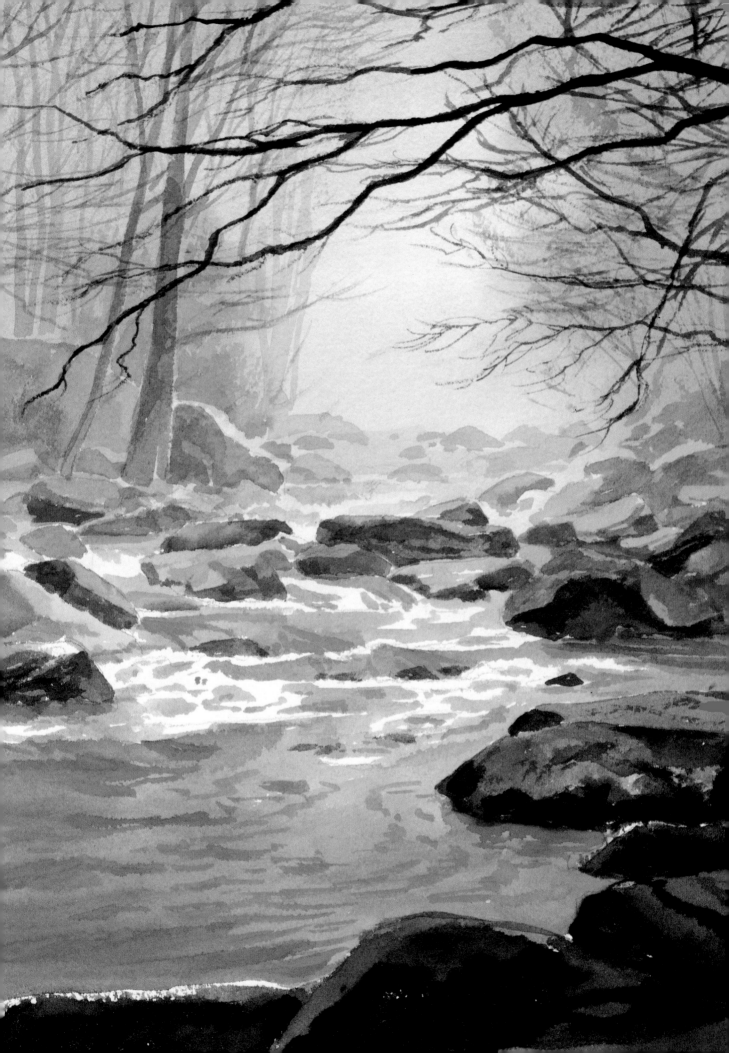

Handling Transparent Water and Reflections Simultaneously

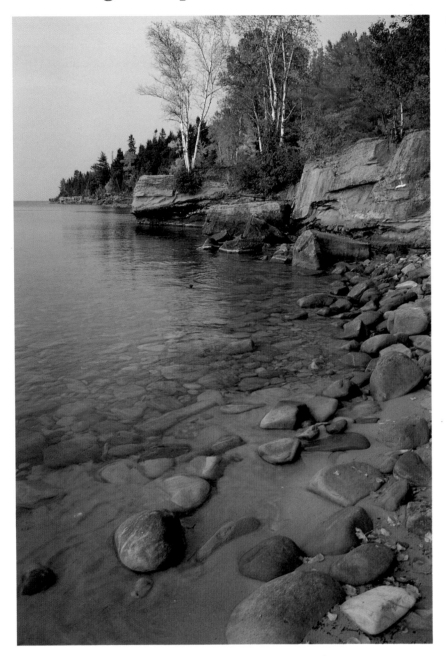

Colorful autumn foliage and craggy brown rocks act as a backdrop for the still waters of Lake Superior.

PROBLEM

In the foreground, the water is transparent; farther back it is deeper and mirrors the trees that line the shore. Both effects are important and have to be captured.

SOLUTION

Paint the sky and the water in one quick step; then build up the rest of the painting around them. Right from the start you can deal with the reflections; gradually add the rocks as your painting progresses.

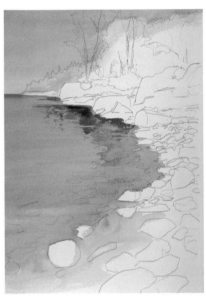

STEP ONE

Sketch the scene; then lay in the sky and the water, working from top to bottom. For the sky, lay in a light wash of cerulean blue with some alizarin crimson. As you approach the horizon, make the wash lighter. To paint the water darken the wash with ultramarine. While the wash is still wet, drop in touches of burnt sienna to render the shadows cast by the trees and to suggest the rocks that are under the water.

STEP TWO
The rocky cliffs that support the trees merge into the rocks that line the shore. Capture this sweep of color by painting the cliffs and the rocky foreground in one quick step. Mix together a wash of alizarin crimson, cadmium orange, and burnt sienna; then lay it in.

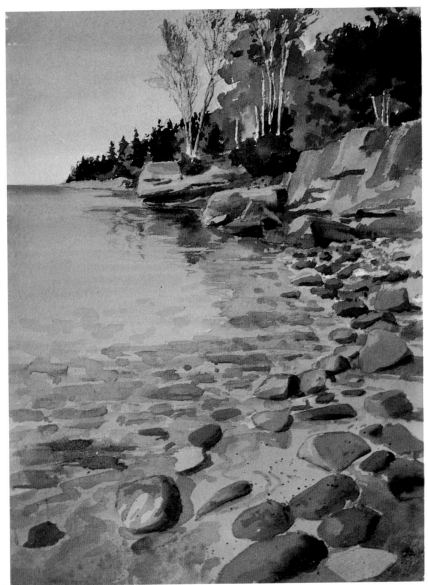

STEP THREE
Add the bright trees in the background with Hooker's green, yellow ocher, burnt sienna, cadmium red, and cadmium orange. Now turn to the cliffs and rocks. First add texture and shadows to the cliffs with a middle-value hue mixed from ultramarine, burnt sienna, Payne's gray, and yellow ocher. The cliffs done, develop the rocks with the same colors. Paint their darkest, shadowy areas first; then go back and wash in the color of each rock. Apply quick dabs of color to the water in the foreground to suggest the rocks farthest from the shore that are covered by water.

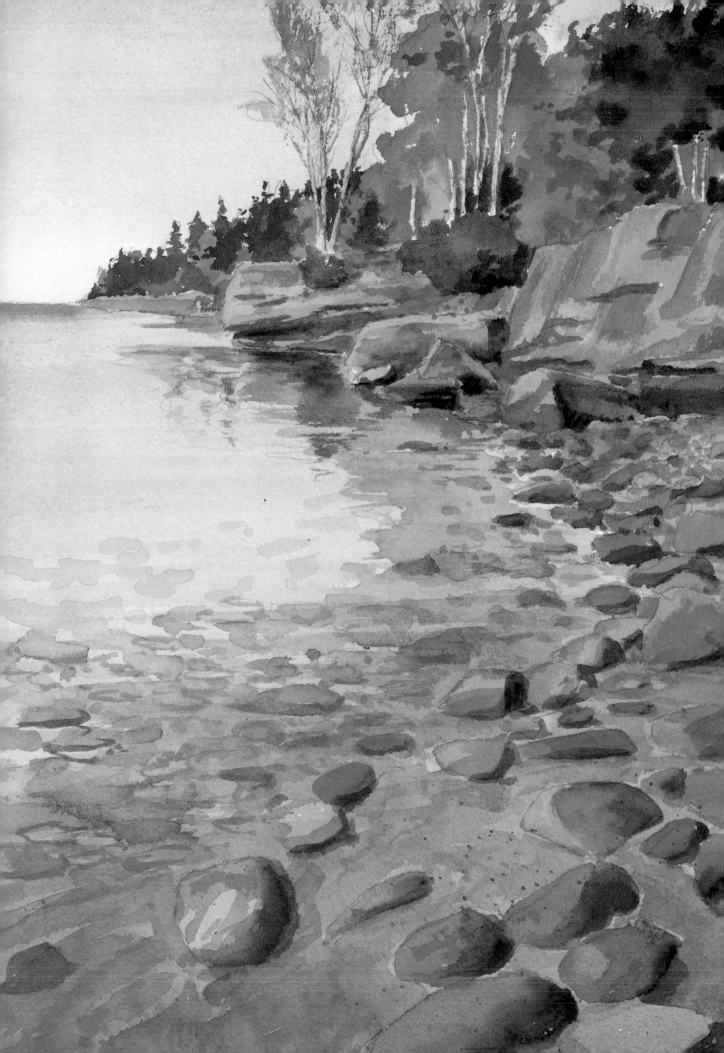

FINISHED PAINTING

Very little remains to be done. Examine the rocks in the foreground and add any details you think necessary; then turn to the rocks that lie a little farther back. If they seem too harsh, try this: Mix a very light wash of ultramarine and quickly run it over the water-covered rocks. You'll soften their contours and make them seem more realistic all in one step.

DETAIL

The reflections of the trees and rocks were painted wet-in-wet. Because the paper was slightly damp, the reflections blur and run into one another realistically.

DETAIL

The rocks were developed gradually, built up with successive layers of wash. Only in the final stages of the painting were their shadows and contours etched out. At the very end, a pale wash of ultramarine was pulled over the rocks that lie in the water to soften their edges and to relate the water to the rest of the lake.

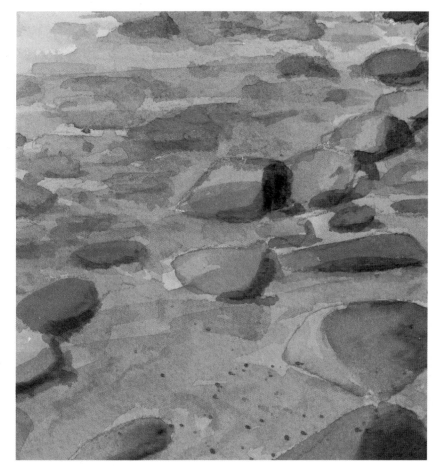

121

Depicting the Abstract Beauty of Water in Motion

PROBLEM

The transparency of water is in itself difficult to paint. Here the situation is made even more difficult because the water is moving rapidly. Finally, the sandy shore that shines through the water is packed with pattern.

SOLUTION

Develop the painting freely, concentrating on abstract pattern. At the very end, add the brights with opaque gouache.

☐ Prepare your palette with sepia, burnt sienna, yellow ocher, cerulean blue, and ultramarine. Now lay in an overall pattern made up of middle-value blues, grays, and browns, trying to capture the effect of the sand beneath the water.

While the paper is still wet, introduce the darker values. Because the paper is damp, no harsh edges will intrude on the pattern you are creating. Next use dark washes of color to suggest the shapes of some of the stones.

Once the paper is dry, flood a wash of cerulean blue and ultramarine diagonally over the center of the composition to show the contour of the incoming water. Finally add the whites, using white gouache mixed with a touch of cerulean blue and yellow ocher. As you dab the paint onto the paper, follow the pattern formed by the highlights that flicker over the water's surface.

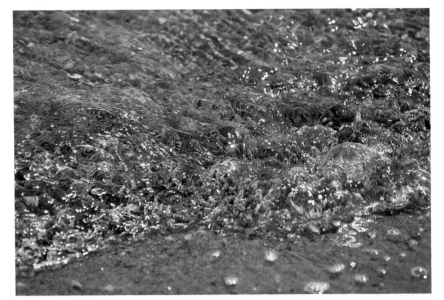

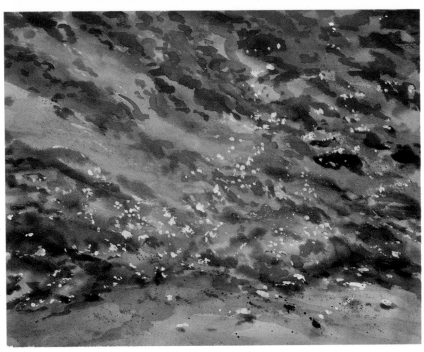

Clear, cold water rushes onto a sandy shore—then quickly turns back, retreating toward the ocean.

DETAIL

The initial blue, gray, and brown washes merge together effortlessly because they were applied simultaneously and then allowed to mix together. The slightly darker tones were also laid onto damp paper to soften and blur their edges. A final wash of cerulean blue and ultramarine shows the directional flow of the water, while dashes of opaque white add highlights that break up the darker tones.

ASSIGNMENT

If you are attracted to abstract paintings, but need a point of departure before you can begin work, use water or ice as your starting point. Select a subject that has interesting patterns or shadows—a frost-covered pane of glass, a sheet of ice, or even a mound of snow.

Execute a sketch by concentrating on the entire subject, without focusing on any particular detail. As you draw, don't glance at the paper—try to coordinate your hand and your eye without thinking. Once the basic shapes are down, repeat the process, this time working with thin washes of color. Gradually increase the density of the pigment until you have a fully developed watercolor.

Your first efforts might seem clumsy—but don't be discouraged. With practice you'll find that you can create dynamic abstract paintings that are unified and coherent because you began with something real.

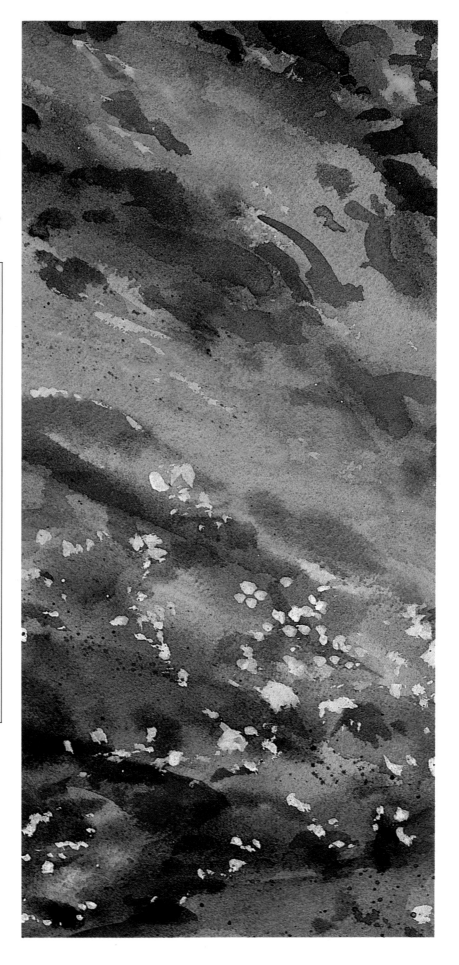

Pulling Out Highlights with a Razor

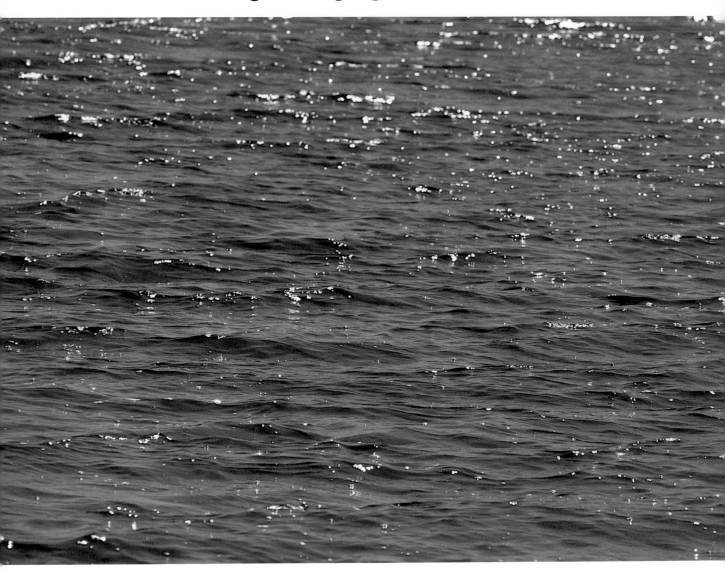

PROBLEM

Capturing the highlights that race across the surface of the lake is the problem here. You can't mask them all out, and painting around them would be almost impossible.

SOLUTION

Pull out the highlights at the end, after you've painted the lake, using a razor. You'll find that a razor is ideal for capturing the jagged, rough feel of the waves.

☐ Whenever you intend to use a razor to pull out highlights, choose heavy, sturdy paper. A 300-pound sheet is thick enough to stand up to the action of a razor or a knife.

Cover the entire surface of the paper with a wash made up of cerulean blue, ultramarine, and Payne's gray. While the wash is still wet, lay in streaks of darker blue to indicate the larger waves that break across the surface of the lake. Because the paper is damp, their edges will be soft.

Let the paper dry; then paint the smaller waves. To achieve a sense of perspective, make them

Dashes of light streak across
the deep-blue surface of a lake.

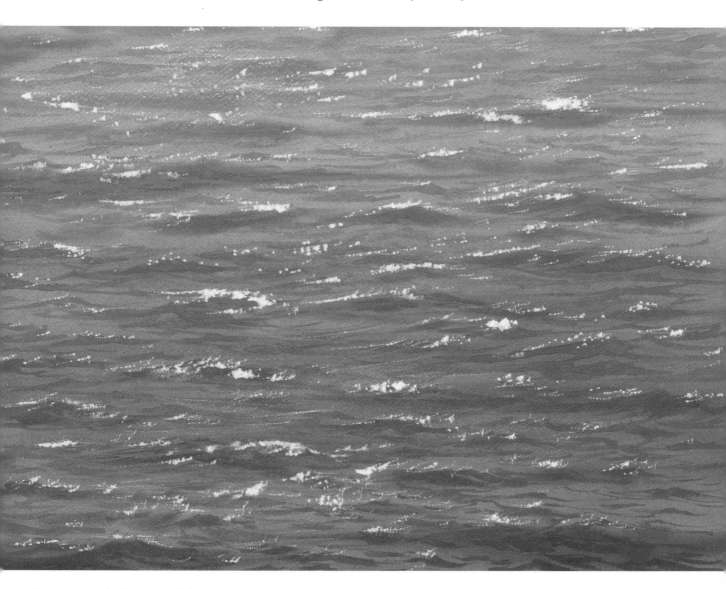

larger near the bottom of the paper and smaller and less distinct as they move back in space.

All that remains now is the scratching out of highlights. Be careful: If the paper is even slightly damp, it will shred and pull apart. While you wait for the paper to dry, note how the highlights flicker on top of the major waves; that's where you'll want them in your painting.

Pull the razor carefully over the paper, never letting it tear through. Concentrate the highlights in the foreground; pull out fewer as you move back toward the top of the paper.

ASSIGNMENT
You'll feel more comfortable working with a razor in the field if you practice the technique at home. Lay in a flat wash on a sheet of 300-pound paper. While the surface is still damp, try scraping the razor across it. As you watch the paper shred and tear, you'll quickly discover the importance of working on an absolutely dry surface.

Now let the paper dry. Experiment by pulling the entire blade across the paper, picking up broad swatches of color. Next, try working with just the corner edge of the razor. Finally, try combining broad strokes with finer ones. Throughout, give your strokes a definite sense of direction.

Separating Sky from Water

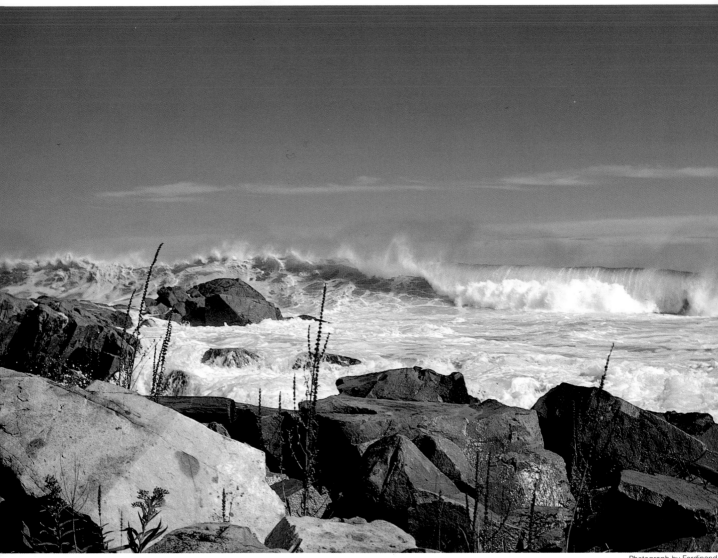

Photograph by Ferdinand

PROBLEM
When the sky is as bright and blue as this one is, there is always a chance that it will steal attention from the real subject of the painting, the powerful wave that breaks across the central rock.

SOLUTION
Make the most of the cloud that streaks across the sky. Use it to separate the sky from the water.

On a clear spring day, heavy surf pounds against a rocky New England shore.

STEP ONE

Sketch the scene; then lay in the sky. Since you are working with deep blue, turn the paper upside down; if the paint runs, it won't dribble down into the wave. First wet the edge of the wave where it breaks against the sky; this will keep the edge soft and smooth. Then paint the sky with ultramarine, cerulean blue, and alizarin crimson, with paler washes toward the horizon. Be sure to leave some white for the cloud in the lower sky.

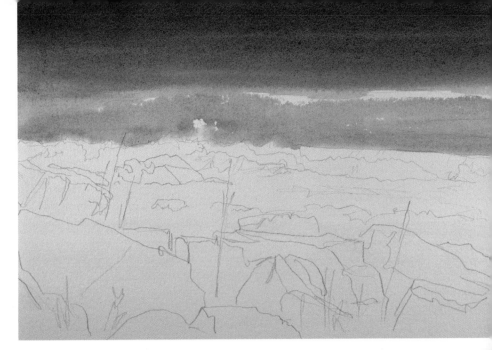

STEP TWO

Now turn the paper right-side up and start to execute the wave. As you paint, let patches of the white paper break through to indicate the brilliant whites of the pounding surf. Here the bluish portions of the wave are rendered with cerulean blue and alizarin crimson. Once these areas are dry, add the greenish wall of water on the right with Hooker's green light and new gamboge. Finally, add splashes of green and blue to suggest the breaking wave on the left.

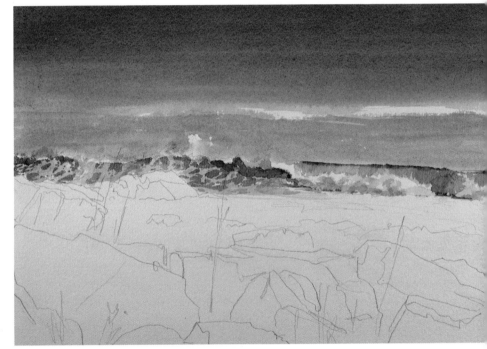

STEP THREE

Now lay in the foamy water that washes across the foreground, again working with cerulean blue, ultramarine, alizarin crimson, Hooker's green light, and new gamboge. Use short, horizontal strokes to make the water look flat.

 Once the water is done, render the rocks with burnt sienna, alizarin crimson, and cadmium orange. At first lay them in with flat washes of color; once the washes are dry, go back and add the shadowy portions.

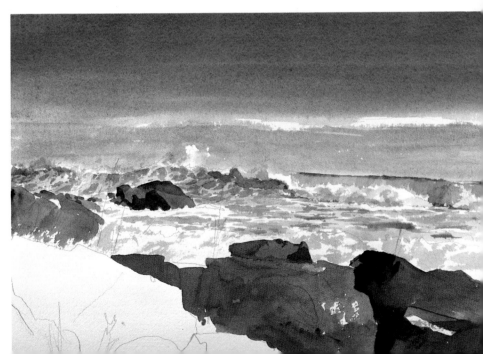

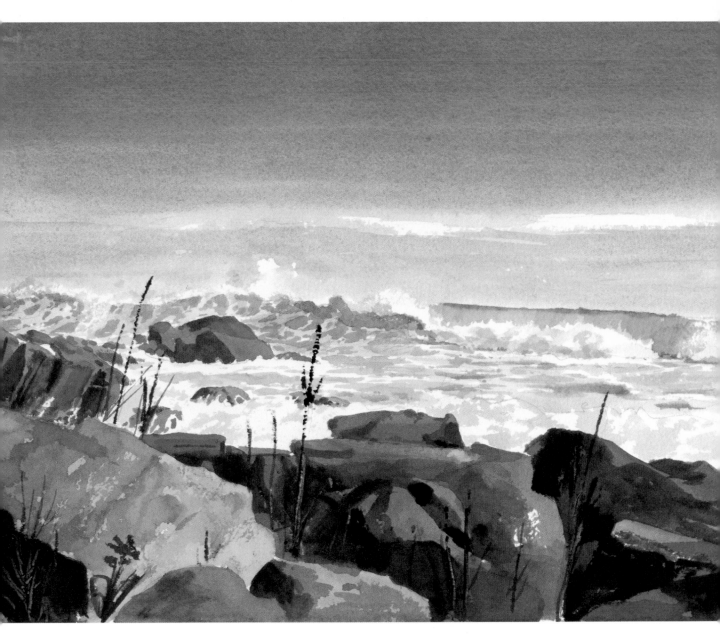

FINISHED PAINTING

When you begin to execute the rocky foreground, use strong, bold color, and pattern the rocks with very dark tones. The stronger and darker these rocks are, the more the water and waves will seem to recede. As a final touch, drybrush in the tall grasses that grow amidst the boulders; and, if necessary, go back to the water and pull out additional white highlights with a razor blade.

ASSIGNMENT

Waves present a special challenge to the landscape artist. They last for but a second, and in that time there is a great deal of visual information that must be rendered if you are to capture the power and drama of pounding surf. The easiest way to become familiar with waves is to sketch them often—and quickly.

Go to the shore on a day when the surf is heavy; bring along a pad of newsprint paper, charcoal, and pencils. Go to work immediately. Keeping your eyes on the water, begin to execute loose, gestural drawings. Use your whole arm to catch the sweeping power of the waves.

Concentrate first on the swells in the distance—they are low and rhythmic undulations. Next, sketch the waves that are closer to shore; note how, as they crest, they rise and begin to topple over. Then sketch the waves as they begin to break. Explore how they turn over and begin to explode in spray. Finally, draw the waves as they crash down onto the water that is lapping toward the shore.

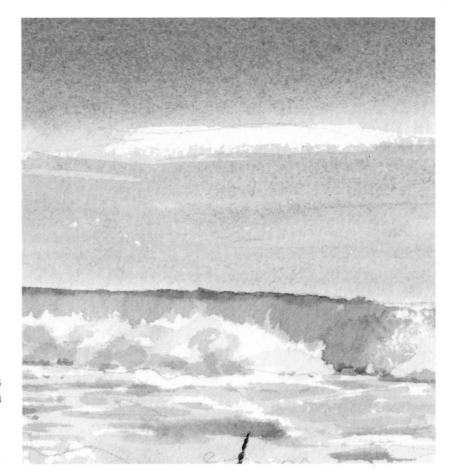

DETAIL
The cloud that streaks across the paper separates the sky from the water below. Without it, the strong blue of the sky would diminish the power of the breaking wave. Green, not blue, makes up the pounding surf. This shift in color further separates the water from the sky. The brilliant white of the paper stands for the tips of the powerful waves.

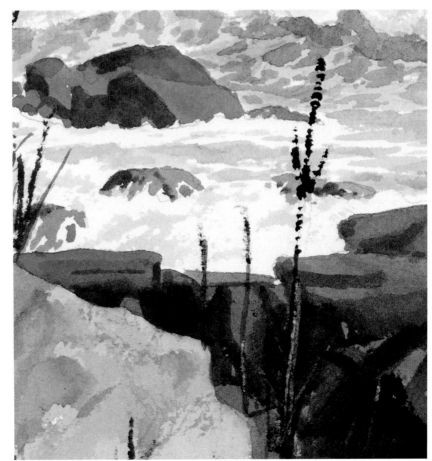

DETAIL
The large rocks in the foreground establish a sense of scale. Because they are painted with strong, dark color, they also make the waves and water recede.

Emphasizing a Light-Streaked Wave

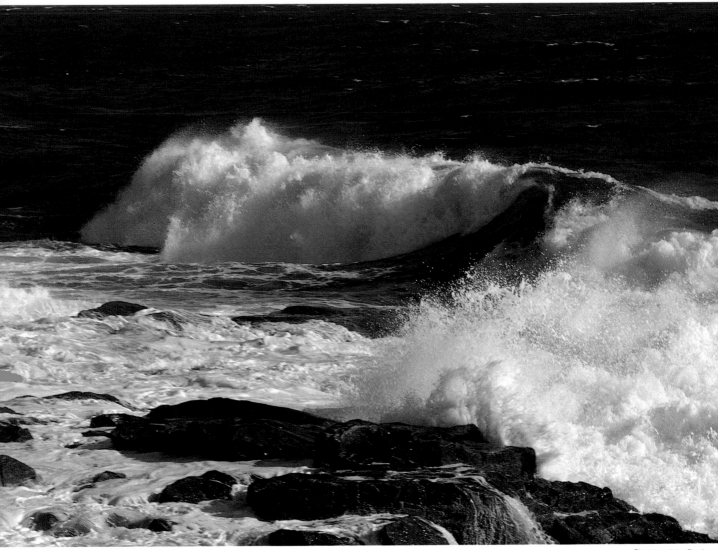

Photograph by Ferdinand

PROBLEM
Compared to the dark water and rocks, the wave is very light in value. Unless it is handled carefully, it may not stand out clearly in the finished painting.

SOLUTION
Paint the dark-blue water and the rocks in the foreground first. Once they are down, you'll be able to adjust the value of the wave.

On a cold autumn day, a breaking wave surges against the rocks.

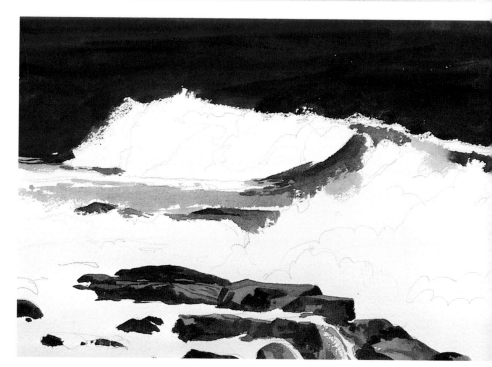

STEP ONE

Sketch the scene; then lay in the sky with a medium-value wash of cerulean blue and ultramarine. Next sweep a very dark wash, made up of the same two blues, over the water. When you reach the wave, use a drybrush technique to render its edge.

STEP TWO

The water done, turn to the rocks. First paint their shadowy portions with sepia, ultramarine, and burnt sienna. As soon as the shadows are dry, lay in the rest of the rocks with a warmer wash. Here it is composed of burnt sienna and yellow ocher.

Before you turn to the wave, paint the sweep of water that rushes up to meet it. Instead of using a straight blue, try working with some green. It will help separate the foreground from the dark-blue backdrop. Use Hooker's green, cerulean blue, ultramarine, and Payne's gray.

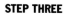

STEP THREE

When you begin to work on the wave, use a light hand: The white of the paper is just as important as any color you lay in. Analyze the wave, searching for the shadows that sculpt it out. Paint these areas carefully, using cerulean blue, ultramarine, Hooker's green, yellow ocher, and Payne's gray. With the same hues, lay in the water that eddies around the rocks in the foreground.

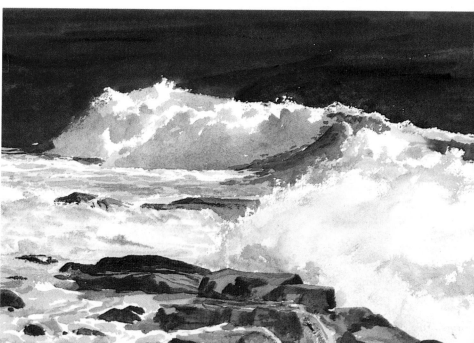

FINISHED PAINTING

At this point, the dark-blue water in the background dominates the composition. Tone it down by adding small waves with opaque ultramarine. When the waves are dry, drybrush in touches of opaque white to suggest how the light glistens over the water. Finally, moisten a small brush with opaque white and add dabs of the paint to the top of the breaking wave.

The dark waves added at the very end break up the expanse of heavy deep blue. Rendered with horizontal strokes, they also flatten out the water and direct attention to the focal point of the painting, the breaking wave.

It's the white of the paper that makes the water sparkle and glisten. The washes of color are applied sparingly to make the most of the watercolor paper.

Painted mostly with Hooker's green, the surging water stands out clearly against the wave and the water in the background. Touches of Hooker's green also run along the edge of the wave, again separating it from the large expanse of dark blue.

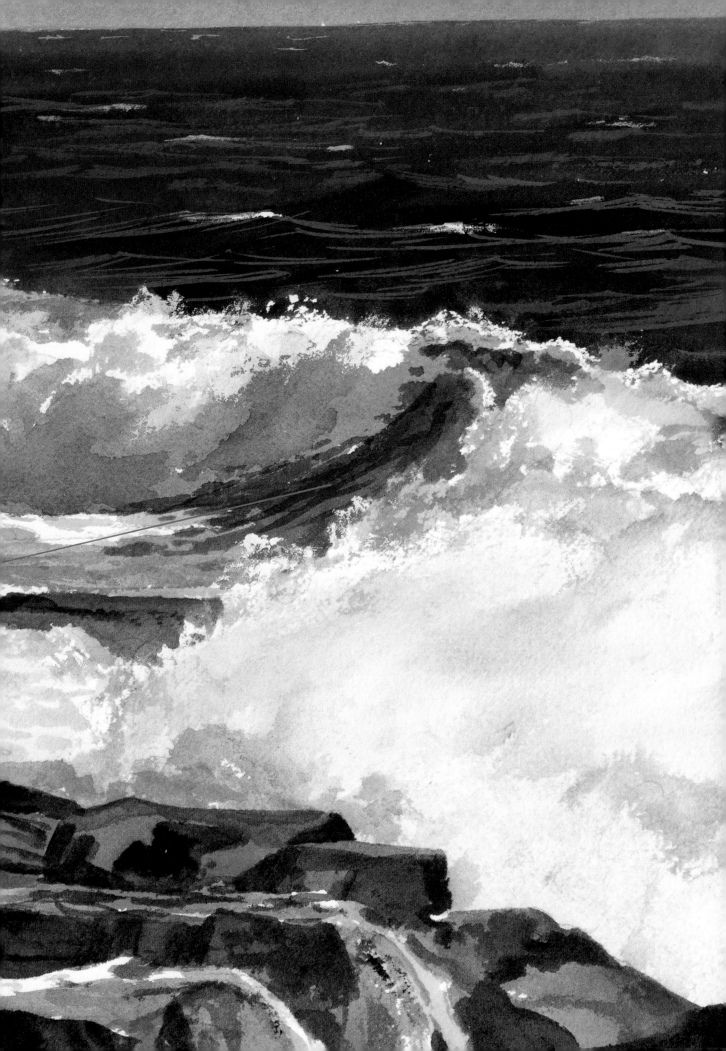

Capturing Soft, Glistening Spray

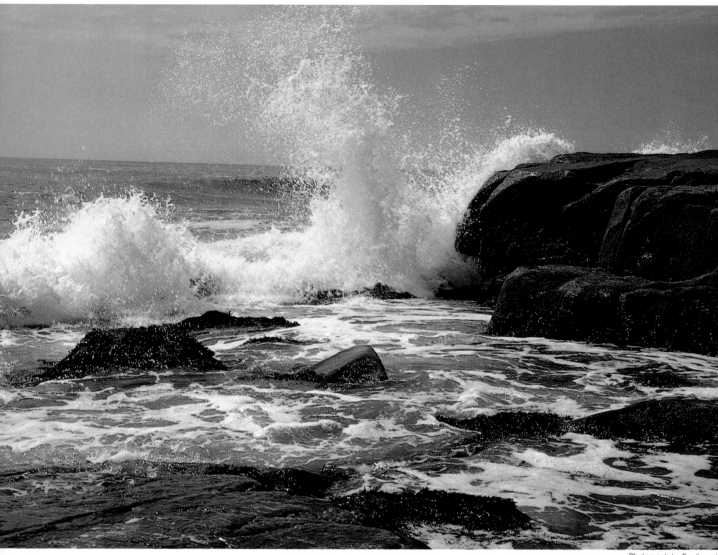

Photograph by Ferdinand

PROBLEM
This scene is dramatic, but it's gentle, too. The spray that shoots into the air and the glistening water that spills over the foreground are soft and filled with light.

SOLUTION
To keep the wave soft and fluid, use a wet-in-wet approach. Let the white of the paper stand for the most brilliant bits of spray and water.

☐ After you have sketched the scene, turn the paper upside down. Wet the sky and the wave's spray with clear water; then lay in a very light wash of alizarin crimson. Don't let the crimson bleed into the spray. While the paper is still wet, drop in cerulean blue and ultramarine, again avoiding the white spray. Now let the paper dry.

Turn the paper right-side up and begin work on the water that lies behind the wave. Here it is rendered with cerulean blue,

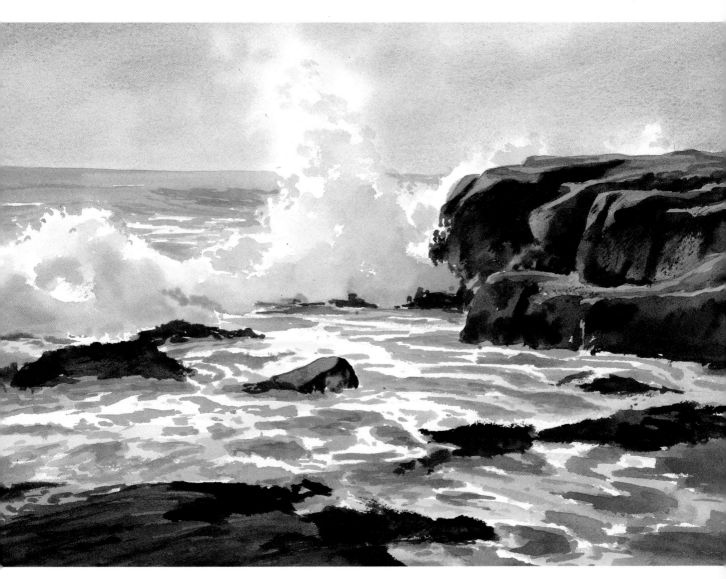

Glistening spray shoots into the air as a massive wave hurls itself against a rock.

ultramarine, and Payne's gray. Where the contours of the spray meet the water, leave a hard edge to pull the two areas apart.

Before you turn to the wave and the water in the foreground, execute the dark rocks with burnt sienna, sepia, and Payne's gray. When they are dry, wash the top of each rock with cerulean blue to suggest how they reflect the sky.

The stage is now set for the wave. Prepare a wash made up of ultramarine, cerulean blue, and alizarin crimson; then gently

stroke the wash onto the paper. Work slowly—don't cover up all of the white paper. You want a band of white to surround the wash you are laying in. To keep the wave from becoming too flat, vary its color slightly. Here the low-lying portion on the left is rendered with more alizarin crimson than the portion on the right.

Finally lay in the water in the foreground, working around the white foam. Ultramarine, cerulean blue, alizarin crimson, and Hooker's green all come into

play here. For the dark pool of water on the left side of the immediate foreground, use strong brushstrokes with a definite sense of direction, and add some brown to your palette to suggest the underlying rock.

In the finished painting, the wave stands surrounded by a soft halo of white. The white pulls it away from the sea and sky and suggests its soft, yet dramatic, feel.

Deciphering the Subtle Colors Found in Waves

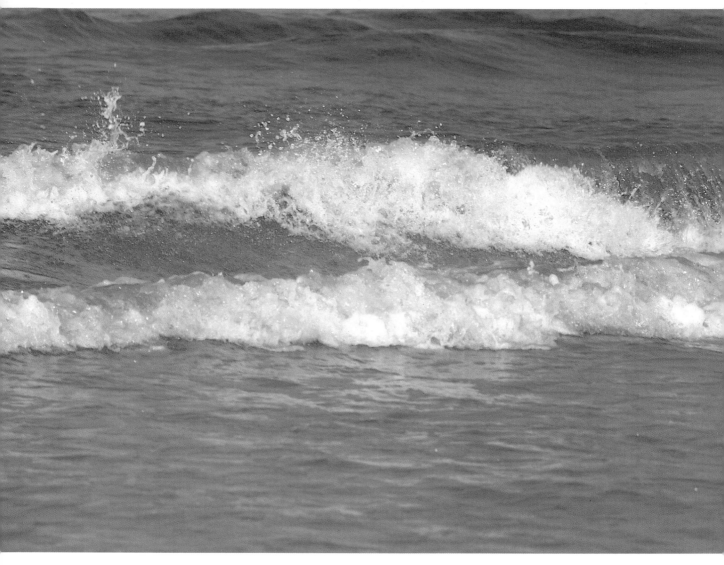

PROBLEM

Set against a blue background, waves can seem almost pure white, yet they are actually packed with color and filled with lights and darks. You have to be sensitive to these nuances in color and value to create a believable painting.

SOLUTION

Paint the water first; then turn to the waves. The blue of the water will give you something to react to as you build up the colors and values of the waves.

☐ Imagine that the scene is divided into three bands: the water behind the waves, the waves, and the water in front of the waves. Deal with each band separately.

Start with the water in the background. Working around the breaking waves, lay this water with ultramarine and cerulean blue, plus just a touch of burnt sienna. Now turn to the water in the foreground, painting it with cerulean blue, ultramarine, and new gamboge. To break up what could become a dull expanse of blue, make the water lightest in the center.

*Gentle waves foam and bubble
as they sweep toward a sandy shore.*

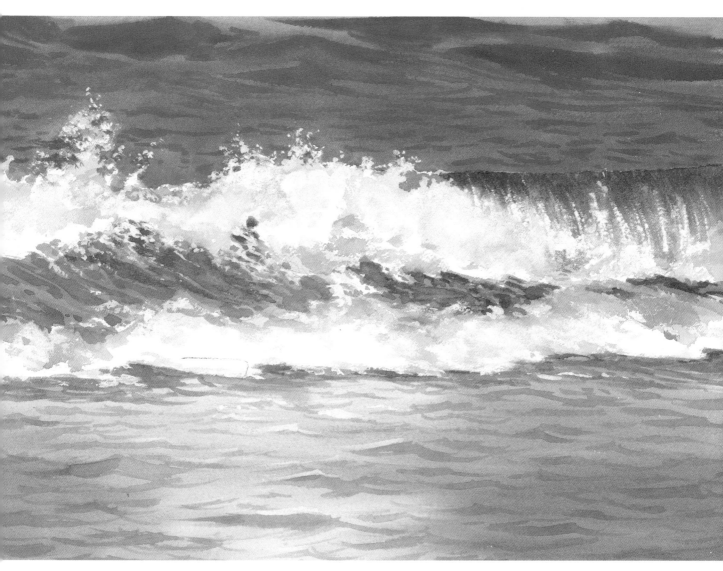

Before you turn to the central waves, go back and add long, undulating waves to the water in the background, using a slightly darker value than the one you originally put down. Then break up the water in the foreground by using shorter, choppier strokes.

Now it's time to paint the central waves. Starting with the darkest value, lay in the swell of the wave at the far right and the dark water that lies between the two waves. Try rendering them with a greenish hue, here made up of cerulean blue, ultramarine, and new gamboge. As you work,

give your brushstrokes a strong sense of direction; they have to capture the power of the moving water. The darkest value down, add the light spray that animates the waves. Use a very light wash of cerulean blue, alizarin crimson, and yellow ocher.

Stop and analyze your painting. At this stage, the chances are that it lacks punch. What it probably needs are stronger, more brilliant whites than the paper can provide. To make your painting sparkle, try two approaches. First, mix white gouache with a touch of new gamboge—straight

white would look too harsh—and dab it onto the paper to suggest the topmost portions of the spray. Next, use a drybrush approach to add the gouache to the turning wave at the right. As a final touch, let the gouache dry; then take a razor and scratch out bits of white to break up whatever areas still seem dark and heavy.

Painting a White Bird Set Against Light Water and Waves

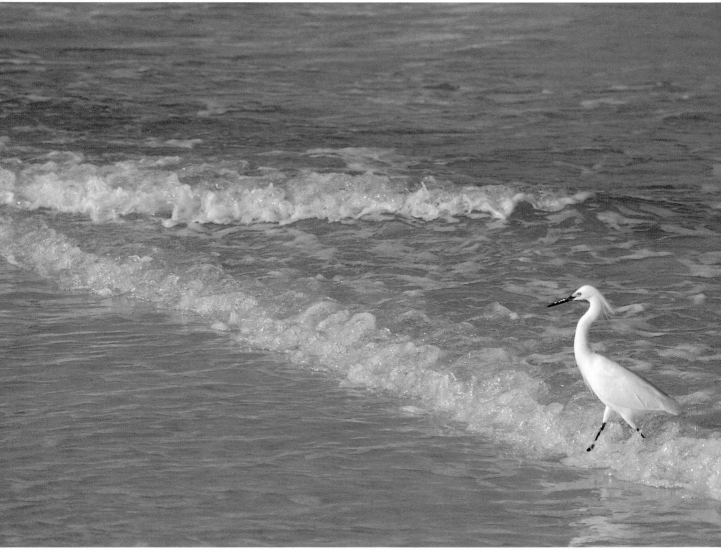

PROBLEM

Everything in this scene is light—
the water, the waves, and even
the bird. The egret is clearly the
most important element in the
composition, but it will be difficult
to make it stand out against the
water and waves.

SOLUTION

Mask the egret out before you
start to paint. Develop the rest of
the painting and then peel the
masking solution off. To make the
bird stand out clearly against the
blue of the water, surround it with
a thin band of black.

☐ Draw the egret and lightly lay
in the lines formed by the waves;
then mask the bird out with liquid
frisket. Now cover the entire
sheet of paper with a light tone of
Payne's gray, cerulean blue, and
yellow ocher.

When the paper is dry, begin to
develop the water in the back-
ground. Using a light wash made
up of cerulean blue and Payne's
gray, lay in the long horizontal

*An egret strides easily
through a softly swelling tide.*

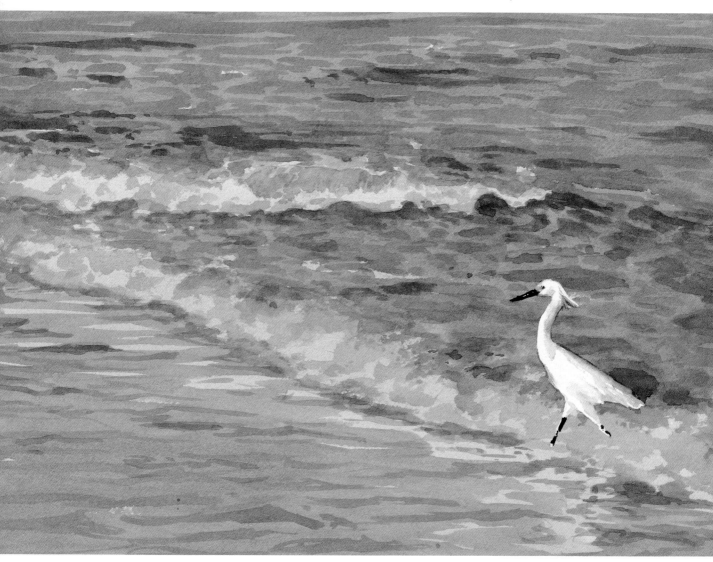

strokes that suggest the lapping water. Don't cover up all of the underpainting; let streaks of it shine through the darker wash. As you approach the two large waves, add yellow ocher and new gamboge to your wash, to produce a slightly greenish tone.

Use soft, gentle strokes to render the waves; continue using the greenish wash as you paint the two breakers and the water

that lies between them. When you turn to the water in foreground, once again work with cerulean blue and Payne's gray. Let the paper dry.

To pull together the different sections of the painting, mix a wash of pale cerulean blue; then apply it to everything except the two breaking waves. Now peel off the masking solution and paint the shadows that define the egret's

head and body with Payne's gray and yellow ocher. A dab of cadmium orange represents the base of the bill; a deep mixture of ultramarine and sepia is perfect for the legs and the rest of the bill. To make the egret stand out against the blue backdrop, dilute the mixture of ultramarine and sepia, and run a fine line of the dark tone around the important contours.

Relying on Values to Capture an Abstract Pattern

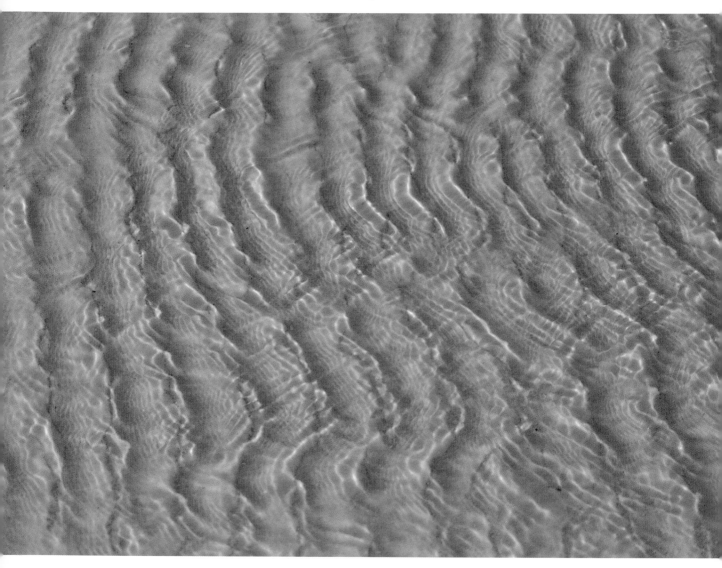

PROBLEM
This is an extremely difficult subject. Three elements must be captured: the sandy ridges, the clear water that ripples over the sand, and the highlights created as sunlight strikes the water.

SOLUTION
Approach the scene as though it were a value study. Search for three definite values—lights, darks, and a middle tone—and build up your painting by working from light to dark.

□ Get the lights down right away by toning the entire paper with a pale wash of yellow ocher. Let the paper dry. Now lay in the darkest value—the tips of the sandy ridges. Keep them as simple as possible; what you are aiming at is their general effect, not each and every ridge. To paint them, use sepia, burnt sienna, Payne's gray, and yellow ocher. While the darks are still damp, gently work in the middle tones, using a lighter value of the same hues.

Once the darks and the middle values are down, you'll probably find that the lights aren't bold enough. If that's the case, add

*As water ripples over a shore,
undulating patterns form in the sand below.*

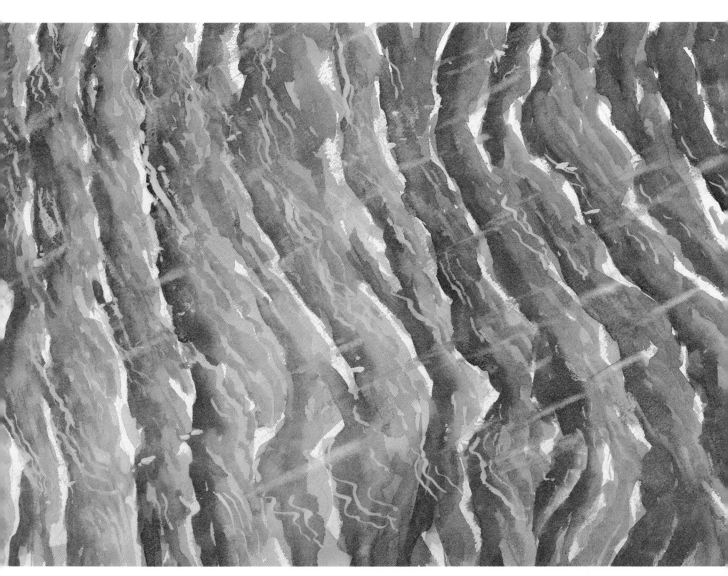

additional flickers of light by using opaque gouache; here white is mixed with yellow ocher, and the pigment is laid down with a small brush and undulating strokes.

At this point you've carefully built up your painting with three distinct values. All that remains to be done is to suggest how the water moves over the sand. Let the surface dry; then moisten a piece of paper toweling. Working diagonally, from the upper-right corner to the lower-left corner, carefully wipe out streaks of paint. The pale passages that result will suggest the motion of the water.

ASSIGNMENT
Water has fascinated men for centuries, and little wonder. It is constantly moving, creating endless abstract patterns. In this lesson you've explored how flowing water sculpts sand. Don't stop here.

After it rains or when the snow is melting, go outside and search for rivulets of water. On a sketch pad, quickly capture the patterns the water forms. If you live near a beach, look for little indentations in the sand; study how water flows into these pools and then slowly moves back toward the water.

Studying the ebb and flow of water can turn into a lifetime preoccupation—and one that can offer you a lifetime's worth of subject matter for your watercolors.

Index

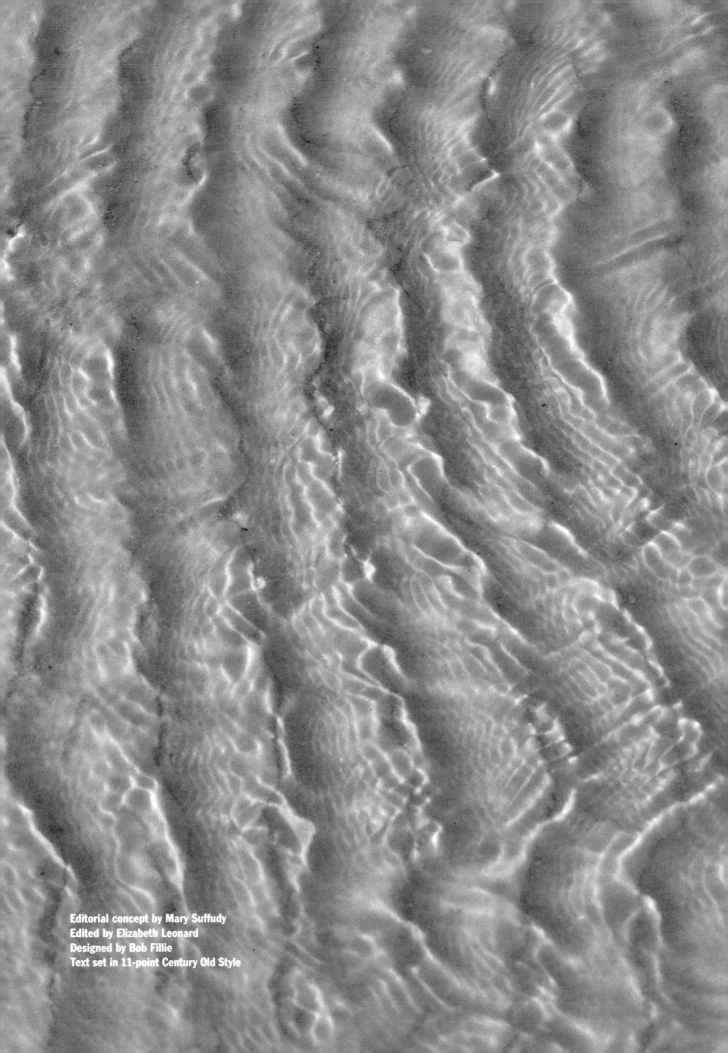

Editorial concept by Mary Suffudy
Edited by Elizabeth Leonard
Designed by Bob Fillie
Text set in 11-point Century Old Style